DESIGN
SYNECTICS

DESIGN SYNECTICS

Stimulating Creativity in Design

NICHOLAS ROUKES

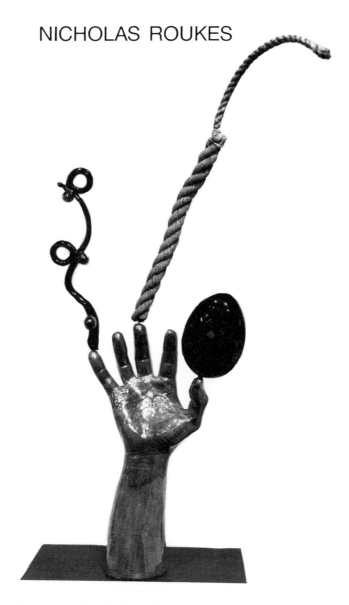

Davis Publications, Inc.
WORCESTER, MASSACHUSETTS

For JULIE

Cover: George Snyder, **Facet,** 1980. Acrylic on canvas, 55× 55″ (139.7×139.7 cm). Courtesy the artist.

Title Page: Lukman Glasgow, **Signal Hill,** 1980. Clay, glaze, luster and stain, 32×12″ (81×30 cm). Courtesy the artist.

Copyright © 1988
Davis Publications
Worcester, Massachusetts U.S.A.

Printed in the United States of America

Library of Congress Catalog Card Number: 88-070675 ISBN: 87192-198-7

10 9 8 7 6 5 4

CONTENTS

Introduction 9

Synectics
The Synectic Trigger Mechanisms
The Mystery of Creativity

Chapter 1 Behind Appearance: The
Substructure of Design 29

Forces
Grouping
Studio Action 45

Chapter 2 Design and Synectics 69

Order
Design
Enter Synectics
Space, Structure, and Form
Visual Analogistics
Studio Action 79

Chapter 3 Design and Signification 101

Signs and Symbols
Metaphor
Semiotics
Analogy
Studio Action 113

Color Gallery 131

Color and Synectics

Chapter 4 Paradox, Humor and Prevarication 147

The Paradox of Art
The Comic Idiom
Studio Action 160

Chapter 5 Change 183

Change: Progression and Variation
The Modular Unit in Art and Design
The Grid
Time As an Expressive Factor
Movement: Implied and Actual
Studio Action 197

Bibliography 219

Index 221

PREFACE

Design Synectics combines design theory with Synectics (a theory of creativity) and presents a way of working that is calculated to stimulate creativity in art. Design and Synectics work well together to enhance creative thought and action—design theory appeals to the sense of reason and order, and Synectics to the sense of fantasy and invention.

This book has two objectives: First, to provide you with information about the many ways in which design and Synectics can be combined to spark unique ideas and artwork; and second, to serve as a guide for organizing and conducting studio experiments. *Design Synectics* is planned as a reference guide for the student or practicing artist, as well as a course of study or reference text for art fundamentals, design and art education classes.

A special note: The information in *Design Synectics* is not to be regarded as a rigid doctrine but rather as a springboard for personal experimentation and discovery. The ideas in the book can be modified, extended, or simplified to suit different temperaments, age groups and grade levels, ranging from post-elementary to post-secondary. Elementary teachers, too, will find many ideas in this book that can be tailored for use in their classrooms.

How to begin? Approach *Design Synectics* with an attitude of creative play. Let the "Synectic Trigger Mechanisms" supply you with a springboard for excursions into realms of fantasy and free association. Suspend judgement as you work and, above all, keep an open mind for emerging ideas—and happy surprises.

Start by skimming the book, noting especially the important concepts presented in the Introduction. Next, read a selected chapter in detail and select a studio action to get you started. It doesn't matter where you begin, or in what order you program your studio activities. The important thing is to start thinking *Synectically*—and turn theory into practice!

—**N.R.**, *Calgary, Alberta, Canada*

ACKNOWLEDGEMENTS

The author is indebted to the artists, museums, galleries and institutions that have provided material for this book. Special thanks go to the design students at the University of Calgary who field tested the Synectic concepts and contributed images and ideas. A thank you is also extended to Laurel Stocking for research assistance.

As always, extra special thanks to Julie Roukes, for help in proofreading the manuscript and offering constructive criticism and empathy during research and production.

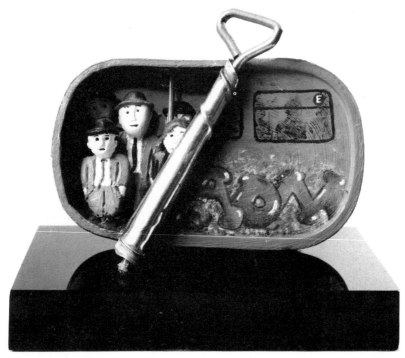

Andrew Mantis, **The E Train,** 1987.
Multimedia. Courtesy Ward-Nasse Gallery,
New York.

INTRODUCTION

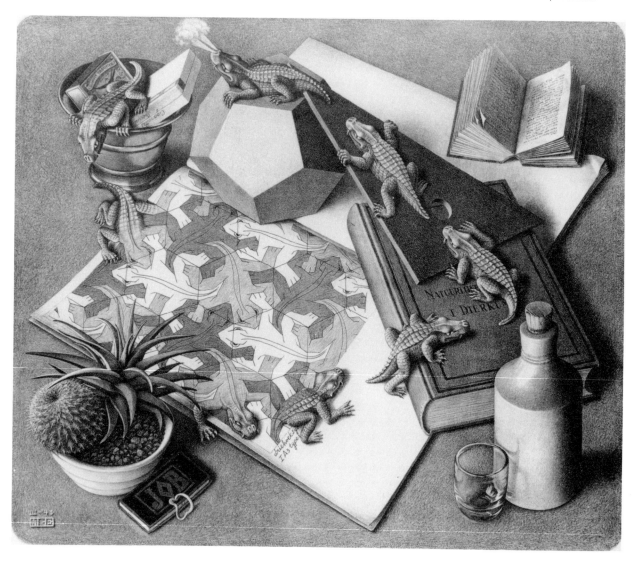

M.C. Escher, **Reptiles,** 1943. Lithograph, 13⅛×15¼″ (334×386 cm). Courtesy Cordon Art B.V., Holland.

Synectics

The term Synectics is from the Greek word *synectikos,* which means "bringing forth together," or "bringing different things into unified connection."

Since creativity involves the coordination of things into new structures, every creative thought or action draws on synectic thinking. For thousands of years, artists and thinkers have been haunted by questions of creativity. A glimpse into this intriguing realm of thought is provided by statements such as the following:

> *Creative behavior occurs in the process of becoming aware of problems, deficiencies, gaps in knowledge, missing elements, disharmonies; bringing together in new relationships available information; identifying the missing elements; searching for solutions, making guesses, or formulating hypotheses.*
> —E. Paul Torrance

> *The first thing we notice in a creative act is that it is an encounter.*
> —Rollo May

> *Creativity is the marvellous capacity to grasp mutually distinct realities and draw a spark from their juxtaposition.*
> —Max Ernst

> *A man becomes creative, whether he is an artist or a scientist, when he finds a new unity in the variety of nature. He does so by finding a likeness between things which were not thought alike before.*
> —Jacob Bronowski

Buckminster Fuller summed up the essence of Synectics when he said all things, regardless of their dissimilarity, can somehow be linked together, either in a physical, psychological or symbolic way.

In summary, Synectic thinking is the process of discovering the links that unite seemingly disconnected elements. It is a way of mentally taking things apart and putting them together to furnish new insight for the solution of problems in both art and industry.

In his book, *Synectics,* William J.J. Gordon sets forth three fundamental precepts of synectic theory: (1) Creative output increases when people become aware of the psychological processes that control their behavior; (2) the emotional component of creative behavior is more important than the intellectual component; the irrational is more important than the rational; (3) the emotional and irrational components must be understood and used as "precision tools" in order to increase creative output.

Don Proch, **Delta Night Mask,** 1984. Silver point and graphite on fiberglass, 26″ (66 cm) high. Collection Norman Mackenzie Gallery, Regina, Saskatchewan. Photograph courtesy the artist.

Three Lessons and a View of Things to Come

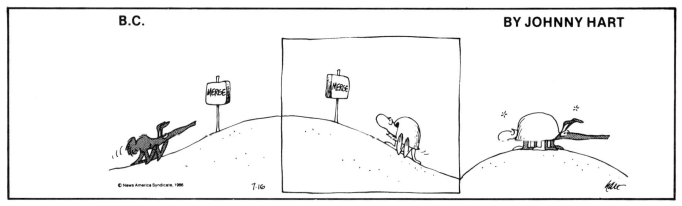

B.C. **BY JOHNNY HART**

The meeting of two personalities is like the contact of two chemical substances. If there is any reaction, both are transformed.

—Carl Jung

Johnny Hart, **B.C.**, 1986. Courtesy the artist and Creators Syndicate, Los Angeles.

Lesson One: The Synectic Attitude

- SYNECTICS ENCOURAGES THE ABILITY TO LIVE WITH COMPLEXITY AND APPARENT CONTRADICTION.
- SYNECTICS STIMULATES CREATIVE THINKING.
- SYNECTICS MOBILIZES BOTH SIDES OF THE BRAIN, THE RIGHT BRAIN (THE DREAMER), AND THE LEFT BRAIN (THE REASONER).
- SYNECTICS PROVIDES A FREE-THINKING STATE OF CONSCIOUSNESS.

In a free-thinking state, analogies between perceptions, concepts, or even systems and abstractions tend to occur repeatedly.

—Silvano Arieti

Creativity demands flexibility and imaginativeness but also tightly organized thought processes, matched by a high degree of emotional and psychological freedom.

—R.L. Razik

Lesson Two: The Synectic Trigger Mechanisms

- SYNECTIC TRIGGER MECHANISMS CATALYZE NEW THOUGHTS, IDEAS, AND INVENTIONS.
- SYNECTIC THEORY IS BASED ON DISRUPTIVE THINKING.

Neither the poet's words nor the inventor's things have any remarkable properties of their own. They are everyday words and things; it is the juxtaposition of them which is new.

—David Pye

The creative process is a matter of continually separating and bringing together, bringing together and separating, in many dimensions—affective, conceptual, perceptual, volitional, and physical.

—Albert Rothenberg

Lesson Three: The Synectic Ways of Working

- SYNECTICS IS BASED ON THE FUSION OF OPPOSITES
- SYNECTICS IS BASED ON ANALOGICAL THINKING.
- SYNECTICS IS SYNERGISTIC. ITS ACTION PRODUCES A RESULT WHICH IS GREATER THAN THE SUM OF ITS PARTS.

The world is totally connected. Whatever explanation we invent at any moment is a partial connection, and its richness derives from the richness of such connections as we are able to make.

—Jacob Bronowski

The Synectic Pinball Machine

Synectic thinking is like a mental pinball game. Stimulus input bounced against the scoring bumpers (The Synectic Trigger Mechanisms) is transformed. Ordinary perceptions are turned into extraordinary ones; the familiar or prosaic is made strange. Synectic play is the creative mind at work.

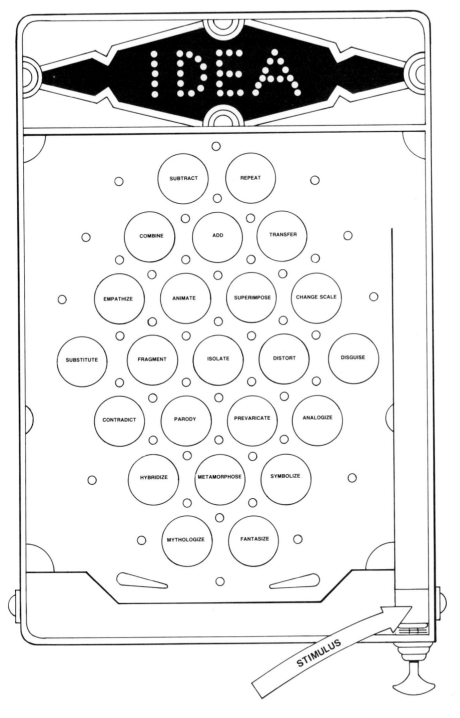

Stimulus input fed into the Synectic Pinball Machine is transformed into perceptions which emerge as concepts for art and design.

Making the Brain Go "Click!"

Playing the Synectic Game

Creativity in art is nurtured by the co-action of left brain and right brain thinking. Rational intelligence from the left brain is used to "nail down" the dreams and intuitions from the right brain, and turn them into objective perceptions and tangible constructions.

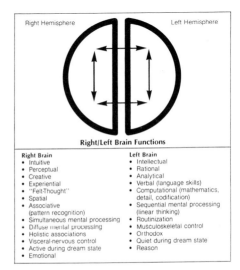

Right/Left Brain Functions

Right Brain	Left Brain
• Intuitive	• Intellectual
• Perceptual	• Rational
• Creative	• Analytical
• Experiential	• Verbal (language skills)
• "Felt-Thought"	• Computational (mathematics, detail, codification)
• Spatial	
• Associative (pattern recognition)	• Sequential mental processing (linear thinking)
• Simultaneous mental processing	• Routinization
• Diffuse mental processing	• Musculoskeletal control
• Holistic associations	• Orthodox
• Visceral-nervous control	• Quiet during dream state
• Active during dream state	• Reason
• Emotional	

The Synectic Trigger Mechanisms

Creative discovery is derived from *analogical thinking,* the process of linking unlike subjects.

Synectics aids such discovery by jostling the brain and stretching the imagination to make unique comparisons. The more outrageous the associations, the better the chance of bringing to the surface notable ideas and inventions.

The twenty-three "Synectic trigger mechanisms" are tools for transformational thinking. They are heuristic devices (mechanisms that "lead to discovery").

In Preparation for Discovery

Ideas are not born in a vacuum. To initiate creative thinking, one must first identify the problem or the task. Secondly, one must gather information about it to mix in with the information already stored in the brain.

The first step towards creative action is to gather information, to refer to many sources that will stimulate your mind. Carefully analyze and research your subject. Inform yourself. Have a springboard to work from.

Chance, or luck, also plays a role in discovery. But remember that chance, as Louis Pasteur pointed out, always favors the *prepared* mind.

The artist's conceptual mechanism is activated by "doing something" to a stimulus. Conceptualization, simply defined, is the process of taking information, patterns and ideas and transforming them into something new. The tools for "doing something," according to Roger von Oech, in *A Whack on the Side of the Head,* might consist simply of changing contexts, fooling around, and looking at what you're doing from strange angles. It might also include adding something, taking something away, fantasizing, or just plain experimenting.

The Synectic Trigger Mechanisms:
Tools for Creative Thinking

Subtract. Simplify. Omit, remove certain parts or elements. Take something away from your subject. Compress it or make it smaller. *Think:* What can be eliminated, reduced, disposed of? What rules can you break? How can you simplify, abstract, stylize or abbreviate?

> *Our life is frittered away by detail. . . . Simplify, simplify!*
> —Henry David Thoreau

Less is more.
—Arni Ratia,
 Swiss designer

Repeat. Repeat a shape, color, form, image or idea. Reiterate, echo, restate or duplicate your reference subject in some way. *Think:* How can you control the factors of occurrence, repercussion, sequence and progression?

> *Every feeling tends to a certain extent to become deeper by repetition.*
> —J. Sully

Combine. Bring things together. Connect, arrange, link, unify, mix, merge, wed, rearrange. Combine ideas. Combine ideas, materials and techniques. Bring together dissimilar things to produce synergistic integrations. *Ask:* What else can you connect to your subject? What kind of connections can you make from different sensory modes, frames of reference or subject disciplines?

> *All art, and most knowledge, entails either seeing connections or making them. Until it is hooked up with what you already know, nothing can ever be learned or assimilated.*
> —Ralph Caplan

Lucio del Pezzo, **Untitled,** 1978. Serigraph, (27½ × 19½″ (70 × 50 cm). Courtesy Studio Marconi, Milan.

Add. Extend, expand, or otherwise develop your reference subject. Augment it, supplement, advance or annex it. Magnify it: Make it bigger. *Think:* What else can be added to your idea, image, object, or material?

Transfer. Move your subject into a new situation, environment or context. Adapt, transpose, relocate, dislocate. Adapt the subject to a new and different frame of reference. Move the subject out of its normal environment; transpose it to a different historical, social, geographical or political setting or time. Look at it from a different point of view.

Adapt an engineering principle, design quality, or other special quality of your subject to that of another. (The structure of a bird's wing, for example, has served as a model for designing bridges).

Transfer can also denote *transformation. Think:* How can your subject be converted, translated, or transfigured? (See also METAMORPHOSE and HYBRIDIZE.)

Empathize. Sympathize. Relate to your subject; put yourself in its "shoes." If the subject is inorganic or inanimate, think of it as having human qualities. How can you relate to it emotionally or subjectively? Offering helpful insight to an art student, the eighteenth century German painter Henry Fuseli once advised, "Transpose yourself into your subject."

I imagine myself as a rider of a beam of light.
— Albert Einstein

Animate. Mobilize visual and psychological tensions in a painting or design. Control the pictorial movements and forces in a picture.

Apply factors of repetition, progression, serialization or narration. Bring life to inanimate subjects by thinking of them as having human qualities.

Superimpose. Overlap, place over, cover, overlay: Superimpose dissimilar images or ideas. Overlay elements to produce new images, ideas or meanings. Superimpose different elements from different perspectives, disciplines or time periods on your subject. Combine sensory perceptions (sound/color, etc).

Think syncronistically: What elements or images from different frames of reference can be combined in a single view? Notice, for example, how Cubist painters superimposed several views of a single object to show many different moments in time simultaneously.

Albert Einstein.

Change Scale. Make your subject bigger or smaller. Change proportion, relative size, ratio, dimensions or normal graduated series.

Substitute. Exchange, switch or replace: *Think:* What other idea, image, material or ingredient can you substitute for all or part of your subject? What alternate or supplementary plan can be employed?

Fragment. Separate, divide, split: Take your subject or idea apart. Dissect it. Chop it up or otherwise disassemble it. What devices can you use to divide it into smaller increments — or to make it appear discontinuous?

Isolate. Separate, set apart, crop, detach: Use only a part of your subject. In composing a picture, use a viewfinder to crop the image or visual field selectively. "Crop" your ideas, too, with a "mental" viewfinder. *Think:* What element can you detach or focus on?

Distort. Twist your subject out of its true shape, proportion or meaning. *Think:* What kind of imagined or actual distortions can you effect? How can you misshape it? Can you make it longer, wider, fatter, narrower? Can you maintain or produce a unique metaphoric and aesthetic quality when you misshape it? Can you melt it, burn it, crush it, spill something on it, bury it, crack it, tear it or subject it to yet other "tortures"? (Distortion also denotes fictionalizing. See PREVARICATE.)

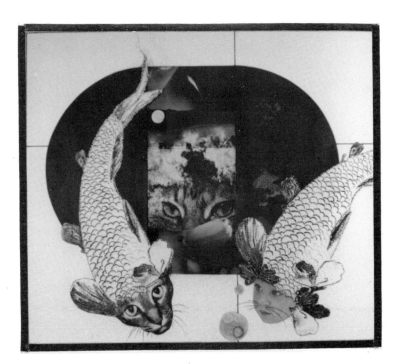

Jein Waldin, **Alter Ego,** 1982. Drawing
22×24″ (55.8×61 cm). Courtesy the artist.

Disguise. Camouflage, conceal, deceive or encrypt: How can you hide, mask or "implant" your subject into another frame of reference? In nature, for example, chameleons, moths and certain other species conceal themselves by mimicry: Their figure imitates the ground. How can you apply this to your subject?

Think about subliminal imagery: How can you create a latent image that will communicate subconsciously, below the threshold of conscious awareness?

The originality and inventiveness of the solution depend as much on talents for finding and formulating problems as on the technical skills for solving the problems once they are found.

— J. W. Getzels

Contradict. Contradict the subject's original function. Contravene, disaffirm, deny, reverse: Many great works of art are, in fact, visual and intellectual contradictions. They may contain opposite, antipodal, antithetical or converse elements which are integrated in their aesthetic and structural form. Contradict laws of nature such as gravity, time, etc.

Think: How can you visualize your subject in connection with the reversal of laws of nature, gravity, magnetic fields, growth cycles, proportions; mechanical and human functions, procedures, games, rituals or social conventions?

Satirical art is based on the observation of social hypocrisy and contradictory behavior. Optical illusions and "flip-flop" designs are equivocal configurations that contradict optical and perceptual harmony. *Think:* How can you use contradiction or reversal to change your subject?

Doublethink means the power of holding two contradictory beliefs in one's mind simultaneously, and accepting both of them.

— George Orwell

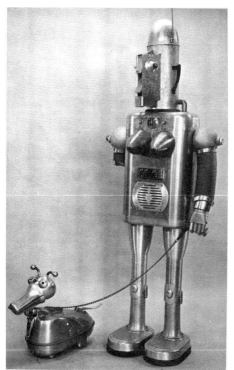

Parody. Ridicule, mimic, mock, burlesque or caricature: Make fun of your subject. "Roast" it, lampoon it. Transform it into a visual joke or pun. Exploit the humor factor, Make zany, ludicrous or comic references. Create a visual oxymoron or conundrum.

Every joke is ultimately a custard pie.

— George Orwell

The sublime and the ridiculous are often so nearly related, that it is difficult to class them separately. One step above the sublime, makes the ridiculous; and one step above the ridiculous, makes the sublime again.

— Tom Paine

Clayton Bailey, **Robot Lady with Arf the Robot Pet,** 1981. Aluminum, sound movement, 20×24″ (50.8×61 cm); 72×24″ (15″ (182.8×61×38 cm). Courtesy Triton Museum, Santa Clara, California.

Stan Klyver, **Home in the Woods,** 1986.
Lithograph, 9 × 11″ (22.8 × 27.9 cm).
Courtesy the artist.

Prevaricate. Equivocate. Fictionalize, "bend" the truth, falsify, fantasize. Although telling fibs is not considered acceptable social conduct, it is the stuff that legends and myths are made of. *Think:* How can you use your subject as a theme to present ersatz information?

Equivocate: Present equivocal information that is subject to two or more interpretations and used to mislead or confuse.

> *Faith, here's an equivocator, that could swear in both the scales against either scale.*
> —William Shakespeare

Analogize. Compare. Draw associations: Seek similarities between things that are different. Make comparisons of your subject to elements from different domains, disciplines and realms of thought. *Think:* What can I compare my subject to? What logical and illogical associations can I make?

Remember, stretching analogies is a way of generating *synergistic* effects, new perceptions and potent metaphors.

> *The person who wants to enhance his creative processes must indulge in the practice of catching similarities.*
> —Sylvano Arieti

Hybridize. Cross-fertilize: Wed your subject with an improbable mate. *Think:* "What would you get if you crossed a _____ with a _____?"

Creative thinking is a form of "mental hybridization" in that ideas are produced by cross-linking subjects from different realms.

Transfer the hybridization mechanism to the use of color, form and structure; cross-fertilize organic and inorganic elements, as well as ideas and perceptions. (See also METAMORPHOSE.)

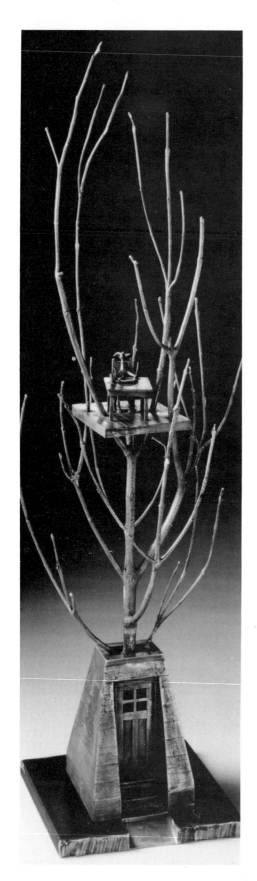

Metamorphose. Transform, convert, transmutate: Depict your subject in a state of *change.* It can be a simple transformation (an object changing its color, for example) or a more radical change in which the subject changes its configuration.

Think of "cocoon-to-butterfly" types of transformations, aging, structural progressions, as well as radical and surreal metamorphosis such as "Jekyll and Hyde" transmutations.

Mutation is a radical hereditary change brought about by a change in chromosome relations or a biochemical change in the codons that make up genes. How can you apply metamorphosis or mutation to your subject?

Nothing in the entire universe ever perishes, believe me, but the things vary, and adopt a new form.

—Ovid

Symbolize. How can your subject be imbued with symbolic qualities?

A visual symbol is a graphic device which stands for something other than what it is. (For example, a red cross stands for first aid, a striped pole for a barber shop, a dove bearing an olive branch for peace, etc.)

Public symbols are clichés insofar as they are well-known and widely understood, while private symbols are cryptic and have special meaning only to their originator. Works of art are often integrations of both public and private symbols.

Think: What can you do to turn your subject into a symbolic image? What can you do to make it a public symbol? A private metaphor?

Mythologize. Build a myth around your subject.

In the 60's, Pop artists "mythologized" common objects. The Coca-Cola bottle, Brillo Pads, comic strip characters, movie stars, mass media images, hot rods, hamburgers and french fries and other such frivolous subjects became the visual icons of twentieth century art.

Think: How can you transform your subject into an iconic object?

The message of the myth is conveyed by the amalgam of its relationships and its mediations.

—Claude Levi-Strauss

Rand Schultz, **Diner,** 1984. Bronze
25×7¼×7″ (63.5×17.7×17.8 cm). Courtesy
the artist.

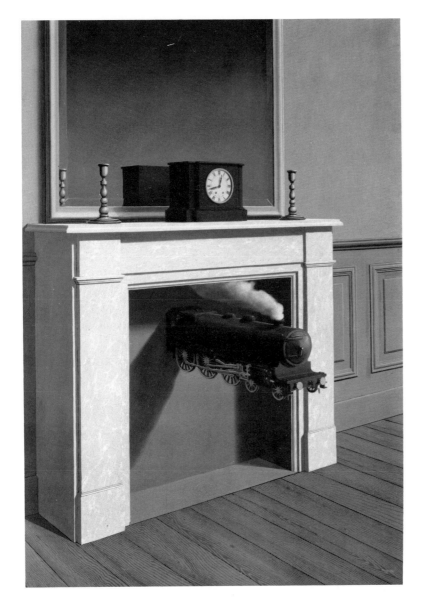

René Magritte, **Time Transfixed,** 1939. Oil on canvas, 57½ × 38″ (146 × 96.5 cm). Courtesy The Art Institute of Chicago.

Fantasize. Fantasize your subject. Use it to trigger surreal, preposterous, outlandish, outrageous, bizarre thoughts. Topple mental and sensory expectations. How far out can you extend your imagination?

Think: "What-if" thoughts: What if automobiles were made of brick? What if alligators played pool? What if insects grew larger than humans? What if night and day occurred simultaneously?

The world of reality has its limits; the world of imagination is boundless.

— Jean Jacques Rousseau

Creative transformation demands an iconoclastic attitude. To invent, one must be contrary and go against established conventions and stereotypes. Remember, inventors create great inventions only by breaking the "rules".

Art-Think: Ways of Working

1. **Identify:** Set the problem or task, identify the subject.
2. **Analyze:** Examine the subject; break it down, classify it.
3. **Ideate:** Think, fantasize, produce ideas. Generate options towards a creative solution. Relate, rearrange, reconstruct.
4. **Select:** Choose your best option.
5. **Implement:** Put your ideas into action. Realize it. Transform imagination and fantasy into tangible form.
6. **Evaluate:** Judge the result. Think about new options and possibilities that have emerged. Go back to Step #1.

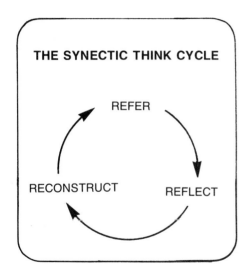

THE SYNECTIC THINK CYCLE

REFER

RECONSTRUCT

REFLECT

The Mystery of Creativity

In recent years much has been learned about the brain, yet curiously, little is known about the exact way in which the brain functions during its creative phases. Creativity is difficult to measure or assess and psychologists have noted with consternation that creative people are often quite vague or even contradictory when they are asked to describe the sources of their creations. It has been found, too, that innovators generally experience "leaps of thought," a sense of discontinuity, during ideation. Creative people claim that a "strange idea" may suddenly appear in the middle of a train of thought—with no logical connections with what went on before. This is accountable to the fact that the right brain (the fantasizer) is nonverbal and supplies its messages indirectly through a subconscious mode of awareness.

The Synectic Think Cycle: The "Three R's"

The Synectic trigger mechanisms can be used to process information in three distinctly different yet interrelated thinking modes which can be categorized as: (1) *referring,* (2) *reflecting* and (3) *reconstructing.*

Referring, as mentioned earlier, denotes the initial stage of awareness, wherein the thinker poses the problem, sets the question or identifies the subject to be acted upon. Obviously, to be most effective, proper orientation requires library research and other investigative activity. Psychologist Donald W. MacKinnon reminds us that "Too little or unavailable information will impede or even make impossible the solution of a problem."

The Synectic trigger mechanisms are also prime references, as are feelings and emotions, personal knowledge, art materials and techniques—all of which interplay in the entire cycle of creative thought and ideation. In short, the more information that is brought to the problem, the better. A common block to a creative solution is the overly narrow concentration on a single idea or frame of reference.

Reflecting connotes an imaginative interplay about the subject or the problem at hand, and speculative thought about the possible ways it can be transformed or solved. To reflect means to contemplate. Incubate many ideas; conjure up more than just one idea. Fantasize. Think up bizarre possibilities. In fact, the more "off-the wall" ideas you generate, the better.

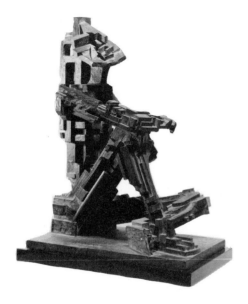

Gimenez Botey, **Man of Wood,** 1960.
Wood. Courtesy the artist.

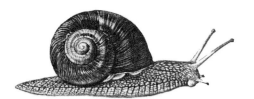

Roman Snail (Helix pomatia). Sketch courtesy Octopus Books Ltd., London.

Paul Klee, **Snail,** 1914. Pen and ink, (4⅝×8⅜″) (11.7×21.2 cm). Collection, The Museum of Modern Art, New York. The Katherine S. Dreier Bequest.

Reconstructing denotes the process of re-inventing or transforming. Do this by using the Synectic trigger mechanisms to examine information and discover new integrations. Reconstruct your subject by mentally taking it apart and reassembling it in a different way. Create new gestalts in terms of ideas, structures and metaphors.

Granted, there will be temporary chaos and anxiety produced when the comfortable world of convention is laid aside by Synectics. Synectics demands risk-taking to jar you loose from complacency and stereotypical thinking. As W.J.J. Gordon points out, "A new viewpoint depends on the capacity to risk and to understand the mechanisms by which the mind can make tolerable the temporary ambiguity that ensues." Such risk-taking is justified when temporary ambiguity and disorder give way to new perceptions and ideas.

The pursuit of "strangeness" is not simply a blasé search for the bizarre, but a conscious and serious attempt to achieve a new look at ordinary things.

Klee forged a new language, one which was no longer tied to the representation of objects in nature but, instead, to a genuine recreation of them.

—Richard Verdi
Klee and Nature

Analogical Thinking (Analogistics)

Analogical thinking is the keystone of Synectics. Essentially, it is the process of recognizing similarities between dissimilar things; a form of cross-referential thinking wherein things from one classification or subject realm can be related to that of another. Analogies are "psychological" tools which at the conscious level almost everybody uses.

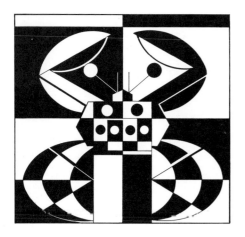

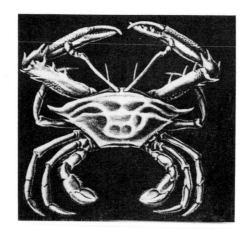

Ernst Haeckel, **Crab Drawing,** from *Art Forms in Nature.* Courtesy Dover Publications, New York. Left: Pen and ink design by Harold Palmer, an abstracted visual analog of Haeckel's image, which served as the reference stimulus. Courtesy the artist.

An *analog* is something which is analogous (i.e., similar or correlative) to some other thing.

A *visual analog* is an pictorial or three-dimensional image which correlates to a reference subject. It is an invented equivalent of a thought or perception. In art, an analog must also possess aesthetic qualities. Two-dimensional visual analogs are designs, diagrams, drawings and paintings of reference objects, while three-dimensional visual analogs take the form of sculptures, constructions and architectural forms.

Creativity is often the ability to see new relationships among familiar objects and structures. What is so startling is when someone sees a different way of connecting ideas that opens up whole new avenues of thoughts.
— Walter Shropshire, Jr.

Two Types of Visual Analogs: Logical and Psychological *Logical analogs* are direct rational correlations. (e.g., a mobile by Alexander Calder is correlative to a tree: its branches, leaves, and movement.) Logical analogs include:

a. *Design analogs:* Images or designs which directly refer to the shape, form or structure of a reference subject.
b. *Function analogs:* Images which are correlative to the function or operation of a reference subject. A jet aircraft, for example, can be compared to a squid insofar as both have similar propulsion systems.
c. *Phenomena analogs:* These are images or structures whose configuration is based on observed qualities of movement or phenomena. In this type of analog, the invented visual form can suggest such things as forces in nature (whirlpools, weather patterns, magnetic and electrical fields) or action events such as the movement of a bicyclist, runner, skier, etc.

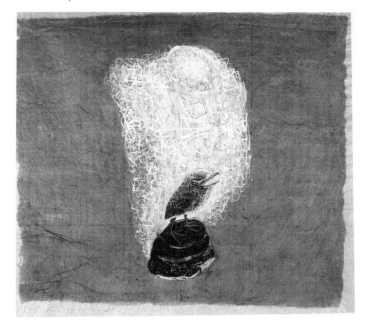

Alfred Pellan, **Floraison/Blossoming,** 1956. Oil on canvas, 71×57½″ (180.4×146.1 cm). Courtesy The National Gallery of Canada, Ottawa. This painting is an example of a phenomena analog: the process of growth, of flowers bursting into bloom, is symbolized.

Psychological analogs are forced, subjective correlations. For example, an artist might create something which correlates to a reference subject, yet in fact may not look much like it at all. Such a comparison is a "stretched analogy." In Paul Klee's words, "We must not imitate nature, but learn to look through nature." Within the category of psychological analogs are:

a. *Sensory analogs:* Visual equivalents drawn from cross-sensory perception. An artist, for example, can make a visual representation of a bird's song or, conversely, create a sound-structure (a tape of sounds) inspired by a visual image. Sensory analogs can be drawn from any cross-sensory comparison—visual, tactile, olfactory or gustatory. Sensory analogs are also called *synaesthetic.* (A few people, known as "synaesthetics", are born with unusual perceptual qualities that allow them to "see" color while listening to music.)

b. *Empathy analogs:* Designs or structures drawn from emotions and personal feelings. These feelings and emotions are projected and transferred to the subject and an equivalent representation is created. Many of Marc Chagall's paintings, for example, are empathy analogs insofar as they are subjective rather than objective representations. The euphoria of love, for example, is often represented in Chagall's paintings by rubbery figures floating in space, defying gravity.

c. *Symbolic and metaphoric analogs:* These "spark" an idea or communicate a special message. In this type of analog, the visual image is synergistic: The combined action of its components produces an effect greater than the sum of its parts.

d. *Fantasy analogs:* Surreal equivalents. Like dream images, they are eccentric, outrageous and bizarre perceptions. They can be symbolic, as some dreams are, or cryptic and mysterious images like those in a Magritte painting.

Pierre Brauchli, **Babylon Today,** 1987.
Montage. Courtesy Tanner & Staehin
Verlag, Zurich.

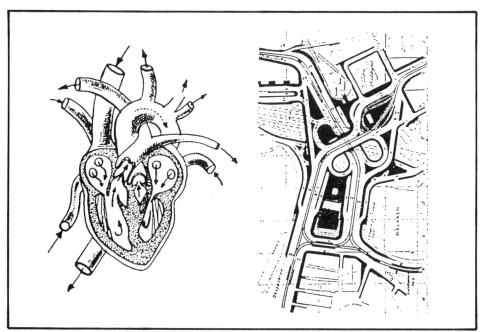

Visual Analogistics: Through stretched analogy, two completely different systems (one organic, the other inorganic) are seen to share a common attribute in their shape and function. (From *Form, Function and Design* by Paul Grillo. Courtesy Dover Publications).

The purpose of thinking is to scan, to get a broader perceptual map and then to apply your emotions to it.
— Edward de Bono

In Surrealist terms, this inner cosmos is the unconscious, the space of irrational conjunction and unlimited analogies, and the secret counterpart of the perceptual world outside.
— Roger Cardinal

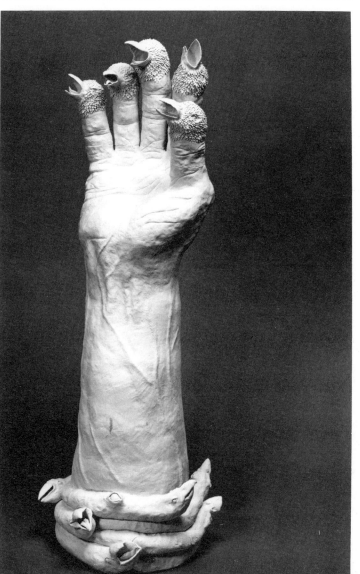

Frank Fleming, **Birdhand** (From **Guernica Series**), 1984. Porcelain, 54×19×19" (137.2×48.3×48.3 cm). Courtesy the artist. This sculpture is an analogy of Picasso's great anti-war painting, *Guernica,* and like the reference painting presents a humanitarian concern for all life forms. As a fantasy analog, the sculpture presents the hybridized image of a human hand and that of five young anguished birds growing from the fingers. It is both a surreal and sym-bolically potent image.

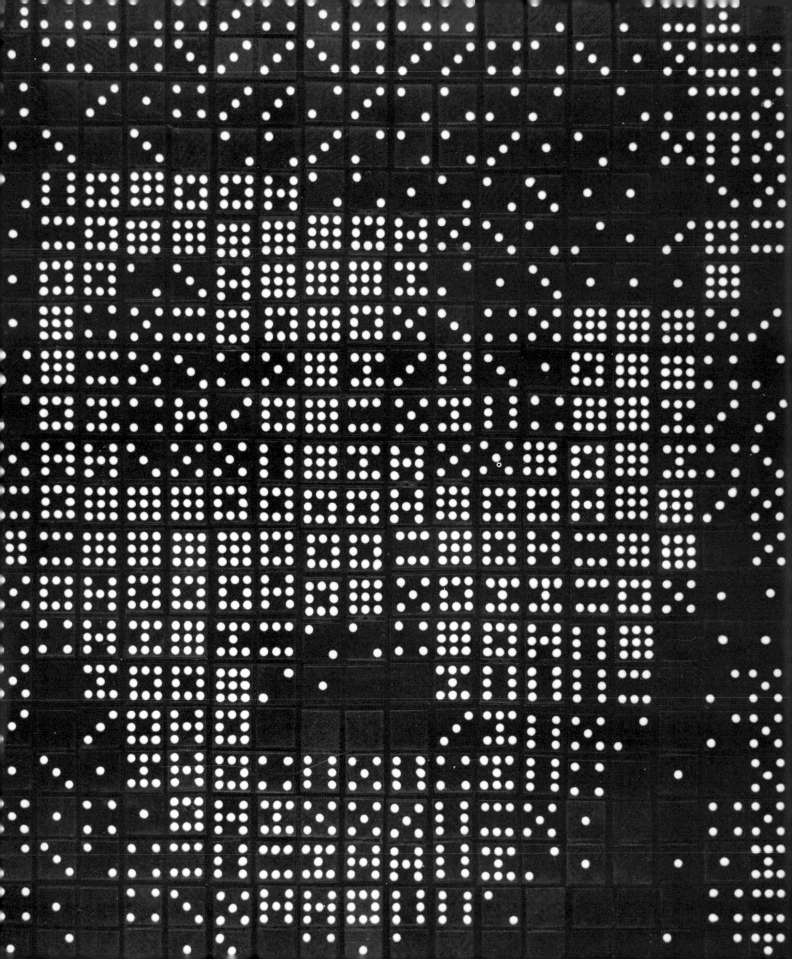

BEHIND APPEARANCE: THE SUBSTRUCTURE OF DESIGN

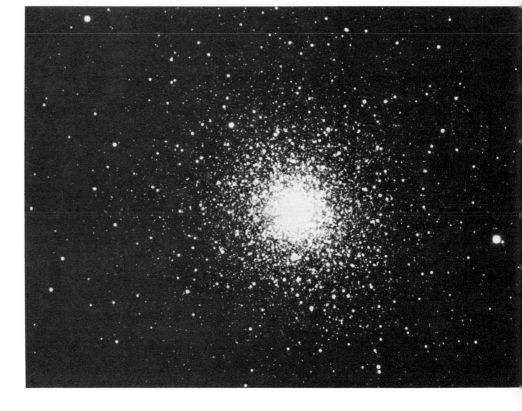

The Globular Cluster M92. Courtesy Lick Observatory, San Jose, California. There are hundreds of such globular clusters in our galaxy, each containing from 50,000 to a million stars.

Previous page:
Ken Knowlton, **Charlie Chaplin,** 1983. Computer-generated domino-set portrait. Courtesy the artist. Four sets of uncut double-nine dominoes were used to establish the matrix for a computer program. Once the black and white positions were registered in the computer's memory, they were arranged to match the light and dark pattern of a photograph of the subject.

Forces

First and foremost, we must understand that behind the surface appearance of art and design lies a complex network of forces. All visual designs are "constellations of energy." Our signature, for example, is a line scribble that not only possesses a symbolic and perhaps an aesthetic quality, but is also, like a cardiogram or seismograph, a diagram of forces. Likewise, every work of art possesses an underlying psychological forcefield that is an inherent although invisible part of its substructure.

We first perceive external things through our sensory organs, which perceive and transmit "messages" to the brain in the form of energy patterns. It follows, then, that the control of the psychological forces in visual composition should be a subject of prime importance to the artist. As Rudolph Arnheim points out, if we wish to understand a work of art, either by intuitive contemplation or by explicit analysis, we must inevitably start with the pattern of forces that sets its theme and states the reason for its existence.

Visual perception is a complicated phenomenon that involves the stimulation of the retina by light rays. The light rays are organized by the brain into spatial units. Psychologically, visual forces are perceived as "felt-tensions" and operate continuously as forces of attraction and repulsion, expansion and contraction. The painter Hans Hofmann, who taught at the Art Students League in New York in the 1930s, constantly reminded his students to be aware of and to control these — "push-pulls" in their designs. Thus, even a simple group of dots or lines produces more than a visual pattern; the interaction generates psychologically felt energy.

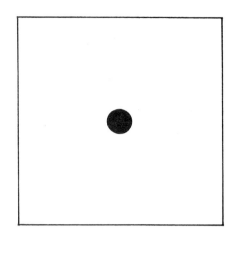

The Perception of Forms and Forces:
A Synectic Action

To fully control pictorial organization, the artist must be aware of the psychological forces in a composition and orchestrate them, along with visible elements such as shape, form and color to produce a visual-psychological synthesis.

Turn your attention to the square with the dot inside it. *Ask:* "How do I know the dot is in the center of the square?" It is perceived to be in the exact center because the dot *interacts* with an "invisible grid," a psychological forcefield that is mentally projected to the figure. This psychological matrix is in the form of an "x" which connects the four corners of the square. Therefore, the tandem factors of visible and invisible elements lead us to the correct spatial determination of the dot.

In every perceptive act, there is a similar coordinated effort of eye-brain action which scans and maps the forms and forcefields. Even in seemingly simple perceptions, such eye-brain action involves thousands of subconscious measurements that determine the size, position, proportion and movement of visual elements. Since this type of scanning and mapping is intuitive, we are virtually unaware of its action.

Rudolph Arnheim underscored the importance of examining the factors of psychological perception when he wrote: "The primary effect of a painting remains unaccounted for as long as images are described simply as agglomerations of objects. A painting speaks only when it is seen as a configuration of forces, generated by its various visual components."

The "invisible grid" is a psychologically projected matrix of visual forces which tells us the dot is in the center of the square. The dynamic forces are equally balanced.

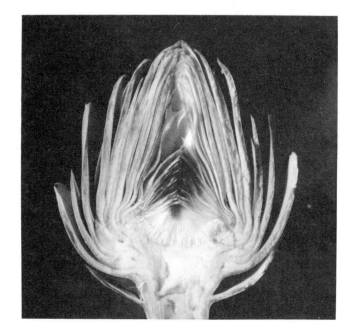

The cross-sectioned artichoke reveals a dynamic design with a design which in a sense is a "diagram of energy."

Richard Pousette-Darte, **Imploding White,**
1986. Courtesy Marisa Del Ray Gallery,
New York. The painting illustrates how an
artist can use a field of dots and squiggles
to produce a strong visual forcefield. The
overall effect is of an integrated yet
palpitating visual energy which produces an
highly unstable optical field.

Kevin D'Souza, **Phenomenon of Force,
Forms and Color,** 1987. Colored pencil on
graph paper, 18×18″ (45.7×45.7 cm).
Courtesy the artist.

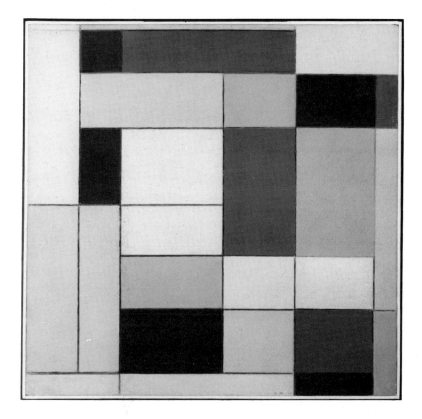

Piet Mondrian, **Composition with Grey, Red, Yellow, and Blue.** Oil on canvas. Courtesy The Tate Gallery, London.

Dynamic Equilibrium. Even in a visually active design, a psychological state of balance can be achieved by stabilizing the dynamics between the psychological forces and the visual forms. Whenever the forms, forces and counterforces of a design are controlled and manipulated to gain a "felt balance" or "stasis", a state of *dynamic equilibrium* is produced.

Piet Mondrian offered personal insight to this tenet when he said that plasticity in art can be expressed through the equilibrium of dynamic movement of form and color. In seeking to accomplish this, Mondrian gave meticulous attention to the proportions between vertical and horizontal lines, rectangular shapes, line thickness and color intensity. He distinguished two types of equilibrium in art: (1) static balance and (2) dynamic equilibrium. "The great struggle for artists," he said, "is the annihilation of static equilibrium in their paintings through continuous oppositions (contrasts) among means of expression."

Unlike Mondrian, Victor Vasarely, Bridget Riley and other Optical artists of the 1960's approached the control of visual tensions from a different point of view. These artists explored the factors of repetition, progression, after-image, optical illusion, and ambiguity between figure and ground. The paintings that emerged from these and other such artists generate a strong visual energy as well as a perceptually unstable picture plane. The result is a picture plane that either pulses, contracts, swells or "flip-flops." I want my painting to quiver in depth and also to have apparent movement within it," said Bridget Riley.

What I intended to express was dynamic movement in equilibrium.
—Piet Mondrian

Right: The psychologically perceived "push-pulls" in this diagram are of equal intensity and produce a state of equal balance. Equal balance is seen in all symmetrical designs (compositions which have component parts arranged equally from a central point or axis). **Far right:** In this diagram, the forces from the top of the picture frame (depicted by the larger arrows) appear to exert a far greater effect upon the two black shapes than the minor push-pulls that are felt to exist between them. Although asymmetrical compositions have unequal forces, they can be made to appear "psychologically balanced" through the calculated placement, proportion and contrast of the visual elements.

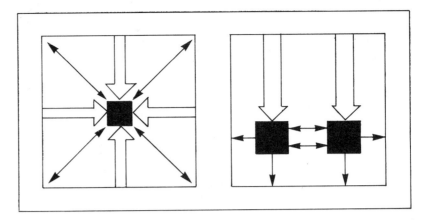

We can conclude, therefore, that all art forms are compositions in dynamic balance. The inherent forms and tensions of a good pictorial or structural design are carefully choreographed to achieve a psychological and visual unity.

We have seen how an empty square appears to exert psychological "pulls" to each corner. The "x"-shaped mental target imposed on the empty square provides a frame of reference; shapes placed within its frame have *position* in relation to the target center and picture frame. Pictorial shapes are also felt to fall under the effect of a "gravitational" force that subjects them to a predominant downward pull.

Optical Movement. Although a painting is in fact a static object, it possesses "kinetic" properties insofar as the eye of the viewer is led through various pathways in its pictorial field. The visual transition may be agitated or tranquil, depending on the artwork and the artist's purpose. To achieve optical movement, factors such as repetition, opposition, transition, rhythm, dominance and variation are applied to line, color, tone, space and texture. The more interesting transitional networks are synectic because they usually incorporate contrasting elements. Master design teacher Henry Rasmusen made an excellent point when he said, "The fluctuation resulting from continuous construction-destruction, disintegration-integration processes seems to animate things with movement, power and life. Opposition and transition, therefore, are fundamental laws of design."

Nicholas Roukes, **Kaleidoscope,** 1986. Pen and ink, 12″ (30.56 cm) diameter. Forces and shapes are equally distributed to create equal balance in this symmetrical composition.

Hassel Smith, **Untitled,** 1978. Acrylic on canvas, 40×68″ (101.6×172.7 cm). This asymmetrical design is a dynamic composition of synectic forces in equilibrium. Psychological balance is attained by proportional use of color—i.e. smaller black and white shapes are contrasted against larger ones of brighter hue; small, cool-colored shapes are bracketed against large, warm-hued shapes. The artist also effectively proportions line by contrasting diagonal against horizontal and vertical line movements.

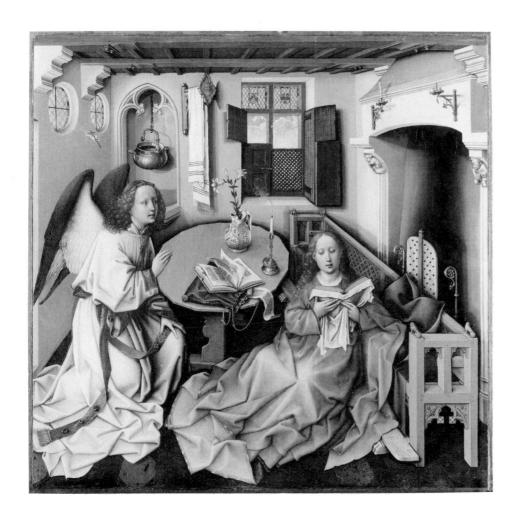

Robert Campin, **The Annunciation** (central panel of a tryptych), about 1425–28. Oil on wood, 25¼ × 25″ (64 × 63.5 cm). Courtesy The Metropolitan Museum of Art, The Cloisters collection.

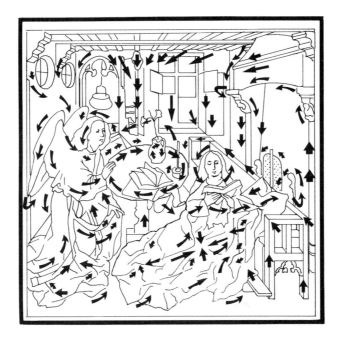

Analysis of forces and visual movements in **The Annunciation.**

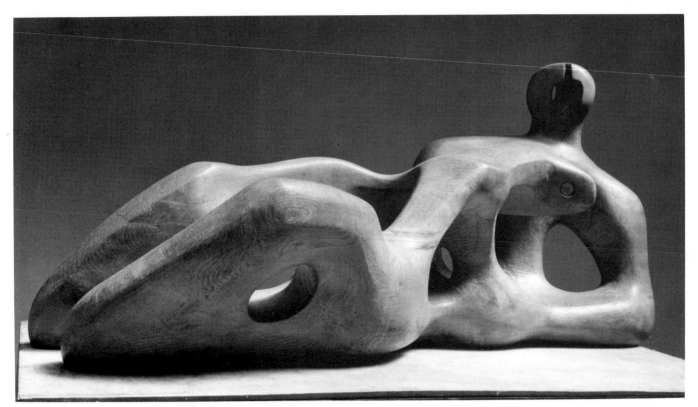

Henry Moore, **Reclining Figure,** 1939.
Elmwood, 81″ (205.7 cm) long. Collection
Detroit Institute of Arts. Photograph
courtesy the artist.

Henry Moore's sculpture presents the image
of a resting human figure that is anything
but static. Its design comprises a dynamic
network of interacting visual forms and
forces.

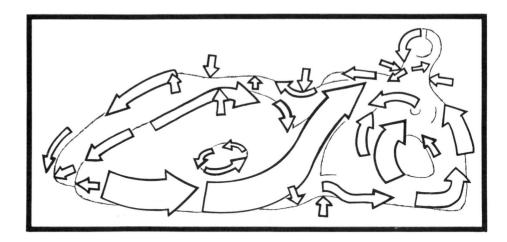

The choreography of energy and optical movement is a subject of vital concern to the artist. Notice, for example, how Henry Moore planned a flowing, yet dynamic movement in his sculpture *The Reclining Figure.* Asked what visual and psychological qualities he sought, Moore replied, "Such qualities that make the observer feel that what he is seeing contains within itself its own organic energy thrusting outwards. If a work of art has its own life and form, it will be alive and expansive, seeming larger than the material from which it is made."

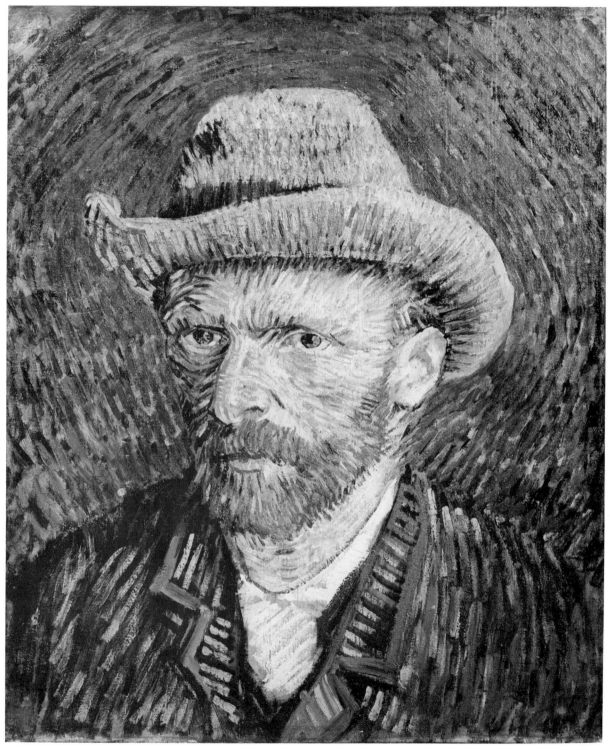

Vincent Van Gogh, **Self Portrait with Grey Felt Hat.** Oil on canvas. Courtesy The Stedelijk Museum, Amsterdam. Van Gogh's portrait shows a dramatic use of color and texture; the painting is a constellation of forces and energy which reflect the artist's empassioned attitude to art and life.

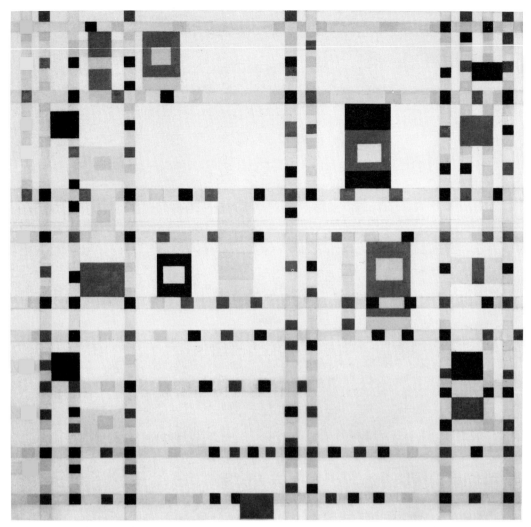

Piet Mondrian, **Broadway Boogie Woogie,**
1942. Oil on canvas, 50×50″
(127×127 cm). Collection, The Museum of
Modern Art, New York. Given anon-
ymously. This painting is a poetic sensory
analog in its reference to music. The
repetitive shapes and colors stimulate an
optical "beat" which in turn produces a
kinetic effect.

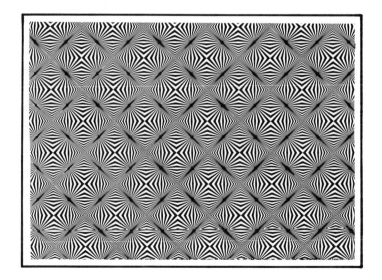

Overload of Visual Forces: This diagram il-
lustrates the powerful effect on visual
perception that a pattern of closely spaced
lines can produce. With too much visual
data to handle, the eye suffers retinal
fatigue which initiates optical "flicker."
Diagram courtesy Dover Publications, New
York.

The form of an object is a diagram of forces. We can deduce the forces that are acting or have acted upon it; in this strict and particular sense, it is a diagram.

—D'arcy Thompson

Trilobyte (from an extinct group of marine organisms from the Cambrian period). Fossils are remains or traces of animals which have been preserved by natural causes, their forms frozen in stone. Photo courtesy Russell L. Hall.

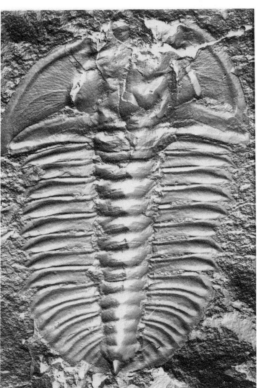

Constructed Analog, Aluminum. The phenomenon of water movement was used as a stimulus for designing this relief. From The Design Workshop, M.I.T. Courtesy Professor Preusser.

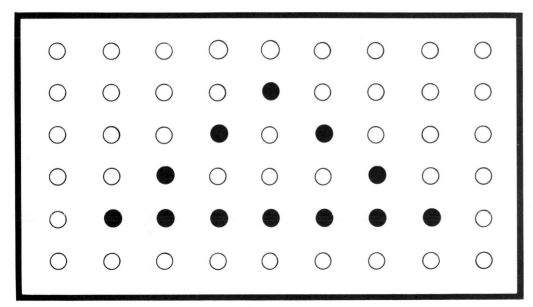

Grouping

The "rules of perceptual grouping" were established by Gestalt psychologists in the early 1900's, particularly by Max Wertheimer. Essentially, these factors deal with principles of perceptual organization, particularly with theories of *similarity grouping.* The basic *principle of similarity,* simply put, asserts that "The degree to which parts of a pattern resemble each other will help determine the degree to which they are seen as belonging together." Over 2000 years ago, Aristotle spoke of similarity as the key factor in the logical classification of things. The Greek poet Homer also defined this unit-forming factor simply and accurately when he wrote, "Like takes to like."

The Gestalt psychologists used simple dot patterns to investigate the tendencies and principles of perceptual organization. They discovered that in the normal process of visual scanning, the eye-brain network seeks and identifies "visual gestalts"—perceived integrations—within any visual field, even in those which at first seem undifferentiated or visually incoherent.

In any design or painting, therefore, things which share common properties will be perceptually linked. Through similarity grouping and closure, dots become lines, lines become shapes, and shapes become images.

Transferring this factor to the conceptual dimension, G.H. Lewis viewed logical thinking as grouping when he wrote, "Logic in its widest sense is grouping. The laws of grouping are the general tendencies of things and the general tendencies of thought."

A premise of visual perception theory is that things which have similar qualities will appear to belong together. Accordingly, the black dots within this matrix are visually linked to present the configuration of a triangle.

The rules of grouping, first formulated by Wertheimer, refer to factors that cause some parts to be seen as belonging more closely together than others. These rules can be treated as applications of one basic principle, the "principle of similarity." This principle asserts that the degree to which parts of a pattern resemble each other in some perceptual quality will help determine the degree to which they are seen as belonging together.

—Rudolph Arnheim

Perceptual linking: The eye links and "closes" to present the perception of line and shapes.

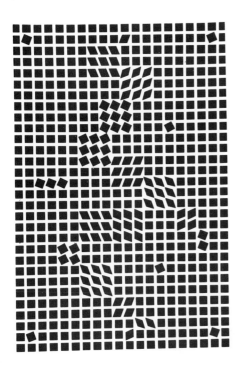

Victor Vasarely, **Tlinko,** 1956. 73¾×51″ (195×130 cm). Courtesy Denise René Gallery, Paris. The modular units which are different from the squares in this matrix pattern are optically linked and produce a sensation of oscillation and kinetic movement.

Victor Vasarely, **Betelgeuse II,** 1958. Oil on canvas 76¾×51″ (195×129.5 cm). Courtesy Denise René Gallery, Paris.

Some Means of Grouping: 1: By proximity;
2: By closepacking; 3: By visual closure;
4: By overlapping; 5: By encompassing;
6: By combining.

Perceptual Grouping

Here are some ways by which things can be combined to produce visual gestalts
(a visual gestalt is a perceived unity):

- By *arranging in proximity;* placing things next to each other, but not touching. (Diagram 1)
- By *closepacking:* Arranging things so that they are clustered, touching, and tightly packed. (Diagram 2)
- By *visual closure:* Juxtaposing fragments of a whole so that the eye "completes" the perception of the total unit. (Diagram 3)
- By *overlapping:* Placing some things in front of others. (Diagram 4)
- By *encompassing:* Placing things inside of a shape which encloses them. (Diagram 5)
- By *fusing:* Physically combining and integrating things. (Diagram 6)

Conceptual Grouping

Here are some ways by which things can be combined *conceptually:*

- By *classifying:* Combining things that share some common quality, i.e., things that are square, things that fly, things that are red, etc.
- By *analyzing structure:* Classifying things that are part of a structure, i.e.: Eyes, ears, nose and mouth are part of the head, etc.
- By *analogizing:* Finding a common link with which to make comparisons between dissimilar things. Stated in another way by the writer Roger Cardinal, "What the poet seeks is ways to establish links between objects of perception and objects of reflection."
- By *analyzing operations:* Classifying operations of things: combining, for example, images which show a stage of growth, such as a butterfly emerging from a cocoon.
- By *irrational means:* Grouping things by emotional, subconscious or non-rational means, such as the visualization of personal imagery perceived in dreams and surreal art.
- By *aleatoric means:* Grouping things by chance, without intention or by accident.

Poetic language, which teaches us to notice more and more different things at the same time as it encourages us to keep track of them by also noticing patterns of resemblance, gives us practice in responding more alertly to the world itself.

—Roger Cardinal

Max Ernst, **Woman, Old Man and Flower,** 1923–24. Oil on canvas, 38 × 51¼″ (96.5 × 130.2 cm). Collection, The Museum of Modern Art, New York.

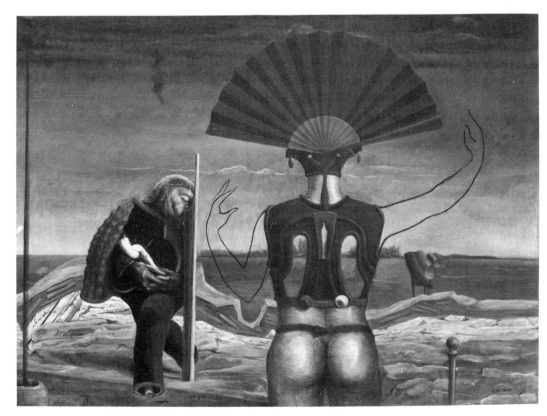

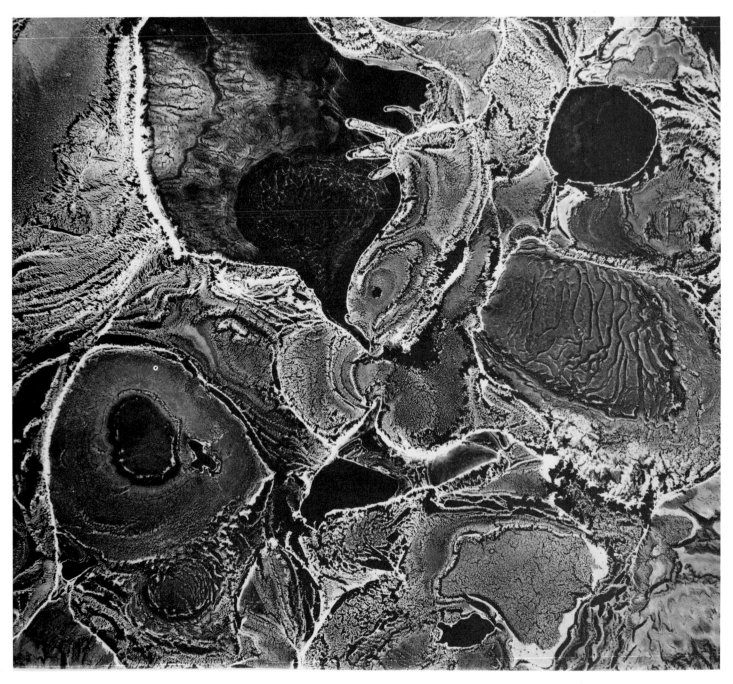

The Effect of Forces on Form. Photographic film dissolved in acetone. From Preusser's design course, M.I.T. Courtesy Professor Preusser.

1 / Behind Appearance: The Substructure of Design
STUDIO ACTION

1.1 Shapes and Forces

Concept: All visual fields are networks of interacting forces.

Key Synectic Trigger Mechanisms:
Repeat, Combine, Animate.

Studio Action: (Collage-Drawing) Create an abstract composition using geometric shapes (i.e., circles, squares, triangles, etc). Develop a motif using one or more geometric shapes with repetitions and size variations. Cut ten or more shapes out of black paper, then arrange and glue them inside of a square or rectangle. Arrange the shapes to create various relationships between the positive and negative spaces. Allow spaces to exist between the shapes, but do not overlap or have them touch.

Next, visualize the psychological forces in your picture. With a felt-tipped pen, draw the invisible forces on your picture. Use big arrows to suggest powerful forces, smaller ones to depict weaker tensions. There is no "right" or "wrong" way to do this exercise. In your own way, try to feel the invisible "push-pulls" that seem to exist and fill the composition with symbolic arrows.

Materials: Black paper, gluestick, ruler, compass, scissors, felt-tipped marking pens. Optional: plastic templates.

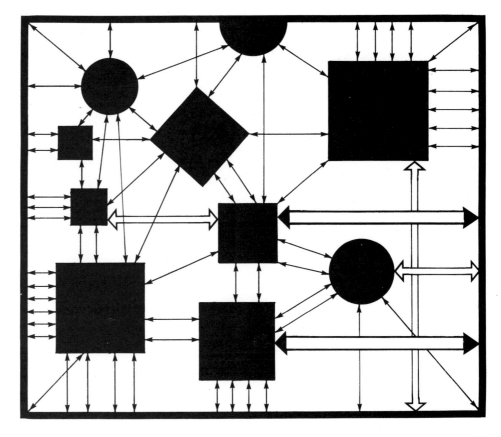

Diagram showing an arrangement of shapes and the network of "felt tensions" that appear to exist between them and within the picture frame.

1.2 Synectic Energy Encounter

Concept: Two different forcefields can be combined in a single plane of reference.

Key Synectic Trigger Mechanisms:
Repeat, Combine, Superimpose, Animate

Studio Action: Imagine two different "armies" of abstract shapes interacting in the same visual space. Symbolize each "army" in a different way, i.e., by straight, curved or dotted lines, or lines made up of letters, numerals, etc.

With a black felt-tipped pen, "weave" the symbolic lines together to produce a hybrid "energy-texture."

Materials: Drawing paper, black waterproof felt-tipped pens. Optional: plastic templates.

1.3 Synectic Encounter #2

Concept: A war of shapes can produce hybrids

Key Synectic Trigger Mechanisms:
Repeat, Combine, Superimpose, Hybridize, Symbolize

Studio Action: Using colored paper, cut out repetitive units of two different shapes and colors, e.g., circles and squares. Deploy the units from different sides on a contrasting background paper. Depict an encounter and production of hybrid shapes. The "offspring" shapes should be unique, but exhibit characteristics of both "parent" shapes.

Peter Johnston, **Synectic Energy Encounters.** Pen and ink. Courtesy the artist.

John Martinelli, **Shape Wars.** Pen and ink. Courtesy the artist.

should be unique, but exhibit characteristics of both "parent" shapes.

Materials: Colored construction paper, scissors, ruler, compass, gluestick.

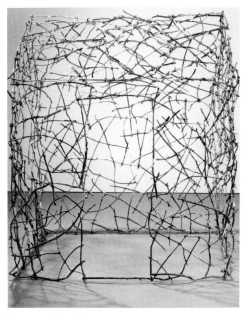

Richard Pousette-Darte, **Untitled,** 1977. Pencil on paper, 22½ × 30″ (57.1 × 76.2 cm). Courtesy Marisa Del Re Gallery, New York. This energy design is seemingly undifferentiated. Yet, like a cloud formation, it encourages subliminal projection. Look carefully. What phantom images can you detect?

Gyongy Laky, **House,** 1986. Twigs wrapped with cotton and plastic tape, 90 × 72 × 54″ (228.6 × 182,8 × 137 cm). Courtesy the artist. Photograph by M. Lee Fatherree.

1.4 The Scribble Field

Concept: An allover pattern of squiggly lines tends to generate visual energy.

Key Synectic Trigger Mechanisms: Repeat, Superimpose, Animate, Disguise

Studio Action: Fill an entire sheet of paper with squiggly lines to produce an allover energy field. Repeat and superimpose both short and long lines until a tightly-woven visual texture is produced. Darken some lines slightly, or accent certain areas to suggest cryptic images hidden within the visual field. Keep the images vague and subliminal (images that are designed to appeal to subconscious awareness). Think of the scribble pattern as an "opportunity field," like cloud formations or inkblot patterns, on which to project mental images.

Materials: Drawing paper, pencil.

Peter Young, **Dot Design #15,** 1969.
Acrylic on canvas, 86×110″
(218×280 cm). Courtesy Neue Gallery,
Aachen, Cologne. This energy painting is
based on perceptual linking. Because it has
no clearly established nucleus, it en-
courages random scanning and provides the
viewer opportunities to detect a multitude
of latent rhythmic patterns.

1.5 Dot-Energy Pattern

Concept: Closely packed dots pro-
duce visual energy.

Key Synectic Trigger Mechanisms:
Repeat, Juxtapose, Animate

Studio Action: Develop an energy
pattern in two steps. First, create the
background: Use a wide brush to
paint flat interlocking areas in dif-
ferent colors. Next, over the dried
surface, "print" dot patterns to
develop a density pattern. Don't
overlap the dots, but pack them
closely together to evoke an
energetic effect. For variety, print
clusters of different color
combinations.

Materials: Liquid tempera or
acrylics, brushes, heavy drawing
paper, "printing" tools (i.e., pencil
eraser, wooden doweling, stencils,
etc. Use a brush to apply paint to
the end of a pencil eraser before
each printing, or print through
stencils.).

Gordon Onslow-Ford, **Who Lives,** 1962.
Synethetic media, 77½×53″
(196.9×134.6 cm). Courtesy Rose Rabow
Galleries, San Francisco.

1.6 Extruded Lines and Dots

Concept: An energy pattern can be created by extruding closely packed lines and dots.

Key Synectic Trigger Mechanisms: Repeat, Superimpose, Combine, Animate

Studio Action: Create an allover pattern by extruding black and white paint from plastic squeeze bottles. Build up a rich, closely-knit texture by juxtaposing and overlapping lines and dots.

Materials: Black and white liquid tempera (or acrylic) paint, plastic squeeze bottles (with extruder tips), heavy drawing paper. Mix the acrylic paint with gloss medium (1:1) to obtain a good extruding consistency.

Follow-Up Studio Action: Using colored construction paper, create a paper mosaic inspired by a musical composition or a particular sound.

Materials: Colored construction paper, scissors, gluestick.

Henri Matisse, **The Bees,** 1948. Paper collage, 39¾ × 95 ″ (101 × 241.3 cm). Courtesy Matisse Museum, Nice.

Afterimage effect. This random dot pattern demonstrates how negative images interrelate with positive black dots. The combined dot patterns become kinetic as the eye chases the white dots. As the eye attempts to focus on the perceived white afterimages, they immediately vanish.

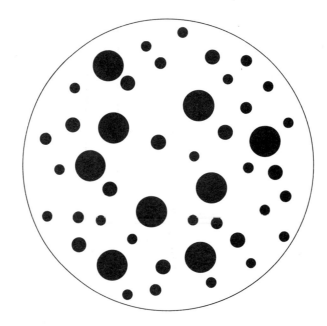

1.7 Afterimage Pattern

Concept: The contemplation of a pattern will induce the perception of its afterimage.

Key Synectic Trigger Mechanisms: Repeat, Animate

Studio Action: Plan a design that makes use of afterimages. Work only in black and white. Repeat and vary a particular shape (e.g., dots, squares or triangles). Allow a generous white background to remain as a screen for the afterimages.

Notice that afterimages are spontaneous and fleeting perceptions; they are seen literally to "dance" within the visual field. Plan your design to exploit this psychological phenomenon.

Materials: Drawing paper, pen and ink. Optional: plastic templates.

Follow-Up Studio Action: A dot of a particular color will produce an afterimage which is complementary in color. (A red dot, for example, will produce a light green afterimage; a blue dot a light orange afterimage, etc.) Plan a composition that exploits such chromatic effects.

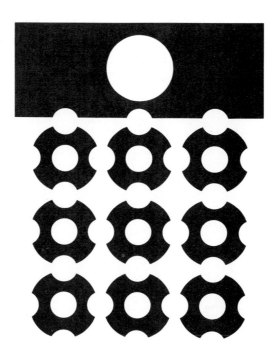

Victor Vasarely, **Epsilon**, 1958–62. 51×38″ (130×97 cm). Courtesy Denise Rene Gallery, Paris. An example of the use of afterimage illusion in fine art.

Above left: Arthur Menkin, **Pointillistic Pattern.** Pen and ink. Courtesy the artist. **Right:** Arthur Menkin, **Composition in Black and White.** Pen and ink. Courtesy the artist.

1.8 Pointillistic Pattern

Concept: Closely spaced dots tend to create visual density gradients and energy patterns.

Pointillism is based on the perceptual phenomenon of optical fusion and was explored by the French painter Georges Seurat.

Key Synectic Trigger Mechanisms: Repeat, Superimpose, Animate, Combine (optically)

Studio Action: Make a line drawing of a selected subject on a sheet of pen and ink paper with a medium-hard pencil.

Switch to an ink pen and render the composition using only dots. Create dark and light passages as well as "modeled" effects by controlling the pointillistic technique. Do not outline any portion of the drawing. Instead, rely on closely-packed dots to define images and edges. Finally, clean up the drawing by erasing traces of the underlying pencil drawing.

Materials: Pen and ink paper, pencil, waterproof felt-tipped pen.

Follow-Up Studio Action: Render the same composition using only closely spaced lines (and some areas of solid black). Create tone patterns through spacing, thickness and cross-hatching of lines.

Julie Merkowsky, **Letter Pattern,** 1986. Pen and ink. Courtesy the artist.

1.9 Patterns by Grouping Letters or Numerals

Concept: An allover pattern can be created by using only letters or words.

Key Synectic Trigger Mechanisms:
Repeat, Combine, Animate

Studio Action: Use only letters, numerals or technical symbols to produce an allover pattern. (The letters or numerals can be English or foreign.) Repeat the units, have them touch but not overlap. As you arrange the elements to produce an integrated design, be aware of positive and negative space, i.e., the figure-ground relationship.

Follow-Up Studio Action: Use words and images to produce an abstract composition. Write, print, type or use collage or rubber stamps to produce the design. Repeat the visual elements to create a visual texture as well as an idea.

Materials: (1) Drawing paper, black waterproof felt-tipped pens. Optional: plastic or cardboard templates, #3 sable brush, india ink (2) Drawing paper, black waterproof felt-tipped pen (or printed copy supplied by collage letters, rubber stamps, presstype, typewriter, etc.)

Mary Dower, **The Eyes Have It,** 1987. Typed words and collage elements. Courtesy the artist.

Ken Knowlton, **Lazarus' Poem and Statue of Liberty Image,** 1987. Computer image. Courtesy the artist.

The New Colossus (by E. Lazarus) Not like the brazen giant of Greek fame, / with conquering limbs astride from land to land; / Here at our seawashed sunset gates shall stand / A mighty woman with a torch whose flame / is the imprisoned lightning, and her name / Mother of Exiles. From her beacon-hand / Glows world-wide welcome; her mild eyes command / The air-bridged harbor that twin cities frame. / "Keep ancient lands, your storied pomp!" Cries she / with silent lips. "Give me your tired, your poor, / Your huddled masses yearning to breathe free, / The wretched refuse of your teeming shore. / Send these, the homeless, tempest-tost to me, / I lift my lamp beside the golden door!" [This poem was written in 1883 by American poet Emma Lazarus, and in 1903 it was inscribed on a bronze plaque in the pedestal of the Statue of Liberty, a gift of the French people to the United States, designed by Frederic Auguste Bartholdi using an iron framework by Gustave Eiffel, dedicated in 1886 by US President Grover Cleveland on Liberty (then Bedloe's) Island, New York Harbor. An extensive restoration of this statue has been coordinated with its 1986 Centennial celebration] © 1986 Ken Knowlton Sunnyvale CA

Dennis W.A. Collins, **Queen Elizabeth,** 1953. Typed image. Courtesy London Magazine Editions, London, England.

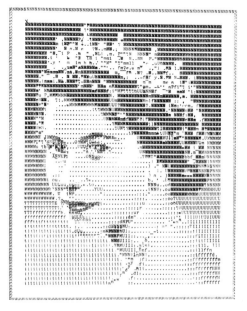

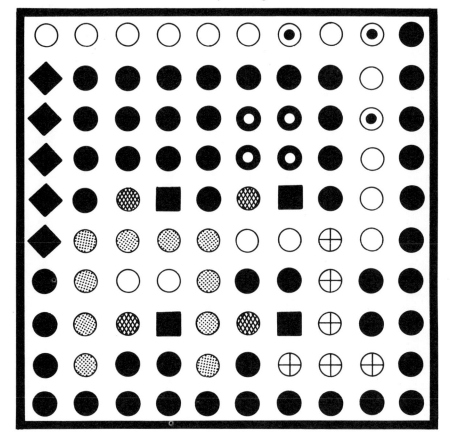

Grid matrix pattern.

The relative degree of similarity in a given perceptual pattern makes for a corresponding degree of connection or fusion.

—Rudolph Arnheim

A dot grouping composition on tracing paper. The tracing paper was placed over the grid matrix, which served as a guide for positioning the dots.

1.10 Similarity Grouping: Dot Matrix Patterns

Concept: Things that look alike will be seen as belonging together.

Key Synectic Trigger Mechanisms: Repeat, Combine (perceptually), Animate

Studio Action: Begin by making a grid matrix which will be used as an alignment device (see illustration): On 1/4″ (6 mm) graph paper, mark off a 5″ × 5″ (13 cm × 13 cm) square with a fine felt-tipped pen. Subdivide it into 10 lines (down and across) to produce a matrix of 100 1/2″ squares.

Some Dot Grouping Experiments. Slip the grid matrix under a sheet of tracing paper and tape it to a drawing board. Use self-stick dot labels, dots punched out with a paper punch or dots drawn with the aid of a plastic template for the experiments. Arrange and attach the dots on the paper using the underlying grid for accurate positioning.

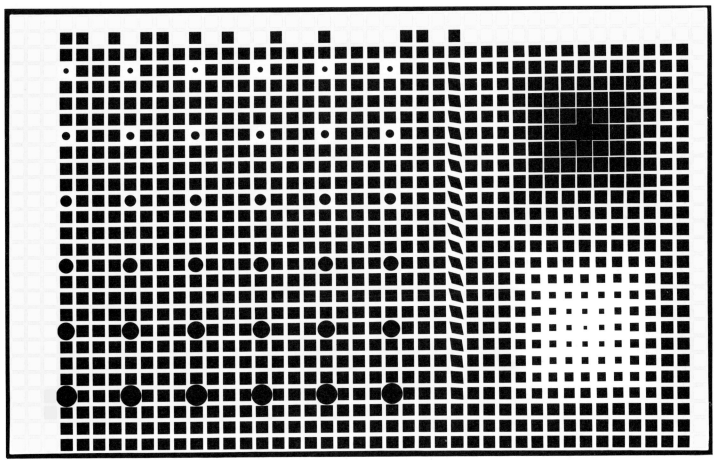

Victor Vasarely, **Supernovae,** 1959–61. Oil on canvas. Courtesy the Tate Gallery, London. Using a square dot pattern as a background, the artist modulated the matrix by changing the size, shape and alignment of some of the elements to produce a highly active visual field.

Create a grouping pattern composition with round, square or triangular dots, used either singly or in combination. Some ways of producing dot grouping patterns are:

1. By changing the color, size or texture of some dots in the matrix.
2. By substituting different shaped dots with those in the dot matrix.
3. By omitting some dots from the matrix pattern.
4. By shifting the alignment of some of the dots in the matrix pattern.
5. By randomizing the placement of some of the dots.

Materials: For the grid: fine-tipped waterproof felt pen, tracing paper (or layout paper), ruler. For the dots: paper, paper punch, glue (or 1/4″ (6 mm) self-stick dot labels), plastic templates.

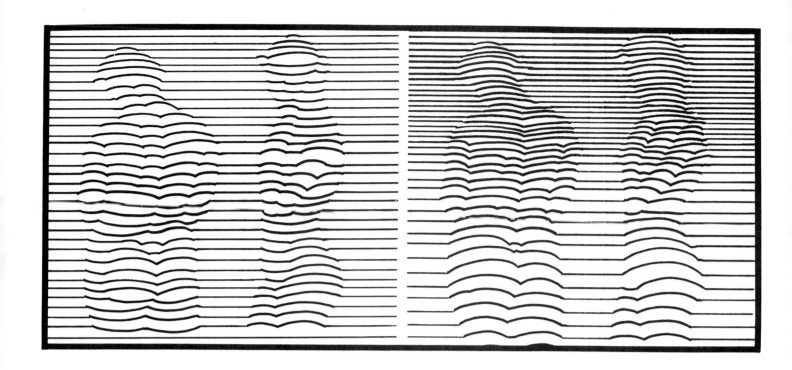

Yolanda Perry, **Images and Energy Field,**
1979. Pen and ink. Courtesy the artist.

1.11 The Interrupted Energy Field

Concept: An energy field can be interrupted and redefined by environmental shapes.

Key Synectic Trigger Mechanisms: Repeat, Disguise, Animate

Studio Action: Imagine an energy field of closely spaced lines and an object (or objects) within it. An analogy would be water flowing around rocks in a river.

 As a subject for this experiment, work either directly from a still life or from an image clipped from a newspaper or magazine. Make a pencil outline drawing of the subject on a sheet of drawing paper. Next, use a felt-tipped pen to draw closely-spaced horizontal lines on the background which cross over the subject to describe its form. The lines should suggest a cross-sectional form as well as producing a visual texture. Do not outline the images in ink, but allow only the cross-sectional lines to suggest their form. Finish by erasing the underlying pencil lines.

Materials: Drawing paper, pencil, black felt-tipped pen.

1.12 Proxemic Variations

Concept: Proxemics deals with the psychological effects of spatial grouping.

Key Synectic Trigger Mechanisms: Combine, Empathize

Studio Action: Make 4 different compositions, each made up of the same components but each arranged in a different way. For a keener insight in proxemics, imagine yourself as an element in the picture.

Plan the visual tensions accordingly. Try the following:

- Group the elements together, but do not have them touch.
- Group the elements so that they touch, but do not overlap.
- Group the elements along the inside edges of the picture frame, leaving the center inactive.
- Group the elements so that all (or some) overlap.
- Group the elements by combining any of the above methods.

Materials: Colored paper, X-acto knife, compass, scissors, glue.

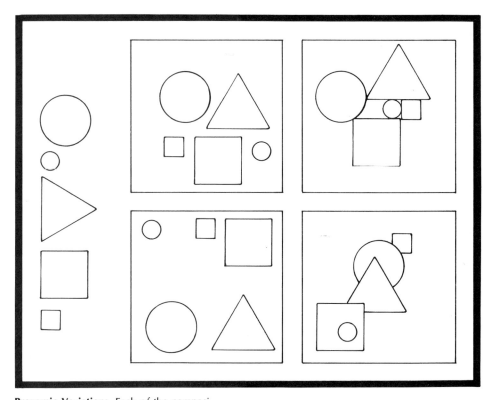

Proxemic Variations. Each of the compositions shown in the diagram is made up of the same visual elements, but arranged by different grouping methods.

Richard Hamilton, **She,** 1958–61. 48×32″ (121×81.2 cm). Courtesy the Tate Gallery, London. The incomplete design demands "closure" by the perceptive viewer.

Mike Robson, **Dancing Bull and Bird,** 1986. Map and marking pen. Courtesy the artist.

1.13 Visual Closure

Concept: The eye tends to "complete" an image, even though only parts of it are evident.

Key Synectic Trigger Mechanisms: Subtract, Combine (perceptually)

Studio Action: Overlay tracing paper on a drawing or photograph. Using pen and ink, make a fragmented tracing of the image: locate continuous and discontinuous lines, but do not make a complete contour drawing. See how much detail you can leave out and still be able to perceive the image.

Materials: Tracing paper, black felt-tipped pen.

1.14 Imaginative Projection

Concept: Images can be detected in seemingly undifferentiated visual fields.

Key Synectic Trigger Mechanisms: Fantasize, Combine (perceptually)

Studio Action: As a stimulus, refer to a road map, scribble drawing or inkblot pattern. Project your imagination into the undifferentiated visual field to seek figurative images. Use a felt-tipped marker to draw the images on the map.

Materials: Roadmap, etc., felt-tipped marker.

1.15 Constellation

Concept: A galactic structure is composed of interconnected lines and nodes.

Key Synectic Trigger Mechanisms: Repeat, Connect, Animate

Studio Action: Arbitrarily position 200 dots on a sheet of drawing paper. Connect them to produce an integrated visual structure.

Materials: For the dots: colored marking pens, self-stick dot labels or paper punch; to make the lines: fine felt-tipped markers. Optional: ruler, plastic curve.

Follow-Up Studio Action (3-D): Using small units made of wood, styrofoam or clay, and different lengths of rigid wire, assemble a colorful three-dimensional constellation. Make it strong enough to stand on its own.

Materials: Wood, clay or styrofoam; wire (brass welding rod, coat hanger, etc), drill and bit (for making pilot holes in wood), acrylic colors, brush.

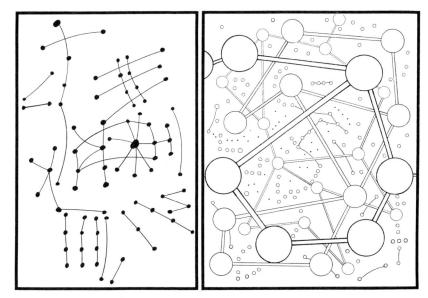

Hank Merrick, **Constellations,** 1985. Pen and ink, 9×12″ (22.8×30.5 cm). Courtesy the artist.

Alexander Calder, **Constellation,** 1943. Steel wire and wood, 31×30×18″ (78.4×76.2×45.7 cm). Courtesy Perls Gallery, New York.

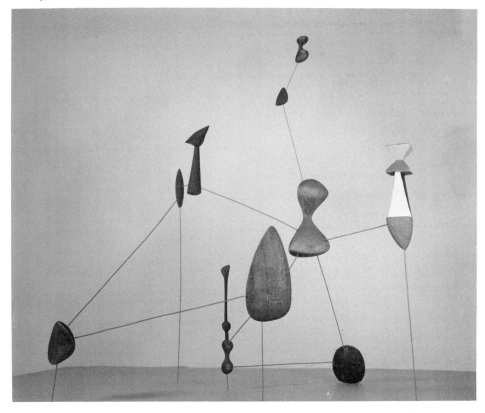

Helen Doolittle, **Memory Matrix,** 1981. Collage, 8×10″ (20.3×25.4 cm). Courtesy the artist.

1.16 Image Matrix

Concept: Images grouped together appear conceptually linked.

Key Synectic Trigger Mechanisms: Isolate, Repeat, Fantasize, Symbolize, Combine (conceptually)

Studio Action: Use collage and mixed media for this experiment. Divide a sheet of drawing paper to make an irregular grid with a large box in the center, and 10 or more smaller surrounding boxes.

Glue a picture in the center panel which will serve as the reference, or "trigger" image. In the smaller units, glue images which are associated with the trigger image, either in a symbolic or psychological way. Consider your composition a "visual meditation" of:

- a person
- a place
- an object
- an experience
- a sensation
- an emotion
- a dream
- a fantasy
- an art object

Combine collage and drawing to make a personal and aesthetic statement. Find images to photocopy; transform them by working into them with colored pencils or other art materials.

Materials: Drawing paper, art media of your choice.

1.17 Design by Combining an Organic and Inorganic Subject

Concept: Disparate elements can be integrated to produce synergistic patterns.

Key Synectic Trigger Mechanisms: Superimpose, Combine

Studio Action: Make an allover pattern by superimposing elements from two disparate subjects. Vary the size and proportion of the visual elements and overlap them to produce an aesthetically pleasing composition. Work out a black and white pattern and add texture for further visual interest.

Begin by making individual drawings of both subjects on tracing paper. Overlap the drawings and observe the shapes produced by shifting the papers slightly. Tape the "sandwiched" drawings together and transfer the composite image to bond paper. Do this by blackening the back of the underlying drawing with pencil, then taping it to the bond paper and tracing over the lines with a sharp pencil. Ink in the light transferred lines with a felt-tipped pen and fill in the solid areas of black with a pointed brush and india ink.

Materials: Bond paper, tracing paper, black waterproof felt-tipped pen, #3 sable brush, india ink.

Marion Andres, **Synectic Composition,** 1982. Pen and ink. Courtesy the artist.

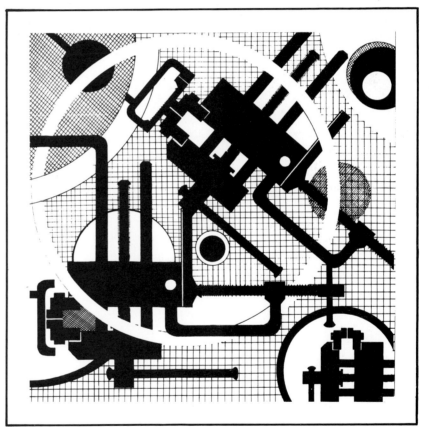

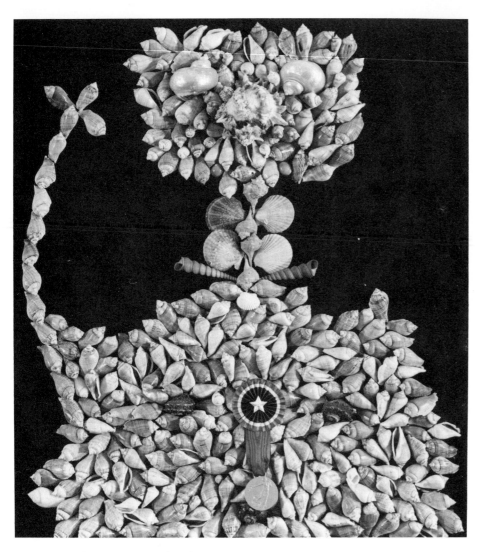

Enrico Baj, **Catherine Henrietta de Balzac,**
1978. Shells, mixed media. Courtesy Arras
Gallery, New York.

1.18 Close Encounters

Concept: A (relief) portrait can be created by arranging closely-packed three-dimensional objects.

Key Synectic Trigger Mechanisms: Repeat, Fantasize, Symbolize

Studio Action: Make a bas-relief (having a raised effect) portrait on a plywood panel. Glue together multiple unit elements such as sea shells, rocks, nails, marbles, etc. Attach the elements to the panel with silicone glue or other similar paste adhesive. Pack the elements closely together or superimpose them to produce a surreal portrait. Work from a theme such as "Cook," "Policeman," "Doctor," "King," "Sports hero," "Musician," "Celebrity," "Artist," "Magician," "Scientist," "General," etc.

Materials: Plywood panel, adhesive: white glue, silicone seal or ceramic tile cement; parts from junked toys, mechanical objects, wood cut-outs, rope, seashells, pebbles, other found objects.

1.19 Idiosyncratic Grouping

Concept: Idiosyncratic grouping defies logic; such combinations exist only to shock or present mysterious imagery.

Key Synectic Trigger Mechanisms:
Fantasize, Combine

Studio Action (Collage): Make a collage composition by pasting together many disparate images cut from magazines. Select a larger image as a stimulus (such as a figure, face, house, tree, building, etc.) Add to it other images to produce an eccentric or bizarre picture.

Follow-Up Studio Action (3-D):
Collect and assemble interesting "junk" to produce a mysterious three-dimensional structure. Assemble the elements by tying, bolting, gluing, taping, etc. Paint the structure with bright acrylic colors.

Materials: (1) Magazine illustrations, paste, drawing paper.
(2) "Found" objects, wood, metal and/or plastic scraps, discarded toys, interesting junk, materials to attach the elements, acrylic colors.

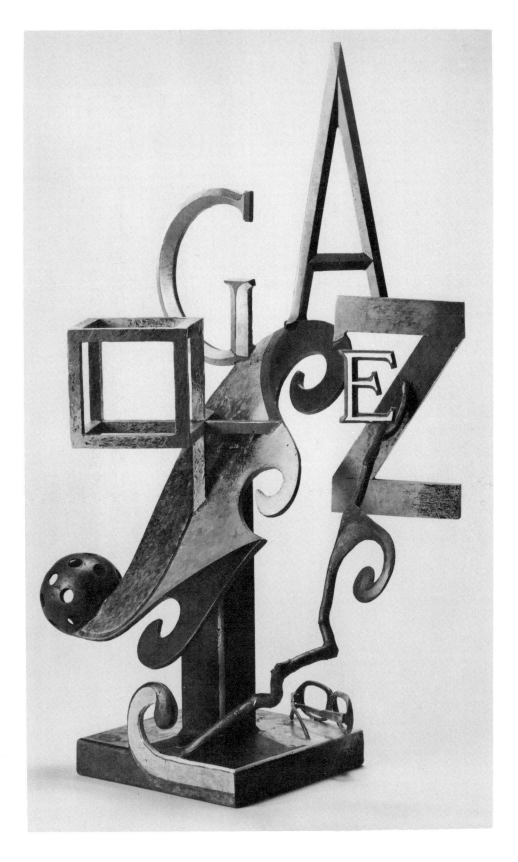

Robert Hudson, **Gaze,** 1986. Polychromed bronze, 31 × 18¾ × 16" (78.7 × 47.6 × 40.6 cm). Courtesy Allan Frumkin Gallery, New York.

1.20 Antithesis as a Fantasy Stimulus

Concept: Combining opposite or antithetical images stimulates surreal imagery.

Key Synectic Trigger Mechanisms: Contradict, Fantasize, Combine

Studio Action: Create a design inspired by antithetical themes such as:

- *Opposite Qualities:* Curved/straight, twisted/straight, continuous/dicontinuous, geometric/organic, opened/closed, concave/convex, simple/complex.
- *Opposite Life Forms:* Human/animal, animal/vegetable, young/old, living/dead.
- *Opposite Realities:* Organic/inorganic, human/machine, rational/irrational, real/surreal.
- *Opposite Time-Frames:* Now/then, Now/tomorrow, Yesterday/today/tomorrow.
- *Opposite Sensory Perceptions:* Hard/soft, smooth/prickly.
- *Opposite Stabilities:* Order/chaos, attraction/repulsion, focused/unfocused, action/inaction.

Make a collage, painting, or mixed media construction to visualize your concept.

Materials: Media and materials of your choice.

Sergio Sarri, **Camera D'Analist Syn-ext,** 1976. Acrylic on canvas, 64×51″ (162×130 cm). Courtesy Galleria D'Arte Nuovo Spazioz, Venice.

1.21 Design from Word Play

Concept: Disparate word combinations can be used to stimulate imagery.

Key Synectic Trigger Mechanisms: Combine, Fantasize, Transfer

Studio Action: Combine two different words to "jump-start" your imagination. Randomly select two words, an adverb and a noun, from the two lists below.

surreal	heart
caged	door
webbed	banana
failed	diary
camouflaged	target
illuminated	ladder
broken	rainbow
bandaged	monument
chained	window
metamorphosed	map
melted	mask
ignited	tree
mechanized	shadow
personalized	bicycle
bonded	statue
twisted	key
armed	tricycle

(add to the lists)

Give your fantasy full rein; use the synectic wordplay as a springboard to generate idiosyncratic imagery. Transfer your thinking to materials. With found objects and selected mixed media materials, produce an outrageous image.

Materials: 3-D found objects and mixed media.

Nancy Carman, **Monument To My Failures,** 1979. Low-fire white clay, underglazes, glazes and chinapaint, 20½ × 17 × 16″ (52 × 43.2 × 40.6 cm). Courtesy the artist.

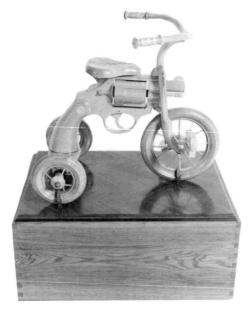

Michael Jean Cooper, **Trainer Tricycle,** 1976. Laminated wood, 32 × 28 × 38″ (81.2 × 71.2 × 96.5 cm). Courtesy the artist.

1.22 Grouping by Surface Similarity

Concept: Dissimilar objects having similar surface qualities are perceptually linked.

Key Synectic Trigger Mechanisms: Add, Combine, Disguise

Studio Action: Arrange and glue nine to twelve different three-dimensional objects on a Masonite or plywood panel. Make the objects "belong" together by giving them a common "skin" (surface treatment). For example, make them all white or black, yellow, etc., or treat their surfaces by creating collages on them with decorative paper, glitter, feathers or other materials.

Materials: Found objects, masonite or plywood panels. Optional art media: acrylic colors, collage and loose materials, white glue.

Barton Lidice Benes, **Money** (detail), 1982. Money and cancelled checks, 6 × 4' (1.8 × 1.2 m). Courtesy Kathryn Markel Gallery, New York.

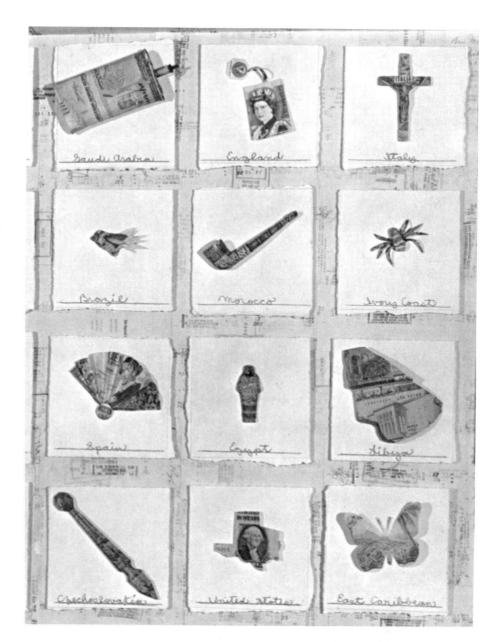

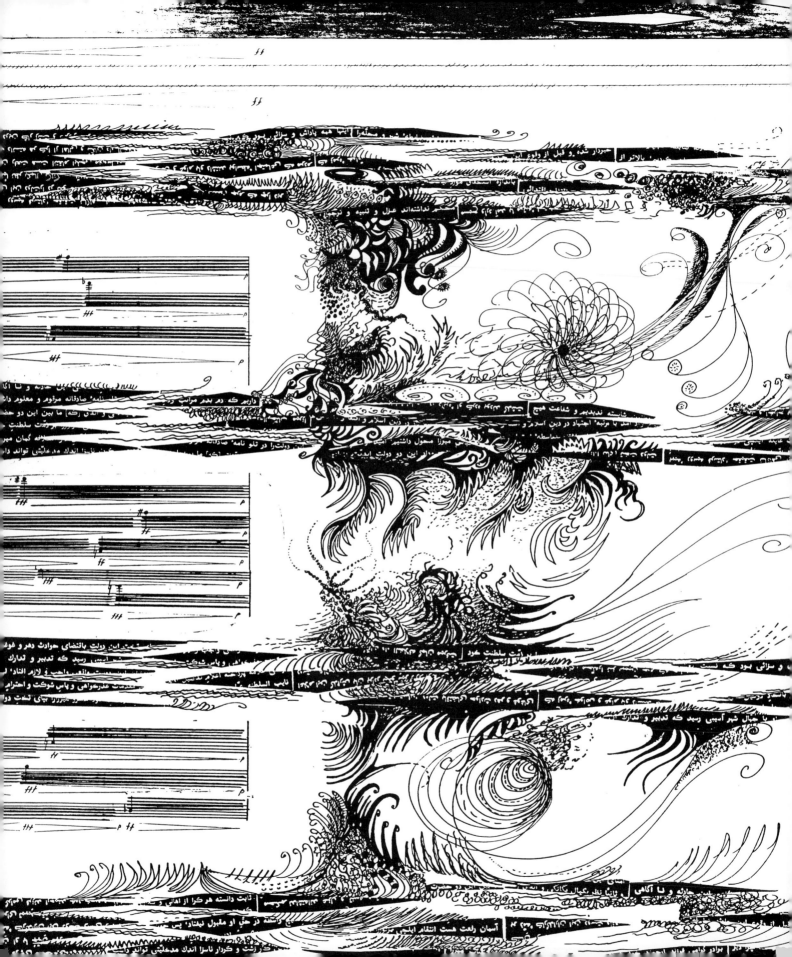

DESIGN SYSTEMS AND SYNECTICS

Photomicrograph of a longitudinal section of an Eastern White Pine, magnified 100×. The star-shaped wood cells contain perforations that permit the flow of water and dissolved minerals to flow from one cell to another on their way from the roots to the leaves. Essentially the cells act as the plumbing (or circulatory) system of the pine tree. Photo courtesy Robert Berdan, University of Calgary.

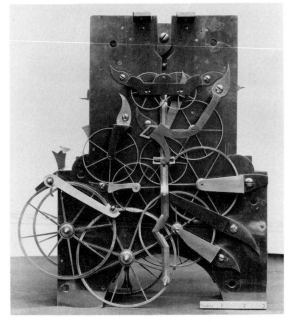

Benjamin Vulliamy, **Regulator Clock** (with outer back plate removed), 1780. Courtesy The Science Museum, London.

An artist is simply one who edits the environment by taking from it that which he deems pertinent, leaving out much that confuses, relocating substructures, and summing up scattered detail into comprehensible units. The image presented is thus an abstraction, and the process outlined is the process of design.
　　　　　　　—Donald M. Anderson

System: An organized, integrated whole made up of diverse but interrelated and interdependent parts.

Previous page: A page from the score Divan, Shams, Tabiz, inspired by the Sufi mystic Jalal al-Din Rumi, an orchestral composition by R. Murray Schafer. The swirls and arabesques represent the sounds of an electronic tape which accompanied the orchestra. Used by permission of the composer.

The French architect Le Corbusier once said, "There is no work of art without a system."

In his book *The Medusa and the Snail,* Lewis Thomas explains the term system as "A structure of interacting, intercommunicating units or components that as a group act or operate individually and jointly to achieve a common goal through the concerted activity of the individual parts."

By virtue of such action, we can also say that all systems are *synergistic:* they produce an effect greater than the sum of their parts.

Order

The process of designing involves creating conceptual and visual order. Ideas are designed, as are objects such as furniture, buildings or art forms. To design is to unify, to make ordered that which otherwise would be formless or undifferentiated. The designer takes random information, stimulus and materials, and through Synectic and systematized thinking, turns them into ideas and cohesive structures. We must remember that artistic activity is a process of thinking and feeling, as well as of object-making. It's an activity that involves conceptual, visual and psychological order.

Invention is the process of discovering a principle. Design is the process of applying that principle.

—David Pye

Kenneth Snelson, **Easy Landing,** 1977. Stainless steel, 30×85×65′ (9.1×25.9×19.8 m). Collection the City of Baltimore. Courtesy the artist.

Design

In defining the term *design* to his students, the master teacher Joseph Albers wrote a poem about it:

> To design is
> to plan
> and to organize
> to relate and to control.
> In short it embraces
> all means opposing disorder
> and accident.
> Therefore it signifies
> a human need
> and qualifies man's
> thinking and doing.

Notice that the term *design* can be used either as a noun or as a verb. Accordingly, it can refer to either an object or an action. As a noun, for example, it can denote a plan, a drawing or a representation. As a verb it can refer to a way of thinking and doing; in this mode "designing" connotes a way of applying organizational principles (also called systematizing), and of endeavoring to achieve a conceptual and aesthetic gestalt. John Ruskin said, "Design is not the offspring of idle fancy; it is the studied result of accumulative observation."

A good design, whether in art or architecture, must have a strong foundation or underlying formal order behind its visual content. The Canadian painter Christopher Pratt emphasized this when he said, "A work of art has to stand on its own merits which are independent of its source. A geometric structure should be engineered, stressed, proportioned, calculated, and balanced with the same care we would bring to the design of a bridge or the cutting of a diamond."

Enter Synectics

The study of the elements and principles of visual organization is generally accepted as an important part of any design course; yet, as Paul J. Grillo points out, the elements and principles are inert in their own right. They flourish only when the artist applies to them a personal concept, special insight or creative thought. Original ideas are stimulated by free-association stimuli such as Synectics. These two factors, then—the principles of visual design, and Synectics—can be put to work jointly to provide the basic "grammar" and springboard for creative design.

The Principles of Visual Organization

The goal of the designer, simply put, is to achieve *unity* in concept, form and purpose. Because unity of purpose can be perceived in psychological as well as physical modes, it must be kept in mind that the artist will vary his compositions, making some appear visually stable and others unstable, depending on the concept and psychological effect that he or she wishes to achieve.

Thus it is important to *subjectify* visual factors—that is, alter them according to personal feelings and intent. Some principles of visual organization (or unifying factors) are:

Repetition. Repeating visual elements such as line, color, shape, texture value or image tends to unify the total effect of a work of art. Repetition can take the form of an *exact* duplication, a *near* duplication, or duplication with *variety.*

Variety. By varying the components of a visual design, the artist creates interest and avoids monotony. A way of accomplishing this is to establish an approach which involves "Theme and Variations"—repeating the same image, but in different sizes, colors, values and shapes.

Proportion. Proportion refers to the relationship between visual elements. The proportion, scale, amount or degree of dominance or subordination between the visual elements helps to establish visual order.

Transition. A composition may be unified by creating rhythmic visual pasage between its units. Transition is effected by controlling the occurrence and sequence of the visual units, thereby providing an optical pathway.

Emphasis. A design may be unified by providing a special accent, allowing something to dominate or to serve as a nucleus or center of interest. Unity can be created by developing a visual hierarchy (making particular visual elements conform to an order of importance by establishing difference in size, color, tone, etc.) and by the balance of contrasts.

Sidney Gordin, **Untitled.** Acrylic on wood, 4′×4′×3″ (1.2×1.2×.9 m). Courtesy Gallery Paule Anglim, San Francisco. A jigsaw was used to cut out shapes of soft lumber which were subsequently painted in acrylic and glued to a plywood background.

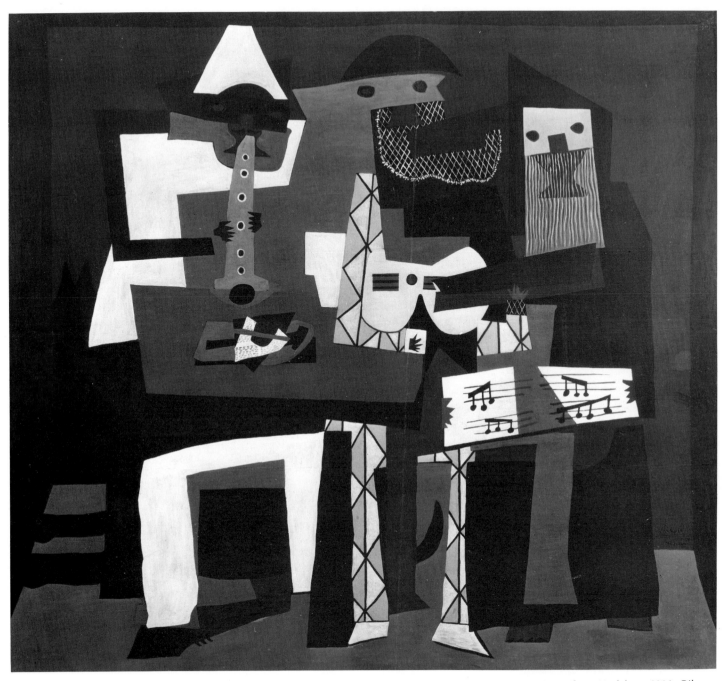

Pablo Picasso, **Three Musicians,** 1921. Oil on canvas, 6′7″×7′3¾″ (200.7×222.9 cm). Collection, The Museum of Modern Art, New York. Mrs. Simon Guggenheim Fund.

Balance. Balance is the attainment of optical and psychological equilibrium in a composition. There are two types of visual balance: SYMMETRICAL and ASYMMETRICAL. Symmetrical balance refers to an even distribution of visual weight on either side of an axis, as in designs which have a radial or bi-lateral configuration. Asymmetrical balance refers to a psychological, or "felt" balance. Here, a small, bright-colored shape can be balanced by a larger neutral-colored shape, or a large shape placed near the center of a composition (as in a fulcrum) can be balanced by a smaller shape placed further out.

Mary Jones, **Beauty,** 1984. Oil on canvas, 72×90″ (182.8×228.6 cm). Courtesy Ovsey Gallery, Los Angeles.

The Visual Elements

All visual art comprises combinations and permutations of the visual elements, the "basic building blocks" of design. Every visual idiom—drawing, painting, printmaking, sculpture, architecture, applied design, and so on—is founded on these factors:

- Point
- Line
- Shape
- Value
- Texture
- Color

These visual elements are animated by the principles of organization, the creativity of the artist, and the Synectic trigger mechanisms. In concert, these stimulators help the artist turn dots, squiggles and shapes into organized and meaningful structures and images.

Space, Structure and Form

The artist puts the visual elements to work within the context of *space, structure* and *form.*

 Space can be defined in two ways: (1) As an *objective* (or external) *reality,* and (2) as a *subjective* (or mental) construction.

 As an objective reality, space interacts with form to determine the shape of a visual image. As a subjective construction, it is an imaginary phenomenon that is manipulated by imagination and fantasy.

Some Definitions of Space

The Interval, Distance or Area Between Things. The physicist is concerned with space that can be measured by mathematics and geometry. The artist, too, manipulates space and form in an objective way to establish physical arrangements within a spatial frame. But the artist is also concerned with the interaction of space and form from a subjective, non-temporal and metaphysical point of view. Buckminster Fuller said,

> *Space is the absence of events, metaphysically. Space is the absence of energy events, physically.*

 Francis D.K. Ching describes space as a material substance like wood or stone, yet a material which is inherently formless. "Its visual form, quality of light, dimensions and scale", writes Ching, "depends totally on the boundaries as defined by elements of form."

The Interval Between Points in Time. We mortals live within a lineal time-space. Things and events are separated by points in time. "There is no dimension without time," writes Buckminster Fuller. "What we call *length* is a duration of experience and is always measured in time."

The General Receptacle of Things. Space can be defined as a factor which encapsulates forms, or co-exists with things which exist within it. Although it is usually thought of as "empty," to the designer and poet, space is real, and has boundaries and limits which conform to the area it envelopes, whether physical or metaphysical.

A Cognition Phenomenon. Human beings perceive and comprehend things through the five senses. The space between objects in a visual field is spontaneously measured by binocular vision. Our two eyes, being set apart, present two slightly different views of a given subject. Both of these images are transmitted to the brain through electro-chemical impulses where they are fused into one spatial image in the mind's eye. As well, each of the senses, in its own way, measures and establishes spatial references, both independently and in concert with the others.

A Subjective Phenomenon. Reveries, daydreams and fantasies are subjective constructions. In the mind's eye, such pictures are exempt from the restrictions of chronological time and space. The mind can collapse space and time, reverse them or mix them with other time-frames. Subjective space is never fixed or static; the mind is an open and flexible repository of images which it constantly collects and juggles. It ignores fixed time and instead presents simultaneous fusions of past, present and speculative future events.

A Factor Used by the Artist to Organize Visual Units. In this respect, the visual artist can choose to work within one of two spatial dimensions: (1) *illusory space:* the flat, 2-dimensional space of drawing, painting, printmaking and photography, or (2) *actual space:* the three-dimensional realm of sculpture, architecture and applied design.

Ron Tatro, **Shape Mountain,** 1984. Painted steel $23 \times 16 \times 14''$ ($58.4 \times 40.6 \times 35.6$ cm). Courtesy Harcourts Gallery, San Francisco.

Through the volume of space, we move, see forms and objects, hear sounds, feel breezes, smell the fragrance of a flower garden in bloom.

—Francis D.K. Ching

The laws of structure are the series, the rhythms, the progression, the polarity, the regularity, the inner logic of sequence and arrangement.

— Max Bill

Structure

Like the term design, the word *structure* can also be thought of as a verb or noun. As Gyorgy Kepes observes,

> *Structure, in its basic sense, is the created unity of the parts and joints of entities. It is a pattern of dynamic cohesion in which noun and verb,* form *and* to form, *are coexistent and interchangeable.*
>
> *As a verb, structure denotes modes of building, constructing, organizing and arranging things.*
>
> *Paul Klee wrote that in art, structural design evolves through a process of metamorphosis: "The structural components, the way they originate and grow are the* conditions. *The result* evolves along the way. *Each phase during formation is the source of further inspiration, the basis on which to build."*
>
> *As a noun, structure connotes something whose parts are joined together in some definite manner. In art, any given element may be a structural unit or building block. The way the structural units are assembled determines the degree of cohesiveness (or unity) in the completed object or composition.*

The German artist and writer Reinhold Pfenning (in *Gegenwart der Bildenden Kunst — Contemporary Art*) explains structure this way: "The elements of structure are the minute individual parts of forms, and therefore unable to stand up by themselves; they are of value only as part of the structure-forming arrangement and as they contribute to the total structural identity. Structure is a dynamic texture of non-autonomous parts."

Form

Form denotes the conformation or total outward appearance of a thing as distinguished from its matter. The form of an object is derived from its structural units. The way in which these units are combined and assembled determines the essence and vitality of the form.

Form is determined by the organization of elements that make up the totality of a design. In this respect form, unlike structure, is definite and closed. When we observe an object from a distance, we may not see its structure, but only its generalized shape and color. As we get closer to the object, we become aware of its structure and of the special dynamics of its construction.

In art, the study of form is usually accompanied by the study of space. As Henry Moore points out, "Form and space are one and the same thing. You can't understand space without understanding form. In order to understand form in its complete three-dimensional reality, you must understand the space that it would displace if it were taken away."

A colony of ants link together to form an organic structure which serves as an ingenious roadway. Photo courtesy Alan Sonfist.

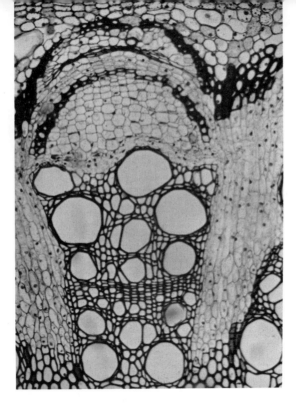

Systems in nature. Micro photograph of Abies Balsamea. Photograph courtesy Professor Edward C. Young, University of Calgary.

Visual Analogistics: Creating Art Systems which Mimic Nature

There can be no knowledge of function without knowledge of structure.
— H. Spencer

The artist can learn a great deal from nature by investigating organic growth and form. The perception of the underlying order in nature—the underlying systems and engineering principles—rather than the mere superficial surface characteristics, are important sources of information for the artist and designer. The process of transferring or transposing such information to art concepts is the basis of invention through analogical thinking. To produce creative analogs, the artist must always, as Paul Klee put it, look *behind and through* nature, not just *at* nature.

Some basic systems in nature which can inspire analogical concepts in design can be characterized as:

- Spiral
- Explosion
- Vertebraic
- Radiating
- Cluster
- Branching
- Grid
- Lattice
- Interlocking
- Stress and Flow
- Close Packing
- Open Packing

Look closely at the way natural forms are engineered. Add to the list and use such information to produce creative visual analogs in the form of art and design.

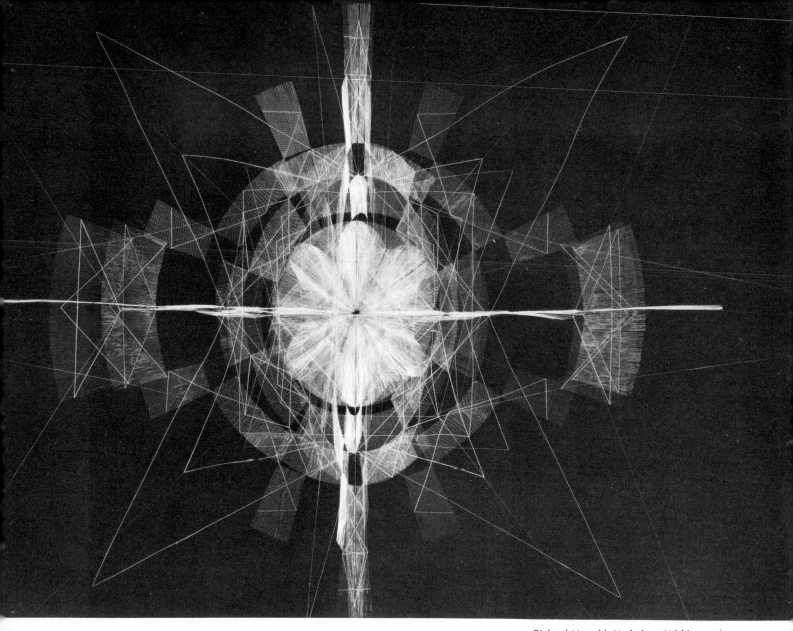

Richard Lippold, **Variations Within a Sphere,** 1956. Gold-filled wire (22K), 11×22×5½' (3.4×6.7×1.7 m). Courtesy The Metropolitan Museum of Art, New York. This radiant "sun" is a finely crafted visual analog.

Art does not lie in copying nature. Nature furnishes the material to express a beauty still unexpressed in nature.
—Henry James

Our source of inspiration should be found in nature, but nature should always stay as a source of inspiration and not as direct model to copy. The error of copying nature blindly never evolved into great art.
—Paul J. Grillo

2 / Design Systems and Synectics
STUDIO ACTION

Note: In addition to applying the Key Synectic Trigger Mechanisms suggested in each of the following studio activities, also integrate appropriate principles of visual organization described in this chapter, i.e., repetition, variety, proportion, transition, emphasis and balance. Remember, too, that art is nourished by *poetics,* that orbit of thought that may be described as the "language of feelings and emotions," a sentient knowledge nourished by sensory and subjective impressions.

2.1 Synectic Lines

Concept: An arrangement of disparate elements appears unified if all of the elements are aligned in a common direction.

Key Synectic Trigger Mechanisms: Repeat, Combine, Superimpose

Studio Action: Draw, paint or "print" fifty different **vertical** lines. Vary them by making some thick, thin, dotted, hard-edge, soft-edge, black and white, color, juxtaposed, superimposed, etc. Explore the expressive potential of different materials such as colored pencils, inks, watercolors, colored markers, crayons, liquid tempera, etc. Experiment by painting some lines with an

unorthodox tool such as a sponge, a cardboard squeegee or a twig. Unify the composition by making all of the lines go in the same direction. Provide visual interest with variety, contrast and selected emphasis.

Materials: Mixed-media materials of your choice.

2.2 Walking the Line

Concept: A line is the path of a moving point.

Key Synectic Trigger Mechanisms: Symbolize, Fantasize, Metamorphose

Studio Action: Starting from one edge of the paper, make a line design that depicts the fantastic

Jason Hall, **Synectic Line Composition.** Ink on paper. Courtesy the artist.

journey of a moving point. As the line progresses, have it change in thickness and configuration. Make the continuous line change to a dotted or discontinuous line; have it describe a shape, face, figure or other image. Make it change from black and white to color, to an explosion of texture, etc. Have it finish up at the bottom of the page by spelling your name or selected prose.

Materials: Drawing paper, felt-tipped markers, mixed media.

Taking a Line For a Walk, 1984. Mixed media. Student work, Design Workshop, University of Calgary. As the line progresses, it changes its form from 2-D to 3-D and back again.

Andrew Pantellas, **Motif Divided and Rearranged,** 1979. Pen and ink. Courtesy the artist.

2.3 Divide and Rearrange

Concept: A shape can be divided into parts which, in turn, can serve as components for a new structure.

Key Synectic Trigger Mechanisms: Fragment, Recombine

Studio Action: Draw a large geometric shape (circle, square, triangle, etc.) on a large sheet of medium-weight drawing paper. With a pencil, subdivide the geometric shape into at least 15 different shapes. Cut out the parts and arrange them to form an interesting composition on another sheet of drawing paper. Keep in mind such visual principles as variety, contrast and proportion. Add additional interest to the design by making it a bas-relief (having a raised effect). To do this, glue cardboard tabs underneath each of the units. When a satisfactory arrangement is produced, glue the components together with white glue. As you compose the design, also take into consideration the effect of light and shade that is produced in the white-on-white relief.

Materials: Pencil, white medium-weight drawing paper, compass, straightedge, scissors, mat knife, white glue.

Follow-Up Studio Action: Make a larger version of your paper relief in wood. Cut out the parts with an electric jigsaw and paint them with acrylic colors. For a more pronounced three-D effect, glue small wood blocks underneath the units.

2.4 "Barnacle" Grouping

Concept: A group of objects can be arranged on a "host" form.

Key Synectic Trigger Mechanisms: Analogize, Repeat, Combine

Studio Action: Analogize the way barnacles attach themselves to host forms such as rocks, piers or floating objects. Translate the perception to the production of a 3-D construction. Use a found object such as a block of wood, beach ball, bottle, stone, etc. to act as the "host" form, and glue "barnacles" such as wood blocks, pebbles, marbles, coins, etc. to its surface to produce a unique design and aesthetic effect.

Materials: Found objects, glue.

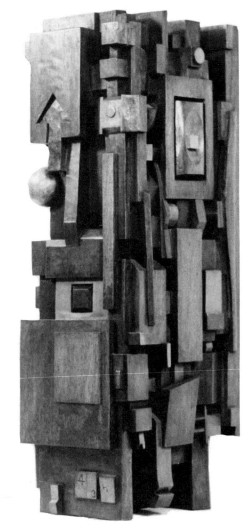

Enrico Pinardi, **Tower Sentinel,** 1964. Carved mahogany, 28½″ (72.3 cm) high. Courtesy Kanegis Gallery, Boston, Massachusetts.

2.5 Combining Geometric and Organic Shapes

Concept: A composition can be produced by combining shapes that have an opposite inherent quality.

Organic shapes, like the shape of the boomerang, are characterized by continuous lines, rather than sharp, hard-edged and discontinuous lines such as those of the square, the triangle and other platonic shapes.

Key Synectic Trigger Mechanisms:
Repeat, Superimpose, Combine

Studio Action: Create a composition by integrating organic and geometric shapes. Use both mechanical drawing aids (such as a ruler, compass, etc.) and freehand drawing to produce the shapes.

Begin by drawing a series of organic and geometric shapes on tracing paper. Overlap the designs and arrange them to create an interesting composition, adding or subtracting elements as desired. Transfer the composition to a sheet of drawing paper (or a canvas panel) and paint the design according to a selected color scheme.

Materials: Drawing paper, pencil, straightedge, compass, color media such as acrylics, liquid tempera, watercolors, colored pencils or felt-tipped markers.

Jocelyn Ajami, **Orphic Experiments, Calyx II.** Pencil on paper, 60×120″ (152.4×304.8 cm). Courtesy Gallery 52, Boston, Massachusetts. This painting not only presents a dialectic of opposites in terms of its organic/geometric design, but also prompts the viewer to extend and analogize the concept of opposites on other planes of thought. The term "Orphic" connotes interconnections which celebrate the unity and multiplicity of things, e.g., man/nature, spiritual/sensual, tense/relaxed, concrete/ elusive, life/death, etc.

The first mark begins to identify a structure. Each subsequent mark joins the first and forms an additional part of the structural definition; it also alters the overall configuration of the remaining space. The two apparent opposites are necessary for our understanding of either one.
— Paul J. Grillo

2.6 Toward Structure: The Cohesion of Visual Units

Concept: Units are "building blocks" which, united, can form an organic structure.

Key Synectic Trigger Mechanisms: Repeat, Superimpose, Combine

Studio Action: Draw a shape to act as a "structural unit."

Make many duplications of the unit; vary its size for additional interest In your composition, try to show the units in the process of approaching, coalescing and forming an organic structure. Think of your design as a structure "in its process of formation": i.e., show some isolated units, some loosely clustered ones, and some which are tightly clustered; imagine them attracted towards an invisible "magnetic pole" located somewhere on the page. As you work, be aware of how the shapes alter remaining space, and of how the positive and negative elements become integrated in the organic structure.

Materials: Drawing paper, pen and ink.

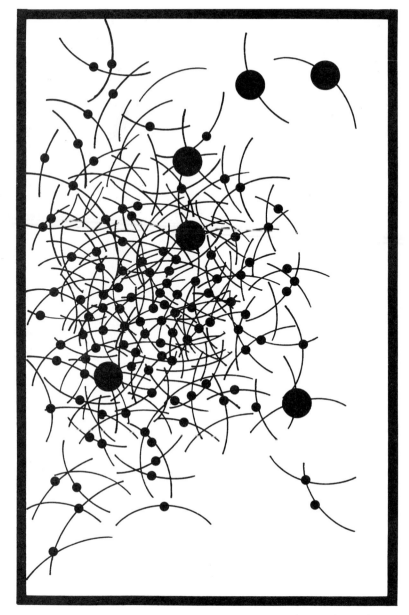

Jane Halverson, **Towards Structure.** Pen and ink. Courtesy the artist. A visual unit is shown merging with similarly shaped components to form an organic structure.

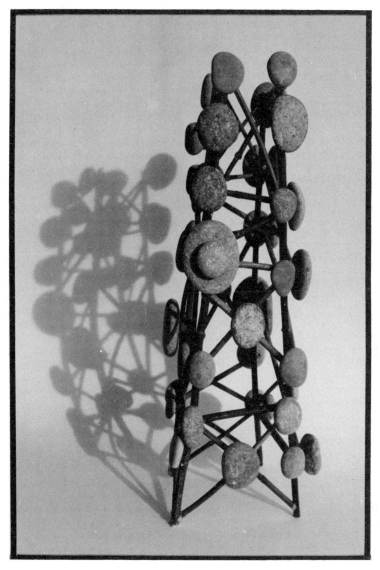

2.7 Stimulus from Industrial Structures

Concept: An industrial structure can serve as a creative stimulus.

Key Synectic Trigger Mechanisms: Analogize, Simplify, Substitute, Transfer

Studio Action: Organize a camera safari to collect pictures of unusual industrial structures. Photograph such things as communication towers, construction rigs, plumbing, heating and electrical systems; mechanical devices, machines, etc.

Select one of the photographs as a stimulus to produce an art form. Analyze the subject, paying particular attention to the parts, configurations and connecting factors. Make some preliminary drawings based on your analysis: Simplify and abstract the components as you desire, and re-arrange them to produce a new integration, one that does not look like the original subject, but in some way maintains the spirit of its structure. Transfer your thinking to 3-D: Find suitable materials to produce a three-dimensional construction.

Materials: Graph paper, pencil, ruler, compass; "found" materials or units made from wood, wire, rope, glass, clay, papier-mâché, etc.

Stimulus and Constructed Analog. Student work, University of Calgary. A communication tower serves as the stimulus for creating an analagous three-dimensional design from twigs and stones.

Alice Berguson, **Design Derived From Cross-sectioned Pomegranate.** Ink on paper. Courtesy the artist.

2.8 Design from Nature: Cross Sections

Concept: Cross sectioned plant growth (fruits and vegetables) can serve as creative stimuli.

Key Synectic Trigger Mechanisms: Simplify, Transfer, Analogize

Studio Action: Select a fruit or vegetable as a stimulus subject for analysis and design. Cross section the subject with a knife to reveal the interior structure.

Make several analytical drawings which describe the subject in accurate detail, followed by additional drawings which are stylized abstractions. Omit detail in the second set of drawings; simplify or exaggerate shape, color and pattern. Make the drawings larger than the actual subject.

Materials: Drawing paper, colored pencils. Optional: mechanical drawing aids, straightedge.

Follow-Up Studio Action: Produce a painting based on the stylized design.

2.9 Design from Nature: Axial Systems

Concept: Axial systems are symmetrical designs, characterized by a line, about which forms and spaces are organized.

Key Synectic Trigger Mechanisms: Analogize, Transfer, Fantasize

Studio Action: Study a subject from nature which has an axial design pattern: i.e., leaves or floral patterns, trees, root systems; butterflies, a face or figure, skeletons, vertebraic systems. Make several stylized drawings based on the study and abstraction of the subject.

Follow-Up Studio Action (3-D): Use wood, clay, or mixed media to produce a "totem" based on one of the drawings.

James Broderson, **Axial System Design.** Pen and ink. Courtesy the artist. An example of bilateral symmetry.

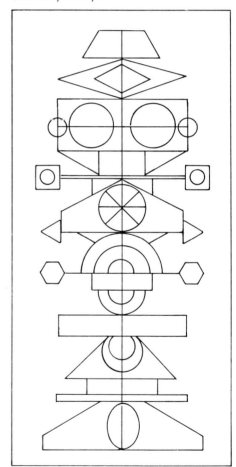

Richard Anusziewicz, **Division of Intensity,** 1964. Acrylic on panel, 48×48″ (121.9×121.9 cm). Courtesy Martha Jackson Gallery, New York.

Ernst Haeckel, **Radiolaria** (A type of marine Protozoa). Drawing from *Art Forms in Nature,* by Ernst Haeckel. Courtesy Dover Publications, New York.

2.10 Design from Nature: Explosion Patterns

Concept: Explosion patterns are radial configurations, characterized by forces and elements which diverge from single or multiple nodes.

Explosion patterns are characteristic configurations of thistles, flowers, palms, dandelions, sea anemones, diatoms, radiolaria, jellyfish, starfish, sea urchins, spiders, etc.

Key Synectic Trigger Mechanisms: Analogize, Simplify, Repeat, Transfer, Animate

Studio Action: Research nature forms with radial configurations such as those listed above. Select one as a stimulus to produce an abstract design. Transform the subject by simplifying, omitting unnecessary detail, changing proportion, contrast and color, and striving to produce a visual aesthetic based on the spirit of the subject's form and growth characteristics.

Materials: Drawing paper, pencil, pen and ink. Optional: mechanical drawing aids, colored felt-tipped markers.

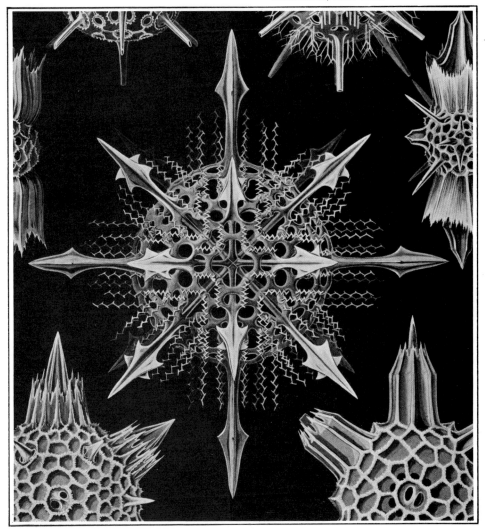

Inflorescence patterns. The diagram shows modes of budding and blooming observed in flowers.

2.11 Design from Nature: Branching Systems

Concept: Designs can be derived from inflorescence patterns (The mode of budding and blooming of flower clusters).

Other design sources for analyzing branching systems in nature can be found in the configurations of rivers and their tributaries, the human cardiovascular and nervous systems, trees, leaf patterns.

Key Synectic Trigger Mechanisms: Analogize, Simplify, Fragment, (Re)Combine

Studio Action: Research a branching system in nature. Make a series of analytical and stylized drawings based on your subject. The object of this exercise is not simply to replicate the shape of the subject, but instead to analyze and use its underlying system as a motif for a stylized pattern. Do this by simplifying, dividing and recombining certain aspects of the stimulus subject.

Enlarge and transfer the design to another surface (heavy watercolor paper, cardboard or canvasboard) in preparation for painting. Use a subjective color scheme: rather than the actual colors of the subject, paint your design with bright, primary colors to transform the subject and imbue it with a personal touch.

Materials: Pencil, drawing paper, color media such as tempera, watercolor, acrylics or colored pencils.

Joe Bonnardi, **Design Derived From Inflorescence Pattern,** 1986. Pen and ink on paper. Courtesy the artist.

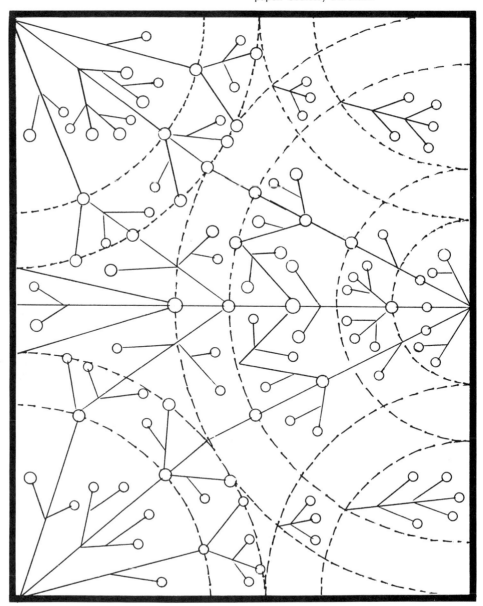

Design systems in nature. Micro photograph of cross-sectioned tilia (woody stem). Photograph courtesy Professor Edward Young, University of Calgary.

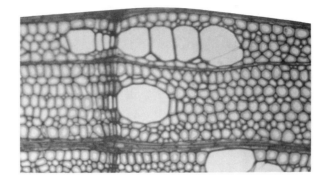

2.12 Design from Nature: Cluster Systems

Concept: Cluster systems are characterized by a configuration of closely-packed elements.

Key Synectic Trigger Mechanisms: Repeat, Superimpose, Combine

Studio Action: Check library sources for images of organisms in nature whose structural form is made up of closely-packed units. Some interesting examples can be found in Radiolaria and other marine protozoa. Analogize: Make a stylized drawing based on such a system. Abstract the stimulus image by applying Synectics and selected organizational principles such as variation, emphasis and balance to produce an aesthetically pleasing composition.

Materials: Dark colored art paper, colored pencils.

Follow-Up Studio Action (Collage fantasy cluster)

Added Synectic Trigger Mechanisms:
Fantasize, Contradict
 Collect a number of identical visual units from two different categories, such as photocopied images, magazine cutouts or three-dimensional items. Glue the units in a closely-packed manner to produce a unique and surreal design.

Cecilia Rojas, **Cluster Composition,** 1980. Collage. Courtesy the artist.

2.13 Counterchange Pattern

Concept: A counterchange pattern involves a planned correspondence and alternation between positive and negative shapes.

Key Synectic Trigger Mechanisms: Repeat, Superimpose, Combine

Studio Action: On tracing paper, make a group of line drawings based on scale variations of two different shapes. A geometric shape, for example, can be combined with a simplified outline drawing of a recognizable object. To achieve visual interest, be sure to vary the size of the various drawings. Superimpose the drawings and move them slightly to discover the best arrangement. As you work, pay particular attention to the organizational principles of *repetition, variety, transition, balance* and *emphasis* to create an interesting composition.

Trace the composite design to drawing paper and render it with pen and ink. Use a fine-tipped waterproof felt marker to make the lines, and a fine pointed sable brush with india ink to fill in a counterchange (based on a checkerboard) pattern.

Materials: Drawing paper, compass, straightedge, black felt-tipped pen, #3 pointed brush, india ink.

Follow-Up Studio Action (Counterchange in Color): Make an abstract design composed of superimposed geometric shapes. An interesting way to produce a composition is to draw many individual shapes on separate pieces of tracing paper, overlap them to form a unified design, and then make a tracing of the combined effect.

Assign colors according to a counterchange motif. Transfer the design to a gessoed canvas or panel and use acrylic colors to produce a painting that has a flat, non-spatial pattern and which emphasizes transparency.

Materials: Gessoed canvas or panel, acrylic colors, brushes.

Rob Chapman, **Counterchange Pattern,** 1983. Pen and ink. Courtesy the artist.

George Snyder, **Facet,** 1980. Acrylic on canvas, 55 × 55 " (139.7 × 139.7 cm). Courtesy the artist.

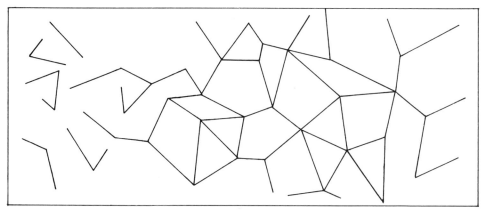

Variations on a crystal structure. The lines, shapes and planes in this design are abstracted from a crystal growth pattern.

Dorothy Schultz, **Meander Pattern.** Pen and ink. Courtesy the artist.

Ron Kostyniuk, **Relief Structure in Three Parts,** 1977. Polychrome wood, 45×135″ (114×342 cm). Courtesy the artist.

2.14 Design from Nature: Crystalline Pattern

Concept: Crystal grain molecules are inherently closely packed. Their structure reveals an interface, rather than a gap, between the molecules.

Key Synectic Trigger Mechanisms: Analogize, Combine, Transfer

Studio Action: Research the realm of crystal grain patterns. From selected images, produce analytical drawings to familiarize yourself with crystalline structure.

Next, make an analogical drawing: With pen and ink, produce a stylized drawing that depicts lines in the process of coalescing to form a crystalline pattern. Vary the size, transition and emphasis of the units to produce an interesting visual aesthetic. Extend the concept by adding imaginative color.

Follow-Up Studio Action (Wood mosaic)
Using pencil and paper, draw a stylized crystalline design. Trace the pattern onto a plank of softwood, cut out the components with a jigsaw and sandpaper the edges. Paint the units with bright acrylic colors and recombine them on a background panel. Glue the components onto the panel with carpenter's glue.

Materials: (1) Drawing paper, felt-tipped marker, colored pencils. (2) Softwood plank, plywood (or Crezone), jigsaw, sandpaper, acrylic gesso, acrylics, yellow glue.

2.15 Design from Nature: Meanders

Concept: Meanders are characterized by lines which take seemingly random or winding courses.

Key Synectic Trigger Mechanisms:
Analogize, Animate

Studio Action: Create a design based on a close-packed meander pattern. Start by drawing a line that serendipitously wanders, doubles back on itself and, in a circuitous manner, modulates pictorial space. Add more meanders; make a composition composed of multiple snaking lines; make some thick, thin, continuous and discontinuous. Analogize: mimic the meanders that can be seen in nature in such configuration as rivers, brain corals or the movement of snakes.

Follow-Up Studio Action (3-D):
Translate your concept to the production of a wall hanging or relief. Use either a fabric or rigid panel as the background. Then, according to your design, attach or weave various materials such as rope, yarn, string, etc. to it. Add some "surprise" elements for variety.

Materials: (1) Felt-tipped markers, drawing paper. (2) Fabric or plywood, white glue, yarn, rope, string, miscellaneous found materials or objects.

Meandering Line Composition. Student work, University of Calgary. Pen and ink.

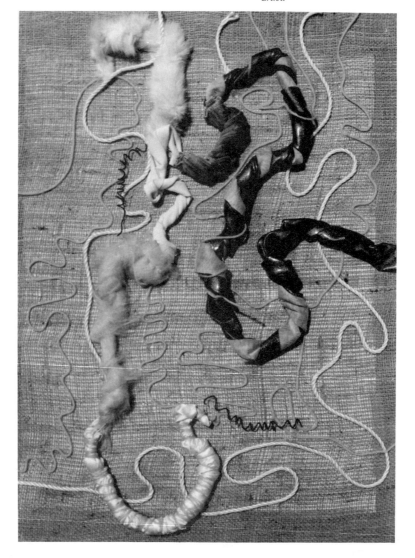

Dorothy Schultz, **Meander Pattern.** Mixed media, 24×36″ (61×91.4 cm). Courtesy the artist.

Kunio Yamanaka, **Return to a Square.**
Drawing. This computer drawing presents
concentric images of a square that pro-
gressively change into a human head, and
back again into a square.

2.16 Concentrics: Shapes from Shapes

Concept: The concept of growth is
related to concentric design.

Key Synectic Trigger Mechanisms:
Repeat, Metamorphose

Studio Action: Start a "growth" pat-
tern by first drawing a small
geometric or organic shape any-
where on a sheet of paper. Then,
draw a shape around it which
echoes the previous one, but is
slightly different. Continue the con-
centric progression, making your
design "metamorphose" into an en-
tirely different configuration as it pro-
gresses toward the outer edges of
the paper.

Materials: Drawing paper, pen and
ink.

2.17 More Concentrics: Mandala Motif

Concept: The Mandala motif can
be used as a symbolic device.
 Mandala patterns are usually
based on concentrically arranged
elements.

Key Synectic Trigger Mechanisms:
Repeat, Symbolize, Mythologize

Studio Action: Use the Mandala
motif to produce a symbolic "portrait."
Place an image of a person or an
object in the center space (the "bulls-
eye") of a series of concentric
shapes. Arrange referential images
around it. Repeat and vary the visual
units to create a unique visual pat-
tern. An additional aim is to mythol-
ogize: Tell something about your
subject by the choice and arrange-
ment of the images.

Materials: Drawing paper, pencil,
pen and ink. Optional: Collage,
photocopied images, glue.

Julie Merkowsky, **Mandala Portrait.** Pen
and ink, collage. Joe Weider, of body-
building fame, is the subject for this
mandala design.

2.18 Lattice Pattern

Concept: Lattice patterns are made up of a network of crossed or interwoven lines.

As research, study the interlace and lattice designs from Spanish, Arabic and Islamic ornamental art.

Key Synectic Trigger Mechanisms:
Simplify, Repeat, Combine

Studio Action: Work out a lattice design on isometric graph paper (paper gridded with both a horizontal/vertical and a diagonal matrix pattern). Develop the design first in pencil on a sheet of tracing paper taped over the graph paper. Use the underlying isometric lines as a guide to create an intricate pattern of interwoven lines. Finally, render the design in pen and ink and erase traces of pencil work.

Materials: Isometric graph paper, layout paper, pencil, black fine felt-tipped marker.

Lattice Design, pen and ink. Courtesy Dover Publications, New York.

2.19 Fantasy in One-Point Perspective

Concept: One-point perspective can be used to create a surreal environment.

Linear perspective is a graphic device that allows the artist to create the illusion of depth on a flat, two-dimensional surface.

The constituent elements of one-point perspective are: (1) The *horizon line*, (which is also the *eye level*), and (2) The *vanishing point,* an imaginary point on the horizon line where the perspective lines converge.

Key Synectic Trigger Mechanism: Fantasize

Studio Action: Use the principles of one-point perspective to create an imaginary picture of a room interior, a street scene or an outdoor setting. Within this setting, draw or collage disparate elements to produce a surreal effect. Start with pencil to make the preliminary sketch, then go over the pencil lines with pen and ink. Use a ruler or straight edge to establish the correct angles of the perspective lines.

Note: To draw a cube or a box in one-point perspective (which can be translated into a room or a building) start by first drawing a square or rectangle. Next, draw lines from the corners of the square to the vanishing point as shown in the diagram. This establishes the correct angles for the side planes and imparts the illusion of the third dimension.

Materials: Drawing paper, straight edge, pencil, pen and ink.

Diagram showing basic factors in one-point perspective drawing. Notice the single vanishing point, ninety degree angles in the frontal shapes, the converging lines which are extended to the vanishing point and the horizon line which is also the eye level.

Fantasy in one-point perspective: Saul Steinberg, **Manassas, VA, Main Street.** Graphite and colored pencil on paper, 28¾ × 22¾″ (73 × 57.8 cm). Courtesy The Pace Gallery, New York.

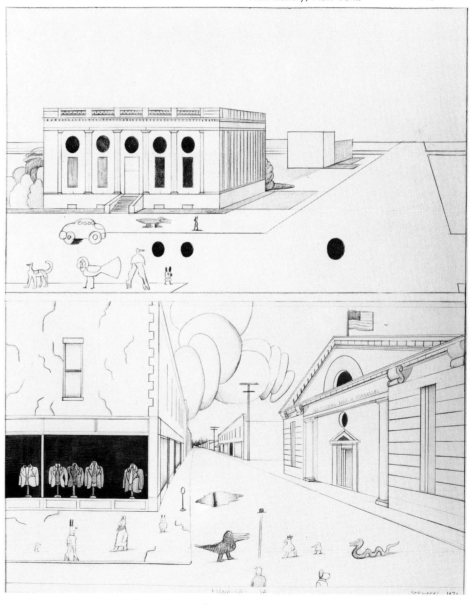

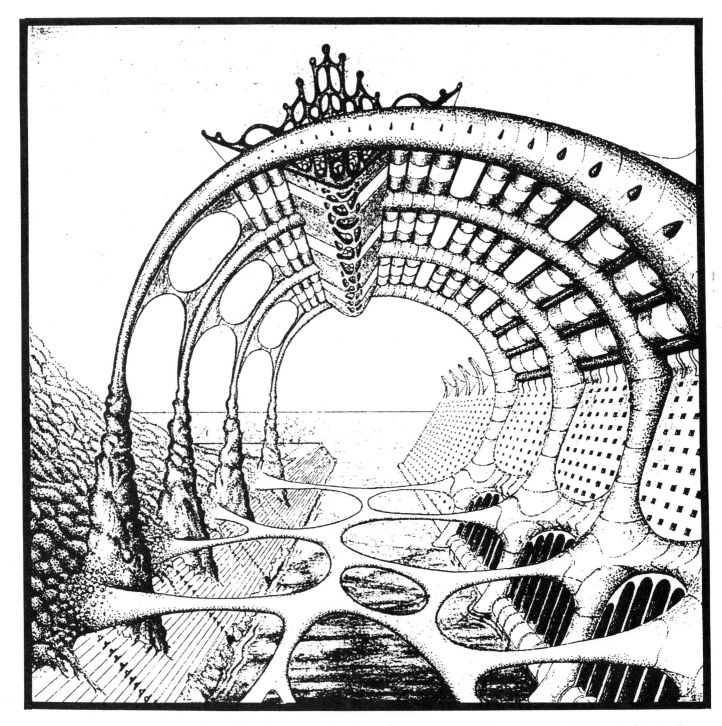

Franco Maria Ricci, **Fantasy Architecture,**
1983. Pencil and paper. (From the book
Codex Seraphinius, 1983). Courtesy
Abbeville Press, New York.

2.20 Fantasy in Two-Point Perspective

Concept: Two-point perspective can be used to draw surreal or fantastic objects.

The constituent elements of two-point perspective are: The horizon line (also the eye level), and two vanishing points located on the horizon line. To draw a cube in two-point perspective, one must think of the box turned "kitty-corner" to the viewer. Therefore, start by drawing the vertical line (which is the foremost edge) of the cube. Then draw lines to the two vanishing points to establish the correct angles of the side planes.

Key Synectic Trigger Mechanisms: Fantasize, Mythologize

Studio Action: Draw a picture which combines organic and inorganic shapes. As in dream imagery, create an irrational scenario.

Use two-point perspective drawing to delineate structure, along with freehand drawing and collage to visualize the concept.

Materials: Drawing paper, straightedge, colored pencils.

Diagram showing principles of two-point perspective drawing. Notice that the cubes are seen turned "kitty-corner" to the picture plane.

Curt Kaufman, **Untitled.** Prismacolor pencil on paper, 20 × 30" (50.8 × 76.2 cm). Courtesy the artist. Although the central cube in this surreal composition is drawn in two-point perspective, the artist used a third vanishing point as a reference for drawing the converging lines of the floor tiles.

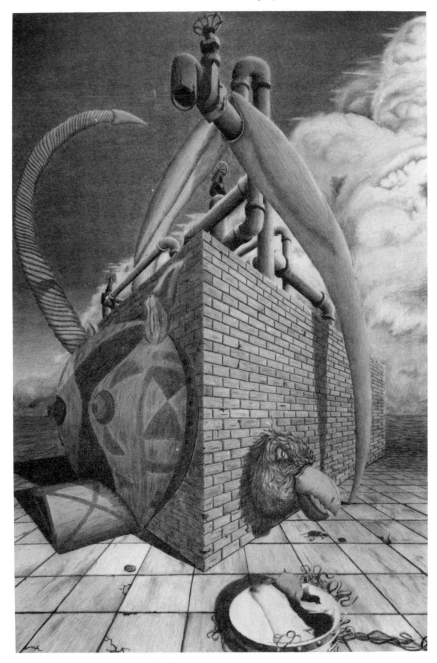

Isometric Graph Paper. Available in sheets or rolls (on either opaque or tracing paper). The graph paper is ruled with horizontal, vertical and diagonal lines and used as a substructure for making isometric perspective drawings.

Isometric Pattern. By placing a sheet of tracing paper over an isometric grid pattern, the artist can plan and render an interlocking architectural structure. (From *Isometric Perspective Designs*, by John Locke). Courtesy Dover Publications, Inc. New York.

2.21 Isometric Perspective

Concept: Isometric drawing is a graphic device used to create a three-dimensional illusion. Unlike linear perspective, the diagonal lines do not converge at a vanishing point. Instead, all lines are parallel and drawn at either 30 or 45 degrees.

Drawing an Isometric Cube: Start by taping a sheet of drafting vellum or tracing paper over isometric graph paper. The grid lines will show through to serve as a guide. Draw a vertical line to represent the foremost edge of the cube. The view of the cube is "kitty-corner" (in a diagonal position). The sides, top or bottom planes of the cube can then be drawn by tracing the corresponding diagonals from the underlying isometric grid.

Key Synectic Trigger Mechanisms: Repeat, Combine

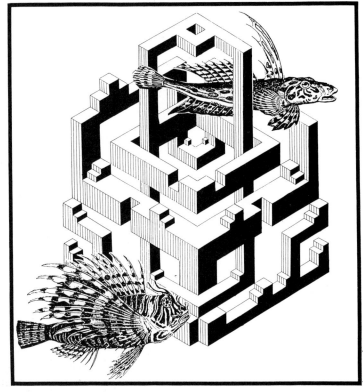

Leonard Bell, **Isometric Fantasy,** 1982. Pen and ink. Courtesy the artist.

Studio Action: Produce an isometric allover pattern: Tape tracing paper over a sheet of 30 degree isometric paper. While referring to the underlying lines, develop an allover pattern based on the repetition of a modular unit.

Follow-Up Studio Action: Combine isometric drawing with fantasy:

Make an isometric drawing that incorporates an anomalous subject—something that doesn't "belong," yet transforms the drawing into a potent image.

Materials: Isometric graph paper, tracing paper, straightedge, pencil, fine felt-tipped marker or pen and ink.

2.22 Endotopic and Exotopic

Concept: Paul Klee, who coined these terms, described *endotopic* as "forms treated from within," and exotopic, conversely, as "forms treated from without."

Key Synectic Trigger Mechanisms: Combine, Superimpose

Studio Action: Endotopic construction. Using soft wood strips, construct a cube or polyhedra. Modulate the interior area by gluing additional wood strips or other elements inside to develop an aesthetically pleasing structure.

Follow-Up Studio Action (3-D): Exotopic construction. Using soft wood, create a cube or polyhedra. Add elements only to the outside parts of the structure.

Follow-Up Studio Action (3-D: Combined endotopic exotopic construction. Using balsa wood strips, create a cube or polyhedra. Add elements to modulate both the inside and the outside area of the structure.

Materials: (1) Soft wood molding. (2) White glue (or hot glue gun).

Nicholas Roukes, **Endotopic and Exotopic Constructions,** 1987. Wood, 24×24×24″ (61×61×61 cm).

Gunther Haese, **Olymp,** 1967. Courtesy Solomon R. Guggenheim Museum, New York. Because the principal parts of this three-dimensional construction are contained inside an established spaceframe, the work can be classified as an endotopic structure.

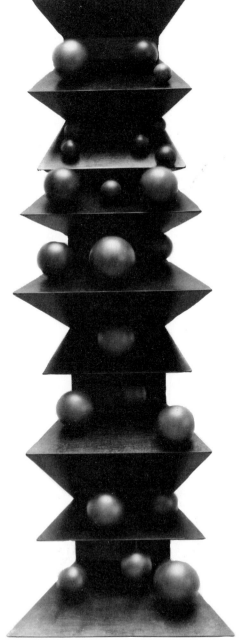

Paul Bury, **The Staircase,** 1965. Wood with motor, 78½″ (199.4 cm). Courtesy Solomon Guggenheim Museum, New York. An example of a three-dimensional art form which is exotopic. Note that principal components lie on the outside of its form.

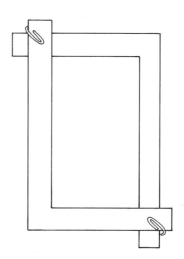

2.23 Design by Chance

Concept: Aleatoric (random) systems involve serendipitous or chance methods to produce designs.

Key Synectic Trigger Mechanism:
Combine

Studio Action: Cut and tear colored construction paper into various geometric and organic shapes. Without consciously controlling the placement, drop the shapes, one by one, onto a larger sheet of paper. Glue the pieces exactly where they fell. Repeat the procedure until all of the shapes are attached to the surface.

Next, with a viewfinder, search the collage for an aesthetically pleasing composition. (Make an adjustable viewfinder by cutting out two "L"-shaped pieces of cardboard and clipping them together as shown.)

Finally, replicate the collage composition in the form of a painting. Use tempera or acrylics on heavy paper or other gessoed surfaces such as canvas or wood panel. The objective is to match the shapes, colors, tones and textures of the collage as accurately as possible. Exhibit the two works on a common background.

Materials: Colored construction paper, glue, viewfinder, liquid tempera or acrylic colors, cardboard or prepared wood or canvas.

Design By Chance, from the design workshop, University of Calgary. Torn and cut paper collage.

DESIGN AND SIGNIFICATION

As long as there is life on earth, men will not cease to tell each other what they have experienced and communicate that part of their experience which has remained an inner possession.

—Herman Hesse

Pieter Bruegel, **Avarice,** 1558. Etching. Courtesy The Royal Albert Library, Brussels. From **The Seven Deadly Sins,** Bruegel presents a powerful image that satirizes man's greed and insatiable desire for wealth or gain.

Previous page:
Jasper Johns, **Target with Four Faces,** 1955. Encaustic on newspaper over canvas, surmounted by four tinted plaster faces in wood box with hinged front, 26×26″ (66×66 cm). Collection, The Museum of Modern Art, New York. Gift of Mr. and Mrs. Robert C. Scull. The synectic mechanisms *repeat, fragment* and *symbolize* are seen as contributing factors in the conceptualization of this image. Communicating through form and color, the artist seems to be saying that man now lives in an estranged society; although he is near others, he is yet alienated. In short, man appears to have made himself his own target.

Signification

The term *signification* denotes the expression or indication of meaning. It involves the use of devices by which thought is, or may be, communicated. In an art context, the artist signifies through such mechanisms as signs, symbols, analogy and metaphor.

Richard Newman, **Assassination Monument,**
1985. Mixed media sculpture, 58×51×5″
(147×129.5×12.7 cm). Courtesy the artist.

Signs and Symbols

Signs and symbols are simplified representations of human experience. They elicit consistent responses because of prior experience of the same stimuli. Signs, in the more general sense of the word, are *indicators* and can take the form of sounds, colors, words or events. A rustle in the woods, for example, may be interpreted as a sign of impending danger, a black cloud as a sign of a coming storm, smoke as a sign of fire, and so on. Aside from this classification, another category is *graphic signs,* which are symbolic representations created and used solely for visual communication. As words are signs of thought, so, too, are visual images signs of conception.

As a *conventional symbol,* a sign (signified graphically or by other means) is one that has grown out of, and is understood and accepted by, custom and usage.

Graphic Signs

A graphic sign is a surrogate mark used as an abbreviation for a known meaning; it is a figure presented technically instead of by the words it represents. Semanticist M. Wallis defines graphic signs as devices designed by an artist (the sender), directed to the spectator (the receiver), and, owing to their peculiar properties and context, able to evoke in the receiver a definite thought, image, notion or judgement about an object other than itself.

Graphic signs, therefore, are *visual notations,* symbolic systems made up of a set of marks, signs, figures or characters. Graphic signs are created specifically to convey complex information, ideas, feelings and emotions in simple, understandable terms. Every culture, social class and realm of human endeavor has its own special signs which can be described as notational systems of coded information.

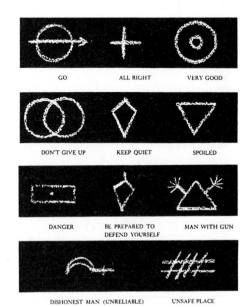

Hobo Signs, from **Symbol Source Book,** by Henry Dreyfus, 1972. Courtesy McGraw-Hill, New York.

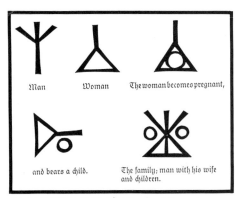

Ancient Signs, from *The Book of Signs,* by Rudolf Koch, 1955. Courtesy Dover Publications, New York.

Signs: Iconic and Conventional

An icon is an image or representation. *Iconic signs* are those which resemble the object they represent. For example, a realistic drawing or a photograph is an iconic sign.

Symbolic elements or objects, on the other hand, such as a signature, signet ring, monogram or birth certificate, are *conventional signs.* Symbolically, each of these in its own way identifies a person. Art images often lie somewhere between (or incorporate both) iconic and conventional signs.

Generally, symbolic visual images can be classified in one of two categories: photographs or schematizations. *Pictographs* are images that are imitations of reality; those which look exactly or much like the objects they represent. This category includes *abstract pictographs,* a subclassification which includes pictographic images which are stylized or simplified. *Schematizations* are configurations which symbolically represent the subject, such as conceptually related images, symbols, flow charts, diagrams, analogs, etc.

Iconography refers to representation by pictures and images; it is defined by Irwin Panofsky as that branch of art history which concerns itself with the subject matter, the *meaning,* in works of art, as opposed to their form.

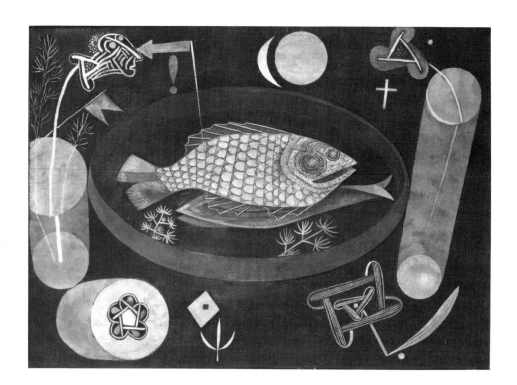

Paul Klee, **Around the Fish,** 1926. Oil on canvas, 18⅜ × 25⅛" (46.7 × 63.8 cm). Collection, The Museum of Modern Art, New York. Abby Aldrich Rockefeller Fund. In this picture, the artist depicts the cyclic process found in nature: the fish, nourished by plants, nourishes man. Man returns to plant to complete the life and death cycle. The image of the fish, a symbol of Christ, also alludes to a spiritual presence, further emphasized by the cross. Biological time is suggested by the image of the sun and the moon. The artist also includes diagrams of diatoms, the lowest entry in the evolutionary chain.

Albrecht Durer, **Melancholia,** 1514. Etching. The iconography in this design portrays five levels of world order: (1) The celestial world ruled by Saturn, the cause of all melancholy; (2) the elemental world of air, water, earth and fire, symbolized by the crucible; (3) the material world, represented by the polyhedron; (4) The living world, signified by the dog asleep under Saturn's influence; and (5) The intellectual world, represented by the figure of the woman. The ladder signifies access to the upper sphere of the world. Courtesy Dover Pictorial Archives.

Symbols

A symbol is something that conveys to the mind an image of something other than itself. Tom Chetwynd reminds us that through symbolism man is kept in direct contact with a light which shone two thousand years ago, millions of miles away. "Symbols have always been treasured as a means of releasing sources of energy from the unconscious," writes Chetwynd. "By gradually integrating conscious with unconscious content in the psyche, they affect the quality of your personal life, as well as bringing value and meaning to it."

Our dependence on symbols is extensive. Virtually our entire daily life pattern is spent going from one circle of symbols to another. Symbolist Felex Marti-Ibanez reminds us that even when the day comes to an end, and we cross the misty threshold of dreams, we enter another special world where *everything* is a symbol.

Tommy Simpson, **Climbing the Success Ladder,** 1976. Wood, wire, metal, 45×24″ (114.3×61 cm). Courtesy the artist. The artist selects a cage-like structure, combined with a step ladder, to satirically portray the plight of the ambitious business executive.

Metaphor

The metaphoric mind wanders through awareness, experiences, images, and all our tacit knowings like a gentle predator as it searches for meaning. If there are gaps in experience or knowledge, it hardly pauses but seeks an alternative route. If there is no valid alternative route, the metaphoric mind invents one. For that is what it does best . . . it invents.
— Bob Samples

Metaphor is the symbolic extension of analogy. As defined by Suzanne Langer, it is an idea expressed by language, which in turn functions as an expressive symbol. It does not analyze the idea it conveys; instead, it formulates a new concept for the imagination. Throughout history, artists have used metaphor to explore and define their heritage and identity, to tap sources such as myths, metaphysics and technology, as well as social, ethical, political and moral issues. The realms of dream, nostalgia, satire, humor and enigma have been, and continue to be, other catalysts of inspiration for the creative metaphorist.

By deciding on whether to use conventional or unconventional metaphors (or both), the artist controls the degree of accessibility to his art. Because mystery is an important factor in art, the artist may rightfully insist on providing his work with "a cloak of obscurity" (a term used by Magritte). To avoid specificity, the artist often uses personal metaphors. This is not to deny the viewer accessibility, but rather to allow for individual statement by the artist and to provide enigma and equivocality and encourage personal interpretation by the viewer.

All metaphoric procedures exploit the mutual psychological tensions between seemingly disparate entities. As Paul Éluard observes, "Les resemblances ne sont pas en rapport; Elles se heurtent." (Resemblances are not in agreement; they clash one against the other.)

The metaphoric mind, as Bob Samples points out, is found in the right half of the brain which governs our intuition, our emotions and our creative consciousness.

Semiotics

Semiotics deals with the general philosophical theory of signs and symbols and systems of signification. Semiology (the study of signs), according to Roland Barthes, aims to take in all systems of signs, whatever their substance and limits: e.g., images, gestures, musical sounds, objects, and the complex associations of all these, which form the content of languages, linguistics, ritual, convention or public entertainment. Barthes's conception of semiotic art is art that:

- does not pretend to mimic reality;
- thrives on the paradox of signification;
- signals its own artificiality;
- is understood to be contrived.
- creates its own "reality" by endowing artifice with an illusion of naturalness.
- remains vague enough in its "moral" to allow the consumer to recreate, through his own imagination, the details of the "myth" it embodies.
- produces psychological effects.

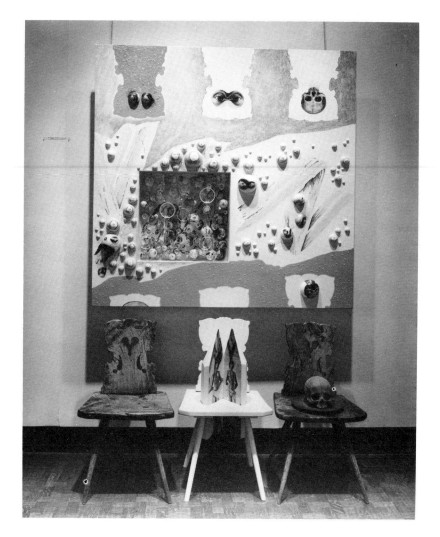

Mary Bauermeister, **Momento Mary on St. Sebastian from Boticelli,** 1970. Mixed media. Courtesy the artist.

Richard Notkin, **Cube Skull Teapot, (Variation 5),** 1984. Ceramic. Courtesy Garth Clark Gallery, New York/Los Angeles. A synectic fusion: the form of the work is inspired by ancient Chinese Yixing teapot design, yet the content reflects a serious contemporary issue. Critics have analogized this teapot image to *Mad* magazine's Alfred E. Neuman, whose "What, Me Worry?" complacency implies that there is plenty to worry about.

Schematic analog: The single dot in the center represents three million tons of explosive power, the total amount used in World War II. The other 5000 dots represent fifteen billion tons of explosive power, the total in U.S. and Soviet nuclear arsenals in 1984. The dots in the upper righthand corner box represent the explosive power (100 million tons) required to extinguish all human species and turn the earth into a dark, frozen planet. Courtesy The Trimtab Factor, Los Angeles.

Alex Grey, **Kissing,** 1983. 44×60″ (111.8×152.4 cm). Courtesy the artist. A bittersweet commentary: the prophesy of love and a lasting relationship doomed by nuclear fallout.

Leonard DeLonga, **Tree.** Wood, 42"
(106.7 cm) high. Courtesy Kraushaar
Galleries, New York. Photo by Geoffrey
Clements.

Analogy

An analog is a constructed simile between things which are unlike. Analogs can be either *symbolic* or *nonsymbolic.* Nonsymbolic analogs are direct comparisons of different things that in some way resemble each other (a ear of corn resembles a high rise building, for example, or, as a functional analogy, the camera is like the human eye). Symbolic analogies, on the other hand, are *metaphoric* in nature; the properties transferred to each object spark an insight to an idea.

A *visual analog* is an integrated graphic equivalent of something other than what it is. For the purpose of study and application to design Synectics, seven classifications of analogs are presented:

- Design Analogs
- Function Analogs
- Phenomena Analogs
- Sensory Analogs
- Empathy Analogs
- Symbolic Analogs
- Fantasy Analogs

The real achievement in discoveries is seeing an analogy where no one saw one before.
— Arthur Koestler

Everything is consistent in the analogical vision: each thing connects with each other thing, and all things cohere in a global motion which is creativity.
— Roger Cardinal

Design Analogs

Design analogs are nonsymbolic visual images or constructions which bear a direct similarity or reference to an object in terms of its form, structure or configuration. For example, a protozoa such as a Radiolaria or Trigolite may be analogized by the artist into a stylized or abstract design that may not look much like the stimulus, yet may still maintain some spirit of its dynamic structure in the aesthetic context.

Function Analogs

Function analogs are concepts which are derived from observation of how something works. In an art context, the working operation of an object or system is transferred to an aesthetic structure. For example, a jet aircraft can be analogized with a squid since both subjects move by "jet" propulsion.

Katsushika Hokusai, **The Great Wave,** 1823–31. Woodblock, Courtesy the Honolulu Academy of Arts, The James A. Michener Collection.

Phenomena Analogs

This type of visual analog is based on comparisons drawn from the realm of phenomena and movement. A graphic design or three-dimensional construction, for example, may be inspired by the analysis of forces observed in such things as a whirlpool, weather pattern, electrical forcefield, the movement of a person (as seen in Marcel Duchamp's *Nude Descending Staircase*), or by kinds of kinetic actions or events.

Sensory Analogs

Sensory analogs are visual equivalents based on perceptions by one or more of the five senses. For example, the famous painter Morris Graves painted the *sound* of a bird by using fine, convoluted lines—visual equivalents of sound. Likewise, one can create other graphic symbolic analogies based on touch, smell or taste. Cross-sensory representations are also called *synaesthetic analogs*.

Empathy Analogs

Empathy analogs are emotional surrogates. Personal feelings are projected to or elicited from a stimulus object or idea. The artist constructs a visual analog of that transfer. Marc Chagall, for example, depicted the "euphoria of love" by depicting young lovers as rubbery figures in a brightly colored, gravity-free environment. Remember, empathy analogs are based on psychological—that is, subjective rather than objective—resemblances.

Symbolic Analogs

Symbolic and metaphoric analogs spark an idea; they communicate a message other than what is presented to the eye. Here, the combination of disparate visual images is synergistic: the analogy evokes a mental conception. The well-known image of a dove bearing an olive branch signifies peace. A picture of an apple and a snake, although not an established symbol, may nonetheless signify temptation, recalling the story of Adam and Eve.

Fantasy Analogs

Fantasy analogs are surreal representations. Like dreams, they are related to experience, yet are transformed into eccentric, paradoxical, bizarre and irrational imagery. Fantasy analogs can conceal meaning, as do dreams, or present meaning in a highly ambiguous or equivocal manner.

Jackson Beardy, **Rebirth,** 1976. Photo courtesy Paula Beardy and The Office of Manitoba Cultural Resources.

3 / Design and Signification
STUDIO ACTION

3.1 Visual Onomatope

Concept: A schematic doodle can be used to analogize feelings and emotions.

Key Synectic Trigger Mechanisms: Empathize, Symbolize

Studio Action: Draw some schematic doodles which analogize the following:

- love
- peace
- distress
- sorrow
- persecution
- tenderness
- anxiety
- fear
- apathy
- birth
- idea
- death
- freedom
- constraint
- puzzlement
- *(add to the list)*

Materials: Drawing paper, pen and ink.

3.2 Synoptic Scribbles

Concept: Synoptic drawings are symbolic digests of thought or information.

Key Synectic Trigger Mechanisms: Simplify, Empathize, Symbolize

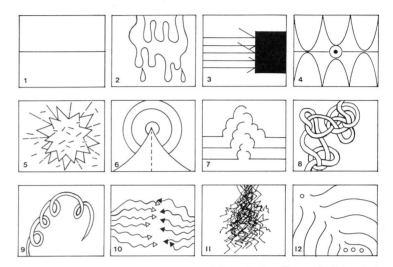

Schematic Doodles symbolizing feeling and emotions: (1) Peace, (2) Grief, (3) Resistance, (4) Constraint, (5) Power, (6) Direction, (7) Joy, (8) Confusion, (9) Failure, (10) Confrontation, (11) Pain, (12) Freedom.

Studio Action: Create some imaginative synoptic drawings based on the subjects listed below as well as from your own themes. Reduce each image down to a simple, yet thoughtful, scribble.

- Dancing at the Copacabana
- An introvert
- Snoopy person
- Music man
- Two people on a tandem bicycle
- Circus act
- A modern artist in action
- Spectacular dive off the high board
- A bad predicament
- Burned out
- Sports action
- Pumping iron
- Curious person
- Riding a strange beast
- *(add to the list)*

Materials: Drawing paper, felt-tipped markers.

James Beasley, **Dancing at the Copa.** Pen and ink. Courtesy the artist.

3.4 Words and Shapes

Concept: A "subjective portrait" can comprise only words and abstract shapes.

Key Synectic Trigger Mechanisms:
Symbolize, Combine

Studio Action: Create a portrait using only words and abstract shapes. Make the image subjective by the special configuration, combination and treatment of the visual components. Use selected words, prose or poetry to heighten the emotional impact and symbology. Design the words by hand lettering, printing, collage, transfer type or calligraphic writing with pen or brush.

Materials: Drawing paper, mixed media.

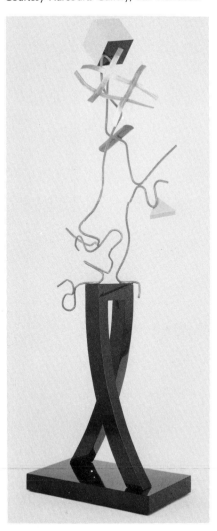

Ron Tatro, **Scribble Man,** 1986. Polychrome steel, 90 × 34 × 28″ (228.6 × 86.3 × 71 cm). Courtesy Harcourts Gallery, San Francisco.

3.3 Ideography

Concept: Ideography is the representation of ideas by graphic symbols.

Key Synectic Trigger Mechanisms:
Simplify, Transfer, Symbolize

Studio Action: Make a list of organic or inorganic subjects, processes, operations, phenomena, behavior, etc. Design an ideogram for each.

Materials: Drawing paper, pen and ink.

Graham Hunt, **Words and Shapes.** Collage and pen and ink. Courtesy the artist.

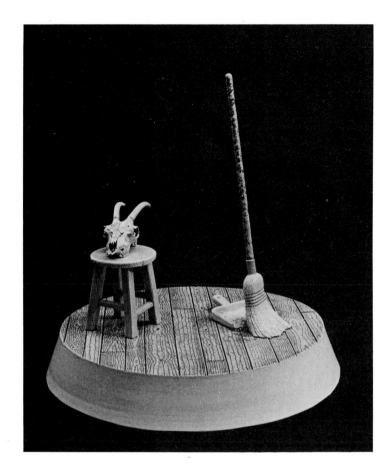

Richard T. Notkin, **Endangered Species #1,** 1978. Ceramic, 7¼" diameter (18.4 cm). Courtesy the artist and the Garth Clark Gallery, New York/Los Angeles.

3.5 Art and Issue

Concept: A social, ethical or moral issue can be visually signified.

Key Synectic Trigger Mechanisms: Empathize, Symbolize

Studio Action: Portray your views on a contemporary issue such as:

- proliferation of nuclear arms
- alcohol abuse
- drugs
- gun control
- endangered species
- capital punishment
- terrorism
- political intervention
- poverty
- moral, ethical issues
- pornography
- geriatric issues
- minority issues
- women's issues
- *(add to the list)*

Create a design in one or more panels which, without words, signifies your point of view and presents a potent image.

Materials: Drawing paper, art media of your choice.

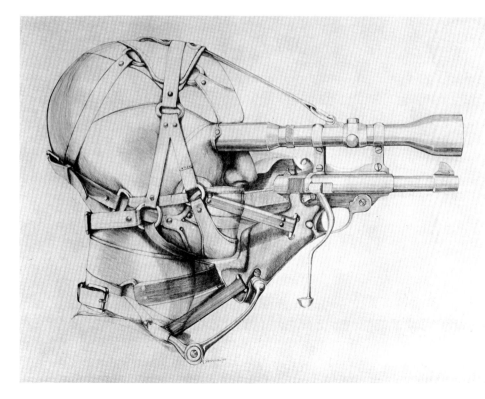

Nancy Grossman, **Gunhead #2,** 1973. Pencil drawing, 19×24" (48.2×61 cm). Courtesy Bonino Gallery, New York.

Coactive Images, student work from the author's Design Workshop, University of Calgary.

3.6 Coactive Images

Concept: Coactive images are made up of disparate elements which are synergistic.

Synergy, to paraphrase Buckminster Fuller, is a simultaneous action of separate agencies which, in combination, produce an effect greater than the sum of their individual actions.

Key Synectic Trigger Mechanisms:
Superimpose, Combine, Symbolize

Studio Action: Superimpose or otherwise combine two or more different images which, when combined, produce an emotional "spark." The emotional spark can signify an idea or metaphor, or simply create a mysterious and compelling image.

Materials: Magazine cut-outs, collage papers, glue.

To make images transparent: Coat magazine cut-outs with five coats of acrylic polymer medium, allowing the medium to dry between coats. Soak the lamination gently in lukewarm water to remove the paper backing. (The image will then be on a clear plastic film which can be subsequently superimposed and glued on another image). Another way to make images transparent is to photocopy them on clear acetate.

David Blackwood, **The Great Peace of Brian and Martin Winsor,** 1987. Lithographic print. Courtesy Masters Gallery, Calgary, Alberta.

3.7 Mythmaking

Concept: Although the term *myth* is traditionally defined as a "fictitious or false story," more contemporary definition denotes mythmaking as one's ability to generate any type of unique story—whether fictitious or not. Mythmaking, therefore, can serve as an outlet for visual narration and symbolic imagery.

Key Synectic Trigger Mechanisms: Analogize, Simplify, Transfer, Combine, Mythologize, Symbolize

Studio Action: Tell a story by using graphic images. Symbolize a true or imaginary happening or event. Simplify: include only five or six visual elements in your composition, but select and combine them carefully to make a potent conceptual and aesthetic statement. Maintain an element of mystery, however—don't overexplain the underlying message.

Materials: Drawing paper, pencil, ink wash.

Edward McCoy, **Lucky Day: Tuesday,** 1983.
Collage. 8×9″ (20.3×22.8 cm). Courtesy
the artist.

3.8 Astrological Portrait (Collage)

Concept: The signs of the Zodiac, in conjunction with other elements, can be used as a stimulus for creating a symbolic self-portrait.

Key Synectic Trigger Mechanisms: Analogize, Transfer, Symbolize

Studio Action: Obtain details regarding your horoscope. Transfer the information, by analogy into a group of visual symbols. Arrange images, designs, calligraphy, drawings, photos, etc. to make a collage composition.

Materials: Magazine cut-outs, photocopied images, typography, calligraphy, drawings, original photographs, memorabilia; drawing paper, glue.

Roger Selchow, **Sea Chanty,** 1981. Mixed media, $18 \times 17 \times 9\frac{1}{2}$″ ($45.7 \times 43 \times 24$ cm).

3.10 Dual Portrait

Concept: A double portrait can simultaneously signify two sides of a personality.

Key Synectic Trigger Mechanisms: Mythologize, Fantasize, Symbolize

Studio Action: Create a biographical portrait composed of two images which depict two contrasting sides of your personality: you, and your alter-ego (the "other" self). Let one face depict the "outside you," the one people see, and the other another "you", a secret personality or fantasy role model. Make the double portrait satirical, humorous or surreal. Some possibilities: combine your face with that of the Mona Lisa, or the face of a celebrity or a mythological hero or heretic. Or make two identical portraits but transform one of them by painting shapes and colors that signify a different psychological state.

Materials: Drawing paper; optional mixed media: drawing, collage, photography, photocopy and color media.

3.9 Subjective Signification (3-D)

Concept: A compartmentalized box can serve as a matrix for creating a three-dimensional "psychological portrait."

Key Synectic Trigger Mechanisms: Empathize, Symbolize

Studio Action: Collect memorabilia, sentimental objects, found materials and miscellaneous "junk" which, collectively, tells a story about you. Thoughtfully arrange the elements in the compartments of a box to produce an aesthetic, as well as a symbolic, statement.

Materials: Miscellaneous found objects, compartmentalized box, adhesive.

Dual Portrait, acrylic on paper. Student work, University of Calgary.

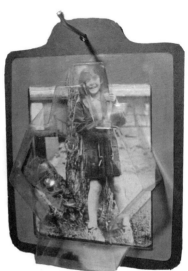

Jein Walden, **Packaged Identities,** 1983. Courtesy the artist.

Package a "myth" or an element of humanity that you think has been commercialized. Collect images and objects that signify the concept and seal them inside a clear plastic container. Mimic the methods of commerce and advertising. Staple cardboard to the package and indicate contents, price, etc. Display the package alongside others on a pegged masonite panel.

Materials: Found objects, collage, polyethylene plastic, mixed media.

3.11 Identity in Packages

Concept: The concept of "commercial packaging" can be used to symbolize and parody human affairs.

Key Synectic Trigger Mechanisms: Transfer, Parody, Symbolize

Studio Action: Consider and react to the following: Today, everything is neatly commercially packaged, including human emotions and personalities.

3.12 Duality in 3-D

Concept: A double-sided sculpture can signify an idea or emotion.

Key Synectic Trigger Mechanisms: Mythologize, Symbolize

Studio Action: Create a sculpture with two sides, each of which presents a different image. Make the sculpture symbolic or cryptic, but try to invoke a psychological tension between the two disparate images.

Materials: Pottery clay or papier-mâché, acrylic colors.

Jack Earl, **Where I Used To Live in Genoa, Ohio,** 1973. Porcelain, china paint, glaze, 5½ × 4¾" (14 × 12 cm). Courtesy Mrs. Karen Johnson Boyd. Both front and rear views are shown in this double-sided ceramic sculpture.

3.13 Signifying Emotion (3-D)

Concept: A 3-dimensional figurative image can be made to symbolize an emotion.

Key Synectic Trigger Mechanisms: Empathize, Symbolize

Studio Action: Make a three-dimensional figure that echoes a strong emotion such as:

- fear
- ecstasy
- anger
- confusion
- persecution
- *(add to the list)*

Create a stick figure out of wire. Drill holes in a wood base to support it, then build up the form with papier-mâché or cloth strips dipped in plaster and wound around the wire armature. Exaggerate gesture and facial expression to signify a particular mood or emotion. Add accessories and paint with bizarre colors that heighten the subjective effect.

Materials: Wire, papier-mâché (or plaster), wood, liquid tempera or acrylic colors.

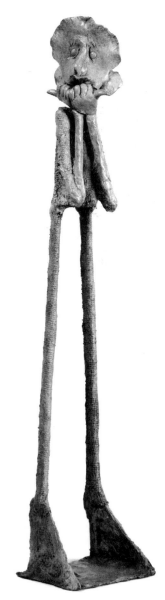

William King, **Phobia,** 1980. Bronze, 24″ (61 cm) high. Courtesy Terry Dintenfass Inc., New York.

Jens Morrison, **Casa de Tononzintla,** 1986. Ceramic, 22×16×19″ (55.8×40.6×48.3 cm). Courtesy Quint Gallery, San Diego.

Jein Waldin, **My Fantasy,** 1983. Drawing and mixed media. Courtesy the artist.

3.14 Iconic Dwelling

Concept: The image of a "dwelling" can have mythic or symbolic overtones.

A dwelling can be a sanctuary, a private place, a temple wherein no one is allowed save the "high priest" or a special personage. It can be a mythic place of refuge, protection or safety; a place immune from ordinary operations in society. It can be a "joke" or a satirical analogical reference to the human condition.

Key Synectic Trigger Mechanisms: Analogize, Fantasize, Mythologize

Studio Action: Design a small surrealistic dwelling or house that is imbued with myth and fantasy.

Materials: Optional mixed media or clay and glaze or acrylic colors.

3.15 Dream Fantasy: Idiosyncratic Representation

Concept: Surreal drawings are controlled visual fantasies.

Key Synectic Trigger Mechanisms: Fantasize, Mythologize

Studio Action: Create a dream analog, a visual equivalent of a dream fantasy. Picture yourself, along with a mythological character or creature, in a strange and surreal environment.

Materials: Drawing paper, photographs or photocopied images; drawings; optional color media.

3.16 Private Symbols

Concept: Graphic images can have private, personal meaning.

Key Synectic Trigger Mechanisms: Combine, Transfer, Mythologize, Symbolize

Studio Action: Paint a picture that is a personal diary of events. Transfer emotions, feelings and experience to visual images. Deny access of your picture to others by using graphic signs and images which have significance only to you.

Materials: Paper or canvas, tempera, acrylics or optional art media.

If art mirrors the world, the mirror is magical; it changes the world.
— Octavio Paz

Diane Schultz, **If You Live Fast,** 1986. Acrylic and oil stick on canvas, 6×4′ (182.8×122 cm). Courtesy deSaisset Museum, Santa Clara, California. Psychological tension is generated through the use of constricted space, distorted perspective and private symbols. Through these formal devices the artist explores the personal fears, confronted daily, consciously and subconsciously, by all people.

Surreal signs.

3.17 Surreal Signs

Concept: Graphic signs can be used as a creative stimulus.

Key Synectic Trigger Mechanisms: Parody, Analogize, Contradict, Recombine

Studio Action: Refer to standard graphic signs and apply your imagination to transform them into comic or bizarre images.

Materials: Images of graphic signs, drawing paper, felt-tipped pens, colored pencils or markers.

3.18 Wacky Monuments (3-D)

Concept: A monument can be an eccentric memorial.

Key Synectic Trigger Mechanisms: Parody, Fantasize, Symbolize

Studio Action: Use mixed media to create a bizarre monument. Possible themes: (1) An ode to an extinct or endangered species; (2) A mythological hero; (3) A problem of modern living.

Materials: Mixed media: Three-dimensional materials, found objects, drawings, photographic images, acrylic color.

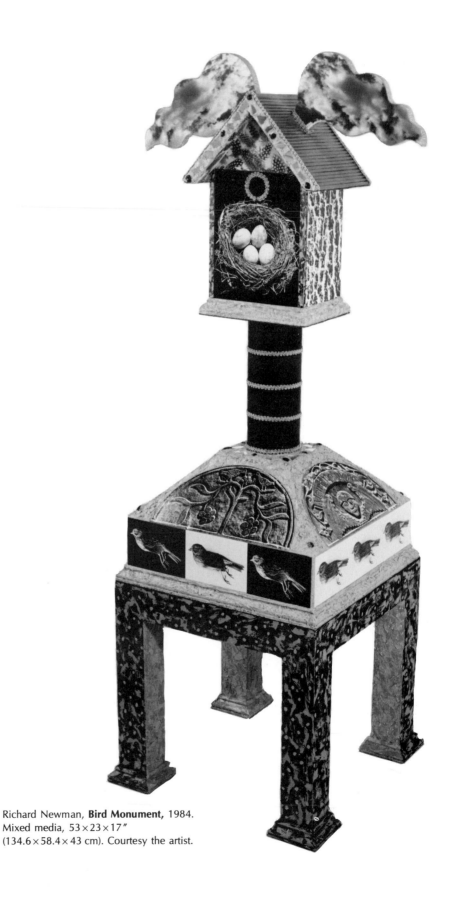

Richard Newman, **Bird Monument,** 1984.
Mixed media, $53 \times 23 \times 17''$
($134.6 \times 58.4 \times 43$ cm). Courtesy the artist.

3.19 Déjà Vu: Reconstructing an Old Myth (3-D)

Concept: A old myth can serve as a stimulus for a new and original work.

Key Synectic Trigger Mechanisms: Analogize, Fantasize, Recombine, Symbolize

Studio Action: Paraphrase an old myth. Change it, update it, give it a new setting, new characters and new meaning. Use mixed media such as wood, metal, fabric and found materials to realize your concept.

Materials: Optional three-dimensional materials.

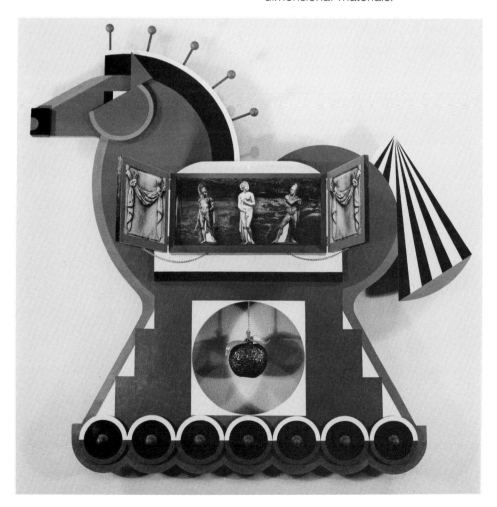

Richard Newman, **Trojan Horse,** 1981. Mixed media, 49×48×7″ (124.5×122×17.8 cm). Courtesy the artist.

Pat Steir, **Line Lima,** 1973. Oil and pencil on canvas, 84×84″ (213.3×213.3 cm). Courtesy the artist.

I got interested in quotation . . . I wanted to include signs that would indicate the origin of the image I wanted my paintings to have or be about.

—Pat Steir

3.20 Analogical Thinking Made Visible

Concept: A subject and its associations can be visualized and presented together.

Analogical Think Mode: "When I hold a mirror to *this*, I see *that*".

Key Synectic Trigger Mechanisms: Analogize, Combine, Symbolize, Fantasize

Studio Action: Using a fruit or vegetable as a stimulus subject, first make an accurate drawing of the subject in one section of your drawing paper. Next, imagine and draw certain physical and psychological associations inspired by the contemplation of the object. Analyze, abstract and depict the associations by making additional drawings and schematizations on the paper.

Materials: Drawing paper, colored pencils, watercolors or liquid tempera.

3.21 Function Analog

Concept: Many inventions come about as a result of analogizing the way something works.

Key Synectic Trigger Mechanisms: Analogize, Transfer, Fantasize

Studio Action: Analyze the way something from industry or nature works. Design an art form which analogizes or mimics that function.

For example, an art form may be based on the operation of a clock, as seen in the mechanized bas-relief by Phillip Johnson.

Materials: Art media of your choice.

A bird is an instrument working according to mathematical law, which instrument it is within the capacity of man to reproduce with all its movements.
—Leonardo Da Vinci

Philip Johnson, **Untitled,** 1986. Mechanized mixed media, 30×20×4″ (76.2×50.8×10 cm). Courtesy Marian Locks Gallery, Philadelphia.

Charles Burchfield, **The East Wind,** 1918. Watercolor, 17½ × 21½ " (44.5 × 54.6 cm). Courtesy Albright-Knox Art Gallery, Buffalo, New York. This painting is a sensory analog insofar as it translates the effect of a cold winter's wind—a physiologically perceived phenomenon—into a visual perception.

We can never understand a picture unless we grasp the ways in which it shows what cannot be seen.
—W.J.T. Mitchell

3.22 Sensory Analog

Concept: A sensory analog is a visual simile which refers to a sensory perception.

Key Synectic Trigger Mechanisms: Analogize, Fantasize, Symbolize, Transfer

Studio Action: Stimulate your senses with jazz, rock or classical music; reminisce about the sensory pleasure provided by the sounds, smells and visual sensations of a special holiday; imagine the midday heat as you trek through a barren prairie; feel the touch of a loved one or the sensation of hang gliding. Using imagined or actual experience, create an abstract visual analog which signifies a sensory perception.

Materials: Art paper or canvas, liquid tempera, gouache or acrylics.

Paul Jenkins, **Phenomena Spectrum Dial,**
1976. Acrylic on canvas, 77×84″
(195.6×213.4 cm). Courtesy Martha Jackson
Gallery, New York.

COLOR GALLERY

He who wants to become master of color must see, feel, and experience each individual color in its many endless combinations with all other colors.
—Johannes Itten

Synectic color harmonies. Harmonious color combinations can be created by combining disparate hues such as: 1) complementary pairs (colors opposite each other on the color wheel); 2) triads (whose hues form equilateral or isosceles triangles on the color wheel; and 3) tetrads (four-color combinations whose colors form squares or rectangles on the color wheel).

Color and Synectics

The twelve-part color wheel is evolved by mixing three different colors—red, yellow and blue. These hues lie equidistantly apart from each other on the color wheel. by mixing these basic colors, the secondary and tertiary hues are derived to complete the color circle.

The great Bauhaus teacher Johannes Itten noted that a color is never perceived by itself, but always with its complementary hue (the color which lies directly opposite on the color wheel). One can notice this psycho-psychological phenomenon in afterimage experiments. For example, by focusing attention on a red color for several minutes, then shifting your gaze to a white or gray surface, a muted complementary hue—green—will be perceived. This muted hue will also modify any color gazed upon next. A yellow patch, for example, modified by the psychologically projected green afterimage hue, will appear yellowgreen.

Because complementary contrast is a fundamental characteristic in human perception, we have a psychological "thirst" for complementary hues. The great colorist Goethe once said, "complementary colors *demand* each other."

Synectic Color Contrasts

Polar contrasts between colors tend to produce the most dramatic effects.

Johannes Itten noted these contrasts in his book *The Art of Color* and labeled them "the seven color contrasts:"

Contrast of Hue. Undiluted contrasts of primary colors—red, yellow, blue—produce the most intense luminosity. Weaker contrasts are produced by juxtaposing primary colors with secondaries and tertiaries or by juxtaposing high-key colors (colors tinted with white) or low-key colors (colors dulled with black).

Value Contrast. This refers to contrasts between white, grays and black or contrasts between pure, fully saturated colors and achromatic (or grayed) colors.

Cold-Warm Contrast. Effective contrasts are made by choreographing differences between the visual "temperature" of colors. Red-orange represents the "hottest" color, and blue-green the "coldest".

Complementary Contrast. This refers to the use of colors which are polar opposites; they lie directly across from each other on the color wheel. For example, yellow/violet, blue/orange, and red/green are polar opposites.

Simultaneous Contrast. A reference to effect of one hue upon another. The rule of simultaneous contrast postulates that whenever two different colors are juxtaposed, the contrast between them intensifies the difference between them. Blue, for example, appears brightest when seen against its complement, orange; yellow appears brightest when seen next to violet, etc. Simultaneous contrast results from the fact that the eye will produce afterimage complements which affect color perception. A gray patch, for example, on a yellow background will appear purplish because the eye will produce the complement of yellow (violet) to optically mix with the gray.

Contrast of Saturation. This refers to contrasts of brightness, or the purity of colors set against those which have been dulled or desaturated. A color can be diluted and desaturated by adding white, black, the complementary hue, or gray.

Contrast of Extension. Contrast of extension deals with the differences of size and area in a color composition. Contrasting color shapes can be made to appear psychologically balanced or imbalanced, depending upon the aims of the artist. For the purpose of achieving psychological balance between color areas, Goethe assigned light values to each color as follows: yellow: 9; orange:8; red:6: violet: 3; blue: 4; green: 6. Accordingly, to achieve a "psychological balance", say in a composition having yellow and violet, one would consider the numerical ratio of 9:3. Accordingly, one would make the quantity of yellow three times as big as that of the violet.

Not only does one complementary color demand its opposite, but the eye spontaneously seeks out and connects complementary colors.

—Calvin Harlan

It is inevitable that colors and forms exert an effect on each other. Some colors are accentuated in their value by forms and dulled by others.

—Karl Gerstner

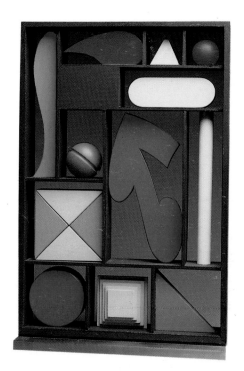

Lucio Del Pezzo, **Box.** Multiple in colored wood, 21 × 13¾ × 3" (54 × 35 × 7.5 cm). Courtesy Studio Marconi, Milan.

Color Chording

Color chording refers to the sequential occurrence of color in a design. The hues can be either analagous color progressions (colors which progress from one adjacent hue to another on the color wheel (e.g., blue, blue-green, green, etc.) or color shapes which progress in terms of value shifts (a change from light to dark or by variations in intensity.) Color "leaps" within a composition of color chord progressions can supply contrasting accents and visual excitement.

Discordant Color

Clashing colors are based on color combinations which are not complementary. It is important to note that discordant color combinations are not to be avoided. Exciting, eye-catching effects can be created by arranging colors which are not complementary hues. For example, some discordant yet unusual effects can be created by combining a primary and a tertiary which lies beyond an adjacent secondary, e.g., red and blue-violet.; a secondary and a tertiary which lies beyond an adjacent primary, e.g., orange and yellow-green; or by combining two tertiaries which lie on either side of a primary, e.g., blue-green and blue-violet. When the value of the discordant hues is similar, the clashing effect is stronger.

Ted Kerzie, **City Life,** 1987. Acrylic on canvas, 5×7′ (152.4×213 cm). Courtesy the artist. The artist first painted areas of background color. He then applied perforated strips (punch-outs) of self-stick tape to act as a stencil for subsequent applications of color, which were painted inside the perforations. The strips were then removed to reveal a rich galaxy of multi-hued dots.

Richard Anuszkiewics, **Division of Intensity,** 1964. Acrylic on panel, 48×48″ (121.9×121.9 cm). Courtesy Martha Jackson Gallery, New York.

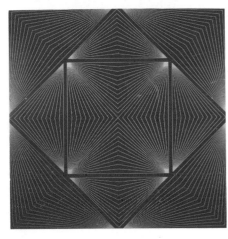

Richard Pousette-Dart, **Ramapo Web,** 1986.
Acrylic and mixed media on canvas,
39×80″ (99×203.2 cm). Courtesy Marisa
Del Ray Gallery, New York.

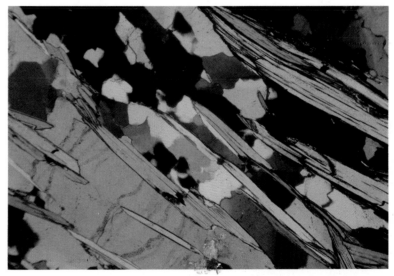

Jun Resultay, **Metamorphic crystals (garnet
mica schist).** Photograph (34×, with
polarized light). Courtesy the photographer.

Ron Kostyniuk, **Relief Structure (Three
parts),** 1976. 45×135″ (114×342.9 cm).
Enamel on wood and acrylic plastic.
Courtesy the artist. Using nature as a
creative source, the artist derived the design
for this triptych from crystalline formations.

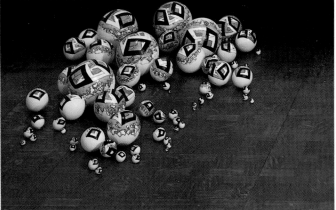

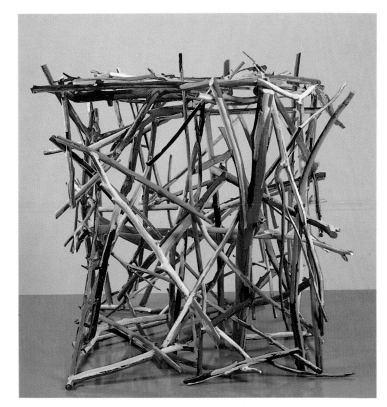

Charles Arnoldi, **Small Sculpture,** 1981.
Acrylic paint and branches, $26 \times 26 \times 30''$
$(66 \times 66 \times 76$ cm). Courtesy
Hansen/Fuller/Goldeen Gallery, San
Francisco.

Mary Bauermeister, **Put-Out.** Acrylic paint
and mixed media. Courtesy the artist. This
design literally pops out of the picture as it
progresses from a two to a three-
dimensional image.

George Snyder, **Twenty-eight Days in April.**
Acrylic on canvas, 64×64″
(162.6×162.6 cm). Courtesy the artist.

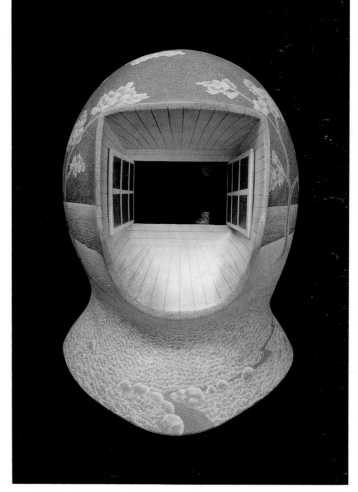

Don Proch, **Delta Night Mask,** 1984. Silver
point and graphite on fibreglass. 26″
(66 cm) high. Collection Norman Macken-
zie Gallery, Regina, Saskatchewan.
Photograph courtesy the artist.

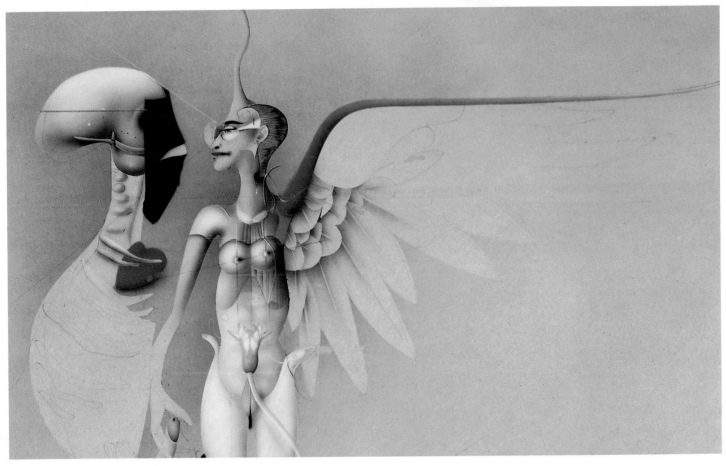

Paul Wunderlich, **Sphinx and Death** (detail),
1983. Acrylic airbrushed on canvas,
47¼×35″ (120×90 cm). Courtesy the artist.

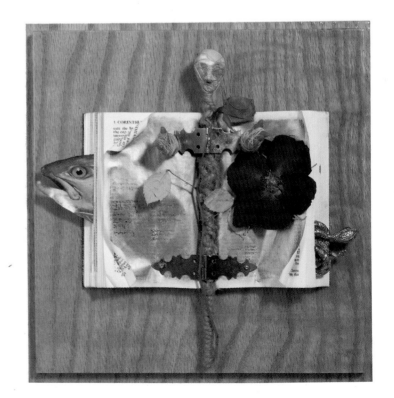

Sandra Jackman, **A Fact of Life.** Book
assemblage, 9×6×9¾″
(22.8×15.2×24.8 cm). Courtesy the artist.

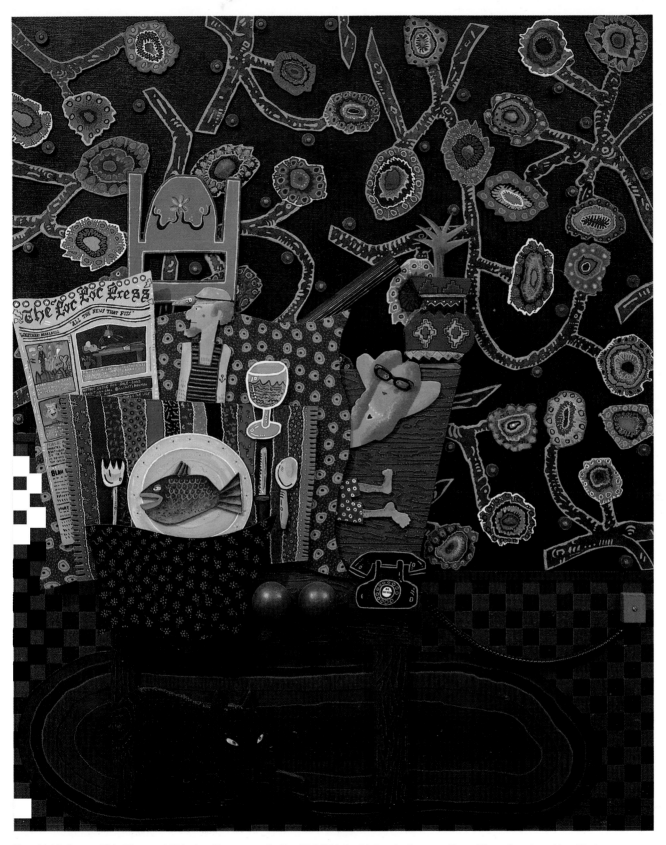

Ronald Markman, **Fish Dinner,** 1981. Acrylic on wood, 48 × 38" (121.9 × 96.5 cm). Courtesy Terry Dintenfass, Inc., New York.

Mary Bauermeister, **Pain-Ting,** 1970. Acrylic and mixed media on canvas. Courtesy the artist.

Pedro Friederberg, **One-Point Perspective Fantasy,** 1980. Acrylic on paper. Courtesy the artist.

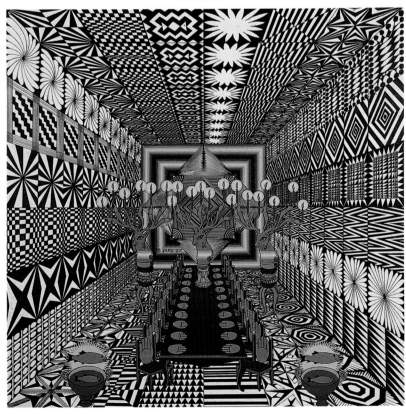

Sidney Gordin, **Untitled.** Acrylic on wood,
4′ × 4′ × 3″ (1.2 × 1.2 × .9 m). Courtesy
Gallery Paule Anglim, San Francisco. A
jigsaw was used to cut out shapes of soft
lumber which were subsequently painted in
acrylic and glued to a plywood background.

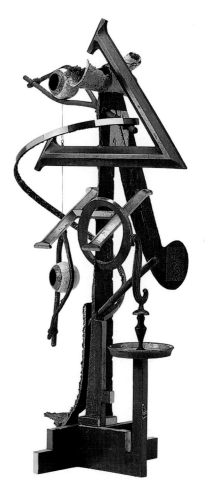

Robert Hudson, **Letter Head,** 1985.
Polychrome bronze, 34½ × 18 × 22″
(87.6 × 45.7 × 55.9 cm). Courtesy Allan
Frumkin Gallery, New York.

Frank Stella, **Lac Laronge III,** 1968. Fluorescent acrylic on canvas, 96×144″ (243.8×365.8 cm). Courtesy Leo Castelli Gallery, New York. Contrasting colors and opposing elements are combined in this painting to produce a unified composition.

Hassel Smith, **Untitled,** 1977. Acrylic on canvas, 68×68″ (172.7×172.7 cm). Courtesy Gallery Paule Anglim, San Francisco.

Harry Koursaros, **First Olympiad,** 1983.
Acrylic on canvas, 33×72″
(83.8×182.9 cm). Courtesy Haber Theodore
Gallery, New York. An underlying grid is
used as a pictorial device to unify the
diverse elements in the composition. In this
synectic design, bold shapes and bright
complementary colors work in counterpoint
to the opposing delicate contour lines,
scratched through the subsurfaces of color
in a graffito technique.

Victor Vasarely, **Hat IV,** 1972. Acrylic on
canvas, 36½ × 31½″ (92.7×80 cm).
Courtesy Denise René Gallery, Paris. This
visually kinetic painting is an optical illu-
sion. Notice how the cubes, drawn in
isometric perspective, seem to "flip" and
reverse themselves.

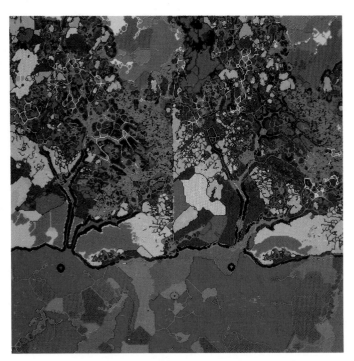
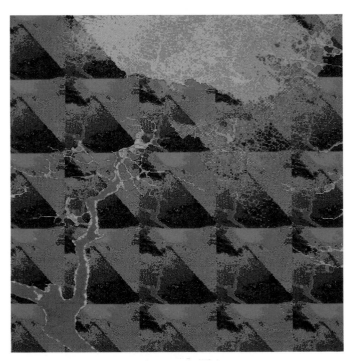

Gerald Hushlak, **Heraclitus' Dendro in Six Progressions,** 1987. Applicon ink jet plot from image processing software, 22×22″ (55.9×55.9 cm). Courtesy the artist. These computer-generated images are transformations of a black and white photograph. The photograph of a landscape and tree was digitally scanned into a central processing unit (C.P.U.), then manipulated on a Komtron image processing unit, followed by pseudo-color mapping pixilated on a D.E.C. Vax. The final output was raster-plotted on an Applicon ink jet plotter.

Ed Duin, **Ymim-602,** 1986. Light sculpture. (The first photo is an exterior view; the other three photos are close-ups of the same sculpture at different times.) Acrylic, lights, optical materials, mechanisms, $17 \times 16 \times 16''$ ($43.2 \times 40.6 \times 40.6$ cm). Courtesy the artist. Light, time and movement is beautifully orchestrated in this kinetic sculpture. Duin: "I found that when sheets of these special polarizers were used in combination, the result was spectral color effects like fire. Polaroid developed the material to eliminate color; it was useful for me because when used backward it created vibrant colors."

Richard Paul Lohse, **Thirty Vertical Systems,** 1970. 65×65″ (165×165 cm). Courtesy the artist. The color chording in this painting is a progression of analgous hues, warm/cold color contrast and contrast of complementary hues.

The giant bird is the mind from which all consciousness emerges. It is the generative essence.

— Tom Chetwynd

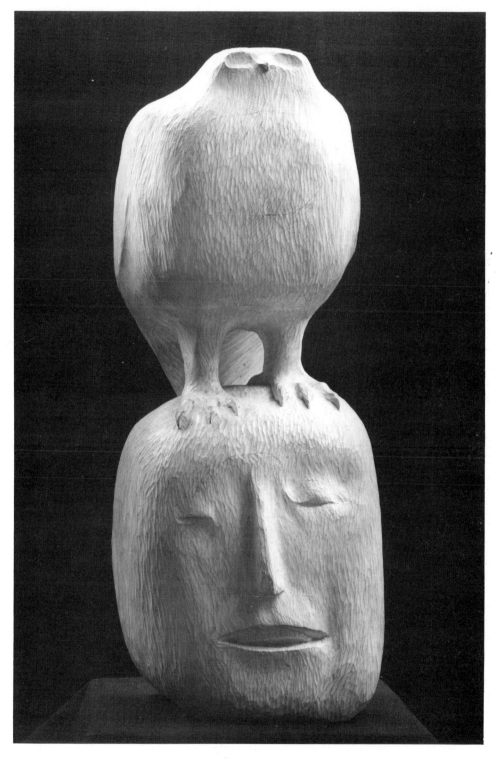

Leonard Baskin, **Oppressed Man,** 1960. Painted wood, 31" (78.7 cm) high. Courtesy Whitney Museum of American Art, New York.

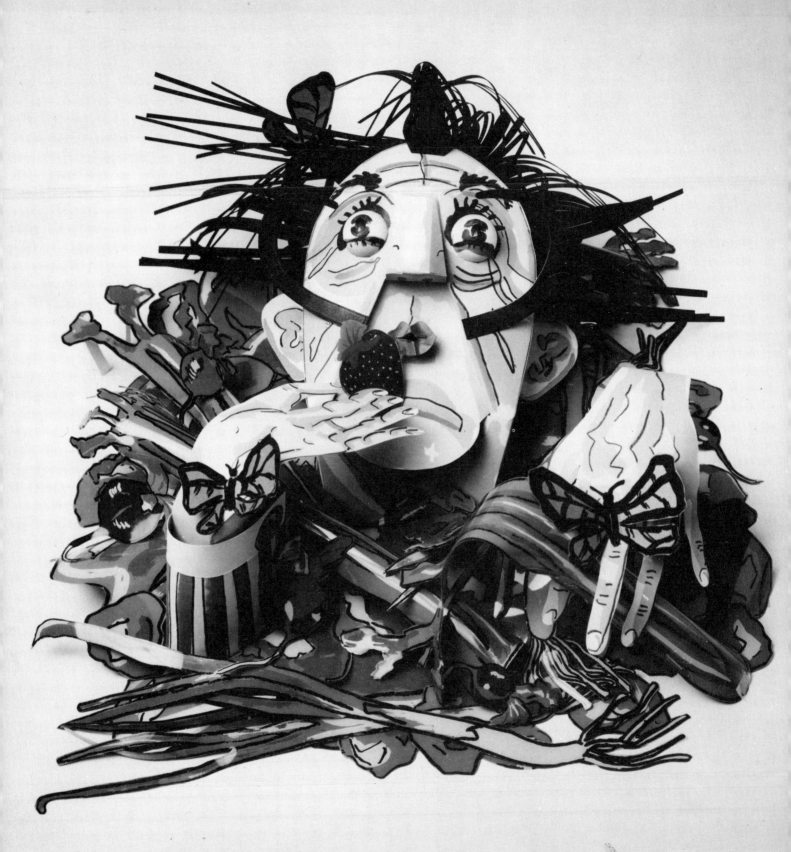

Paradox, Humor
and Prevarication

Robert Hudson, **Posing the Question,** 1984–85. Polychrome steel, 96×95×51″ (243.8×241.3×129.5 cm). Courtesy Whitney Museum of American Art, New York.

The Paradox of Art

All art forms contain more than meets the eye. Besides objective facts, art forms initiate and convey subjective information. Each person's interpretation of a given work of art, therefore, will be different, activated by the special intellectual and emotional qualities which are projected to the work.

The creative artist often deliberately cloaks his art with mystery and enigma, further inducing independent rather than universal interpretation.

Critic Edward Lucie-Smith notes that one of the distinguishing characteristics of a true work of art is its ability to both contain and express different meanings—meanings which may in fact contradict one another. "A fruitful ambiguity," he writes, "is in fact one of the great strengths of the art of the past decade."

Charles Caleb Colton observed, "Man is an embodied paradox, a bundle of contradictions." Because art is a man-made product, it too can reflect the mysterious and paradoxical qualities of humanity.

We need not shy away from, nor fear, the mystic. Mystery, according to psychologists, provides an important stimulus for creative thinking. Stéphane Mallarmé wrote, "There must always be enigma in poetry." Obscurity is an essential component of true poetry; the ambiguous co-existence of contrasting motifs, moods, and ideas. It can rightfully be said that the origin of art truly lies in the human longing for enigma.

The word *paradox,* literally defined, means *beyond belief,* something which appears anomalous or self-contradictory. Paradoxical images such as the *necker cube* (the skeleton cube), for example, are perceptual flip-flop figures. Such types of optical illusion figures send confusing messages to the brain, which in turn produces an equivocal perception. Likewise, on the conceptual level, apprehending disparate images creates psychological tension which may provoke either a metaphoric or equivocal (or multi-layered) interpretation. Examples of visual paradox can be found in optical illusions, Op art, camouflage, idiosyncratic art and surrealism.

Previous page:
Red Grooms, **Dali Salad,** 1980–81. Mixed media, 26½×27½×12½″ (67.3×69.9×31.8 cm). Courtesy Brooke Alexander Gallery, New York.

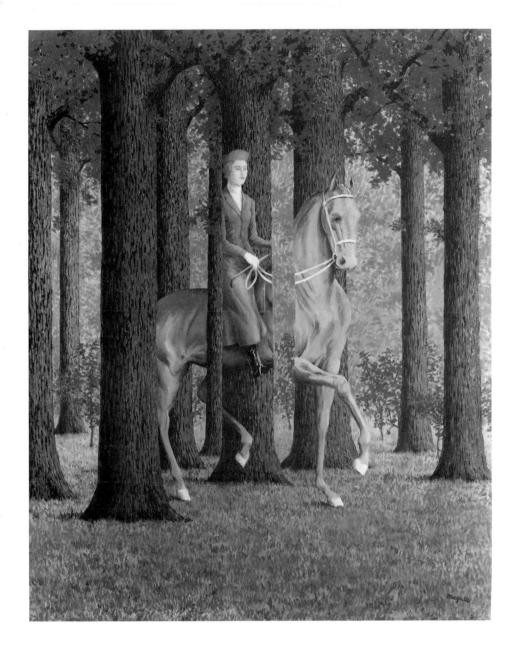

Rene Magritte, **The Blank Signature,** 1956.
Oil on canvas, 32×25⅝″ (81.3×65.1 cm).
Courtesy The National Gallery of Art,
Washington, D.C. Collection of Mr. and
Mrs. Paul Mellon.

In a sense, all graphic images are illusions. The components of a painting are no more than canvas and paint; the pictures on its surface have no objective reality, but act only as a catalyst to help viewers form mental constructs. As Suzanne Langer points out in *Feeling and Form,* the harmoniously organized space in a picture is not an *experiential* space that you can touch or feel, but an *illusion* that does not exist. It can be said that all graphic images are "opportunity structures" insofar as they provide sensory data for each spectator to form his or her own mental impression.

With art materials and imagination, the artist acts as a kind of sorcerer who presents illusions and prevarications. Art comprises the realm of make-believe, paradox and fabulation wherein anything can be made possible.

*A picture cannot depict its pictorial form;
it displays it.*
 —Ludwig Wittgenstein

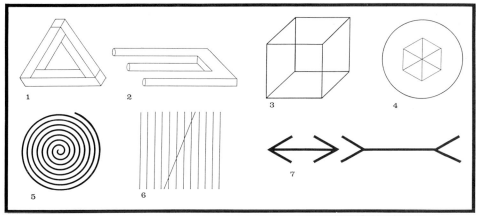

Some optical illusion figures. (1) The impossible triangle of L.S. and R. Penrose. The implied three-dimensional shape cannot possibly exist in actuality. (2) Another structure that cannot possibly exist in actuality. The middle prong shifts, attempting to be in two places simultaneously. (3) The Necker Cube. This skeleton cube "flips" from an above-right to a below-left eye level perceptual plane. (4) This equivocal figure "flips" from a two-dimensional "kite design" to a three-dimensional cube. (5) Archimedes Spiral. When set in motion, the spiral produces sensations of swelling and contracting, and also creates an illusion of a three-dimensional cone. When the motion stops, the opposite effects are perceived. (6) Illusion of a fragmenting line. When a single line crosses a grating of parallel lines at angles of less than 45 degrees, the line appears to break up. (7) Visual distortion. Which of the two lines is the longest? Neither one. Both are of identical length.

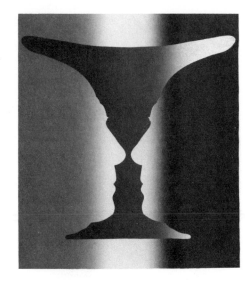

Jasper Johns, **Picasso Cup (detail)**, 1972, 22×32″ (56×81.2 cm). Courtesy Leo Castelli Gallery, New York. A striking example of visual reversal. The image is seen alternatively as a pair of faces and as a vase.

Paradoxical Images

Images are paradoxical when they contradict rational perception. The "impossible figures" of L.L. and R. Penrose, for example, are optical illusions which play havoc with the viewer's attempt to reconcile them logically. Because of their particular configuration, combined with the peculiarities of human visual perception, they appear highly unstable. The "impossible triangle," for example, presents a paradox in perspective; the "impossible prongs" show things to be simultaneously in two places, the Necker cube appears to "flip," and other ambiguous figures and patterns trigger yet other kinds of unstable perceptions. Such figures are incorporated in many of the engravings by Dutch artist Maurits Escher.

The use of optical illusion figures in art serves to produce *equivocality,* defined by Webster as "subject to two or more interpretations and designed to mislead or confuse." Discordant color, if added to the images, further increases perceptual ambiguity.

Paradoxical Perspective

William Hogarth's engraving, *The Fisherman* (1754), spoofs and contradicts the laws of linear perspective and thus presents an "impossible picture", a visual conundrum.

A different kind of ambiguity in art can be seen in Cubist painting of the early 1900s. Here, Picasso, Braque and Gris literally destroyed the "rules of perspective" handed down to them by the Renaissance masters. The Cubists eschewed linear perspective, using instead *reverse* perspective, characterized by split and shifted planes, reverse color and *simultaneity,* the process of showing several views of an object in a single picture. In Cubist art, the converging lines of furniture and architectural forms are often shown in reverse, i.e., perspective lines appear to diverge outwardly, rather than to a vanishing point set within the picture. Op artists of the 1960s added further impetus to ambiguous perspective and visual kinetics.

William Hogarth, **Fisherman,** 1754. Engraving. Courtesy The British Museum. The artist's deliberate misuse of perspective produces several visual paradoxes. Can you spot them in this impossible picture?

Camouflaged Images

Ambiguous or "double-images" are seen in the work of many artists of the 16th and 17th centuries. Noteworthy is the imagery of Giuseppe Archimboldo. Archimboldo cleverly combined common objects to form outrageous "portraits." Salvador Dali was also fond of encrypting images, as can be seen in *Apparition of Face and Fruit-dish on a Beach.*

Camouflage is a premise of *subliminal communication,* a mode of communication used by the advertising media to appeal to subconscious perception.

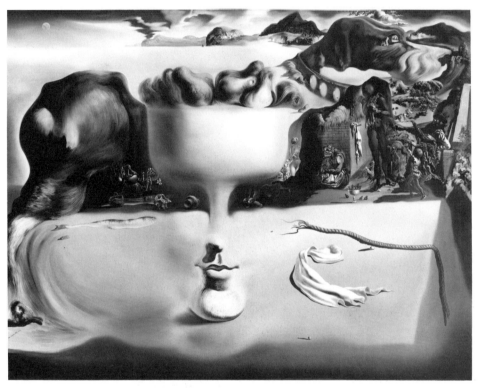

Salvador Dali, **Apparition of a Face and Fruit-dish on a Beach,** 1983. Oil on canvas, 45×56½″ (114.3×143.5 cm). Courtesy Wadsworth Atheneum, Hartford. The multiple image is revealed in a sequence of subjects. Notice that the base of the dish is also a face. The dog's head is part of the beach, its back made up of fruit. Dali has said, "The double image may be extended, continuing the paranoic advance, and the presence of another dominant idea is enough to make a third image appear, and so on, until there is a number of images limited only by the mind's degree of paranoic capacity."

R.R. Dvorak, **Lifetree,** 25×36″ (64×91 cm). Courtesy the artist.

The Comic Idiom

Of what value is humor? Philosopher George Santayana made this poignant observation: "The world is a perpetual caricature of itself; at every moment it is the mockery and the contradiction of what it is pretending to be. But as it nevertheless intends all the time to be something different and highly dignified, at the next moment it corrects and checks and tries to cover up the absurd thing it was; so that a conventional world, a world of masks, is superimposed on the reality, and passes in every sphere of human interest for the reality itself. Humor is the perception of this illusion."

The majority of artists are dedicated people who tend to take themselves too seriously to consider combining humor and "fine art." To balance that, however, we must remember that humor is a vital part of life, communication and survival. We must be thankful for creative spirits like Paul Klee, Alexander Calder, Claes Oldenburg and Red Grooms, who have dedicated a significant part of their work to the philosophy of fun and good humor. In their own way, they have humanized the art world and have supplied a much-needed breath of fresh air.

Quite often, however, the artist does not employ humor for purposes of light-hearted entertainment, but as a means of focusing attention on political, ethical, moral or other social matters. An insight to this mode of thinking is offered by comic writer William Zinsser, who said, "What I want to do is to make people laugh so that they'll see things seriously."

Incongruity is central to all humor. Something that does not fit the generally accepted mold, something out of context, unexpected, or inappropriate seems to be the essential element of humor.
—L.J. Peter

Anton Van Dalen, **Aliens Rescue Animals From Central Park Zoo,** 1981. Oil on canvas, 48×64″ (122×162.6 cm). Courtesy Grace Borgenicht Gallery, New York.

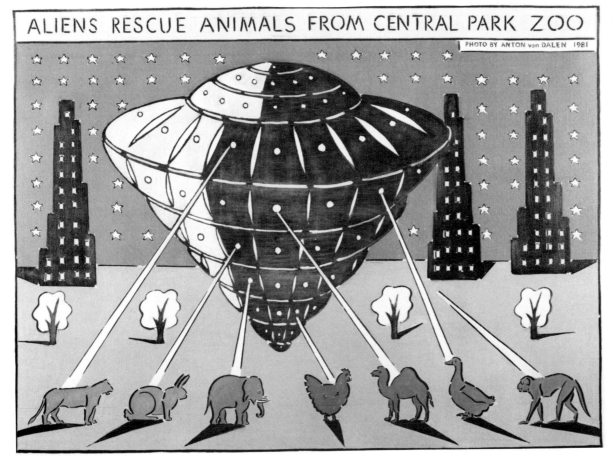

Humor is the other side of tragedy. It is a serious thing. I like to think of it as one of our greatest national treasures.
— James Thurber

Red Grooms, **Walking the Dogs,** 1981.
Mixed media, 39×26×21″
(99×66×53.3 cm). Courtesy Douglas and
Carol Cohen.

In the Spirit of Frivolity

Today, many artists use the apolitical comic idiom as their principal mode of expression. Alexander Calder expressed the sentiments of this legion when he said, "I want to make things that are fun to look at, that have no propoganda value whatsoever."

Red Grooms is a contemporary artist who mixes memory and myth to produce hilarious caricatures and lampoons. His comic pictures and tableaux are often inspired by the private lives of important historical figures, famous artists, heroes and heroines, urban street characters and famous American cities.

Why, then, should an artist use the comic idiom? André Maurois summed it up nicely when he said, "Art is an effort to create, beside the real world, a more human world."

Visual Puns

The term *pun,* according to the dictionary, connotes "The humorous use of a word or of words which are formed or sounded alike, but have different meanings, in such a way as to play on two or more of the possible applications." Visual puns are not very different from verbal puns, other than that visual images, rather than words, are used in the interplay.

Eli Kince, in *Visual Puns in Design,* writes that a visual pun, like a verbal pun, exists in the juxtaposition of two possibilities. "The effect of a visual pun", he writes, "is akin to that experienced by someone observing Edgar Rubin's famous face/vase optical illusion. In Rubin's image, there is a dual image reading of the figure/ground relationship, so that the image flops back and forth."

The surrealistic portrait heads by Giuseppe Archimboldo are visual puns, as are some of Picasso's works—one notable one is his sculpture, *Baboon and Young,* in which the baboon's head is made from a look-alike toy automobile.

Giuseppe Archimboldo, **Summer,** 1563. Courtesy Kunstistorisches Museum, Vienna. The ambiguous double image presents both a surreal image and a visual pun.

Pablo Picasso, **Baboon and Young,** 1951. Bronze, 21" (53.3 cm) high, base 13¼ × 6⅞" (33.3 × 17.3 cm). Collection, The Museum of Modern Art, New York. Mrs. Simon Guggenheim Fund. The absurd substitution of a toy automobile for the baboon's head transforms an ordinary concept into a preposterous image and a visual pun.

Lampooning the Human Condition

An old proverb says "One picture is worth 10,000 words." It cannot be denied that pictorial images, properly used, can pack a wallop far greater than words. Because artists use natural rather than artificial signs, their "messages" have an immediate intellectual and emotional impact.

With biting invective, artists such as Honoré Daumier (to name just one powerful activist) take aim at the folly of mankind. His efforts, like those of modern-day editorial cartoonists, point out the hypocrisy, foolishness and moral and ethical transgressions observed in the human fraternity.

In this respect, the etchings of Hieronymous Bosch are pictorial sermons: They not only lampoon the general folly of mankind, but also depict the fearful consequences of sin. Other political satirists are James Ensor, George Grosz, William Gropper, José Posada, Heinrich Klee, Otto Dix, Thomas Nast, David Levine and Peter Saul, to name a few. Does the caricaturist have a honored place in the art world? "Certainly," says writer Geoffrey Taylor. "There is something rare and rich in the wit who can evoke a thousand thoughts in a thousand minds with a single turn of a line."

Kenny Scharf, **When Earths Collide,** 1984.
Oil, acrylic and enamel, 122 × 209¼″
(309.8 × 531.5 cm). Courtesy the Whitney
Museum of American Art, New York.

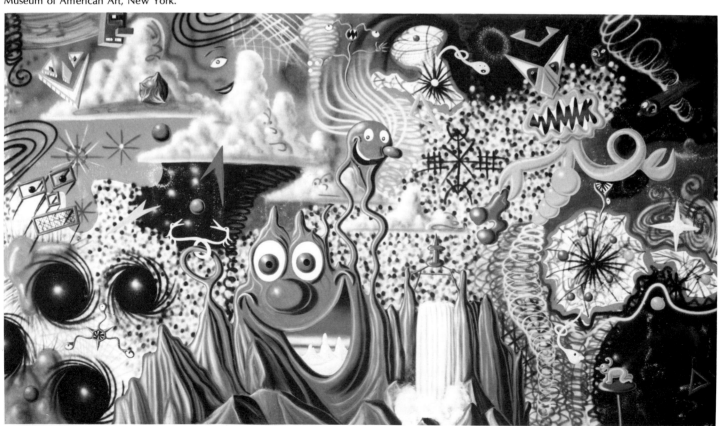

Ed Gamble, **Editorial Cartoon,** 1985.
Courtesy the artist and The Florida Times-
Union. Reprinted by permission.

Heinrich Kley, **At the Hofbrau.** Pen and
ink, from the Dover Pictorial Archives.
Courtesy Dover Publications, Inc., New
York.

Roger Brown, **Warp-Woof—The Fabric of City Life,** 1986. Oil on canvas, 72×72″ (182.9×182.9 cm). Courtesy John Berggruen Gallery, San Francisco.

4 / Paradox, Humor and Prevarication
STUDIO ACTION

4.1 Effecting Visual Discontinuity: The Camouflaged Contour

Concept: A disruptive surface pattern tends to "break up" the contour of a shape or form.

Camouflage: To mask, hide or otherwise disguise the normal appearance of an object.

Camouflage by disruptive contrast is used by the military to disguise warships and military vehicles.

Key Synectic Trigger Mechanisms: Disguise, Contradict

Studio Action: Make a outline drawing of an organic (freeform) shape. Next, invest the shape with a contrasting black and white pattern that tends to visually break up its contour. Use strong contrasts of line, dot, shape and color as required.

Materials: Drawing paper, pen and ink. Optional: Colored felt-tipped markers.

4.2 Figure-Ground Camouflage

Concept: One way to camouflage an object is to change its appearance so that it mimics or blends in with the background.

In nature, figure-ground camouflage takes the form of protective coloration (or differential blending) and is a survival factor for many species.

Key Synectic Trigger Mechanisms: Disguise, Contradict

Studio Action: Make a three-panel composition, each panel made up of an identical image or design placed inside a 5″ × 5″ (13 cm × 13 cm) square. Allow at least 1″ of background space around the image.

Create a different background for each panel, each showing different degrees of camouflage. In the first panel, design a contrasting background that provides no camouflage at all for the central image. In the second, create a background that mildly mimics the reference image and provides minimal camouflage. In the third panel, design a background that strongly mimics the reference image and provides maximum camouflage, yet does not completely hide the reference image.

Materials: Drawing paper, pen and ink. Optional: Colored felt-tipped markers.

Below left: **Disruptive Surface Pattern.** A disruptive surface pattern tends to break up and camouflage the contour of a shape.

Below right: **Figure-Ground Camouflage.** The closer the figure resembles its background, the more effective its concealment.

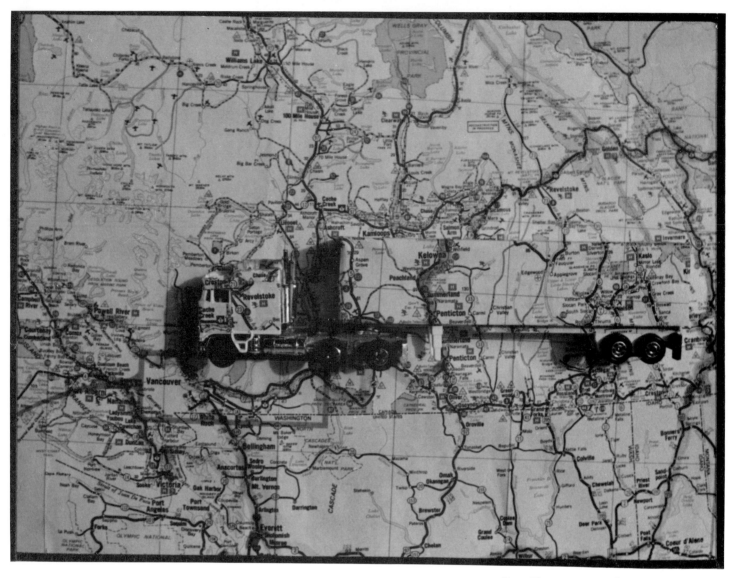

Gene Silverman, **Camouflaged Object,**
1982. Collage and toy truck. Courtesy the
artist.

4.3 The Camouflaged 3-D Object

Concept: Camouflage is based on figure-ground similarities.

Key Synectic Trigger Mechanisms: Disguise, Contradict

Studio Action: Attach a small found object such as a toy or light-weight utensil to a patterned background (a map, wallpaper, poster, wrapping paper, etc.). Change the surface pattern of the object so that it blends in perfectly with its background. Mimic the background by either painting or collaging the object.

Materials: Mixed media of your choice.

4.4 Patterning

Concept: The use of contrasting patterns tends to disguise images and flatten pictorial space.

Key Synectic Trigger Mechanisms:
Repeat, Combine, Disguise, Mythologize

Studio Action: From a selected theme, make a line drawing of a figurative subject. Divide the background space and parts of the image into smaller increments. Fill up to ninety percent of the shapes with different decorative patterns and textures but allow some shapes to remain untextured. Emphasize decorative pattern as seen in the work by Gustav Klimt.

Materials: Drawing paper, pen and ink, watercolor or colored pencils.

Gustav Klimt, **Water Serpents,** 1904–07.
Mixed technique on parchment, 19½ × 7¾ ″
(49.5 × 19.7 cm). Courtesy Osterreichische
Galerie, Vienna.

The Isle of Man: The Rocks of Scilly at a Distance. From a book of engravings, *Catchpenny Prints,* originally published by Bowles and Carter around 1790. Courtesy Dover Pictorial Archives, New York. This optical illusion presents two simultaneous images: a sleeping man and a panoramic landscape.

4.5 The Double-Image

Concept: An image (or images) encrypted in a background produce an optical illusion. Artist Reference: Salvador Dali.

Key Synectic Trigger Mechanisms: Disguise, Reverse

Studio Action: Two possible approaches: (1) With pen and ink on paper, create a drawing which contains other hidden images. (2) Use collage media to make a double-image: Select a photograph from a magazine or poster to serve as the matrix image. Paste different images (from magazines or newspapers) inside the shape of the matrix image. Exploit the camouflage factor. Make the viewer work to discern the imagery.

Materials: (1) Drawing paper, pen and ink. (2) Magazine cutouts, glue, art paper.

Salvador Dali, **Enchanted Beach With Three Fluid Graces,** 1938. Oil on canvas, 25⅝×32″ (65×81.3 cm). Courtesy the Salvador Dali Museum, St. Petersburg, Florida.

Michael Deardon, **Pen Pals.** Pen and ink on paper. Courtesy the artist.

4.6 The Visual Pun

Concept: A verbal pun can be transformed into a visual pun.

Key Synectic Trigger Mechanisms: Analogize, Transfer, Fantasize

Studio Action: Make up a list of verbal puns (words with double meaning) to add to the list below. Select a visual pun and make an analogous drawing, cartoon or sculpture.

Materials: (1) Drawing paper, various art media.

- Spelling bee
- Tree surgeon
- Handyman
- Pickled herring
- Home run
- Internal Revenue
- Funny bone
- Smoked salmon
- Hotdog
- Sandwich shop
- Boxing match
- Brainstorm
- Pen pal
- Niagara Falls
- *(add to the list)*

David Gallagher, **Shoe Tree.** Collage and pen and ink. Courtesy the artist.

Ann Adair, **Two Gators Playing Pool,** 1979.
Porcelain, 10×48×24″
(25.4×122×61 cm). Courtesy the Quay
Gallery, San Francisco.

4.7 Mimics

Concept: A humorous scenario can be inspired by giving animals or inanimate objects human qualities.

Key Synectic Trigger Mechanisms: Empathize, Parody, Animate, Fantasize

Studio Action: Using media such as pen and ink, watercolors or colored pencils, make visible one of the following scenarios:

• Elephants learning to ice skate
• Bottles taking a walk
• A Frog Dixieland band
• Turtles on a coffee break
• Musical instruments in concert
• Doggies at a diner
• Crocodiles at a school for mountain climbing
• Alligators playing pool
• *(add to the list)*

Materials: Drawing paper, pen and ink or other media.

Follow-Up Studio Action: Visualize the scenario in 3-D: Create a ceramic sculpture of your concept.

Heinrich Kley, **The Bottle Family.** Pen and ink. Courtesy Dover Publications, New York. Through empathetic projection, inanimate objects can be animated and given human qualities.

4.8 Making It Strange

Concept: Synectic Trigger Mechanisms are procreative devices.

Key Synectic Trigger Mechanisms: All

Studio Action: Select a commonplace object (an appliance, tool, sports equipment, mechanical device, etc.) to serve as a subject for Synectic transformation. Make six or more drawings of the object, each one representing a different kind of Synectic transformation. Make the first drawing a representational one (for purposes of analysis and reference), and the rest of them radical transformations triggered by Synectic fantasy. Arrange all of the images on a common background.

Materials: Drawing paper, black felt-tipped markers, colored pencils.

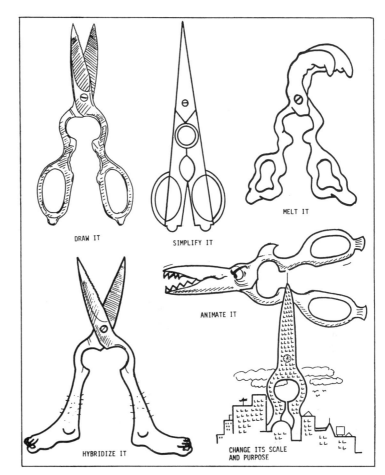

Denis Grant, **Transformations,** 1980. Pen and ink. Courtesy the artist. A commonplace object is transformed by applying Synectic Trigger Mechanisms.

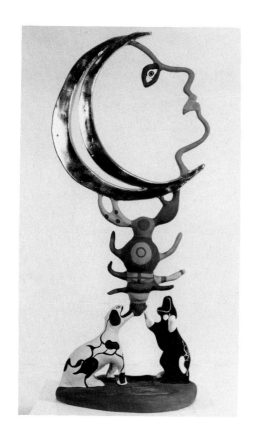

Niki Saint Phalle, **La Lune,** 1985. Painted polyester, 27½ × 11¾ × 9¼″ (70 × 30 × 24 cm). Courtesy Gimpel Fils Gallery, London. The moon is shown as a subject of synectic transformation.

4.9 More Making It Strange

Concept: Synectics can bridge *analysis* and *anomaly.*

Graphic Analysis: An examination of a subject and its component parts; a graphic statement regarding such analysis.

Anomaly: Something out of keeping with accepted notions of order.

Key Synectic Trigger Mechanisms: Analogize, Transfer, Fantasize, Animate, Distort, Hybridize, etc.

Studio Action: Object: To analyze and fantasize a subject. As a subject, refer to a garden vegetable (or a fruit or berry), e.g., bell pepper, okra, cucumber, hot pepper, green pea, apple, melon, orange, pomegranate, fig, orange, artichoke, etc. Start by making three analytical drawings. Approach the graphic analysis as if you were a draftsman or architect: make a side, top and cross-sectional view of your subject.

Get some facts about your subject: Look up its dictionary definition. Record its size, color, texture and structural characteristics. Label its parts.

Next, make an anomalous representation of your subject. Fantasize it. Change its function, scale and environment. Make an outrageous visual statement. Arrange all of the drawings and data together on a single sheet of paper.

Materials: Drawing paper, felt-tipped pens, colored pencils.

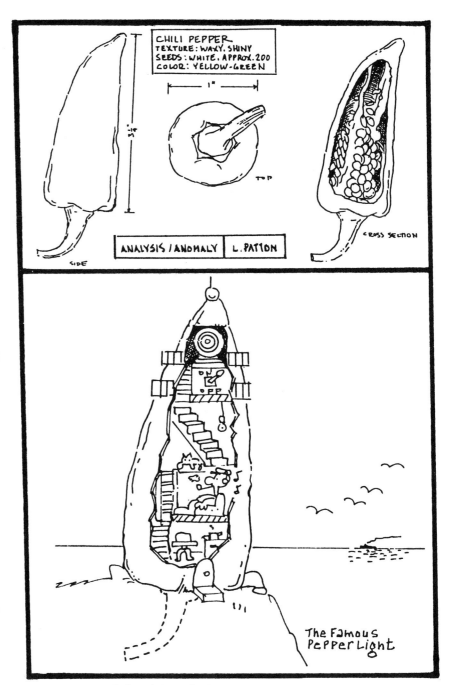

Louise Patton, **Analysis and Anomaly.** Pen and ink. Courtesy the artist.

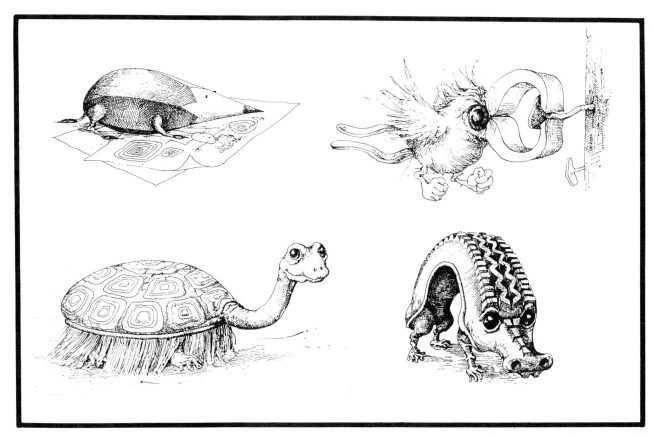

Kurt Halbritter, **Crosslink Critters,** 1981. Pen and ink. From *Halbritter's Plant-and-Animal World.* Courtesy Grove Press, New York. Top: *Graffitie* (Fabermouse), *Nipper-will* (Forcepts Mordax); Bottom: *Linteater* (Peniculum Saetigerum), *Tyre Back* (Cingulum Rotans).

4.10 Preposterous Crosslinks

Concept: Synectic hybridization can link organic and inorganic subjects.

Key Synectic Trigger Mechanisms: Hybridize, Fantasize, Parody

Studio Action: Create a fantastic hybrid: a "critter" that is part organic, part inorganic. Motivate your thinking by selecting two words, one from each of the columns below. Visualize your idea by making a drawing in pen and ink.

Tarantula	Pencil
Snake	Saw
Bird	Awl
Ostrich	Knife
Turtle	Pliers
Bee	Ruler
Fish	Hammer
Octopus	Scissors
Mouse	Screwdriver
(add to the lists)	

Materials: Drawing paper, black felt-tipped pen.

John Milton Gilbert, **Personality Portrait: Stanley Marcus.** Mixed media. Courtesy the artist. This humorous three-dimensional personality portrait depicts the subject as a traveler, author, pipe lover, marketing visionary, lecturer, gourmet, miniature book collector and Harvard graduate.

4.11 Comic Portrait

Concept: A portrait can have a comical rather than serious nature.

Key Synectic Trigger Mechanisms: Combine, Hybridize, Fantasize, Symbolize, Parody

Studio Action: Create a humorous portrait of a famous person. Consider two elements: (1) An object which symbolizes the person's occupation, interest or hobby, and (2) The image of the person. Fuse the two elements to produce a humorous caricature.

Materials: Drawing paper, pencil, pen and ink.

Follow-Up Studio Action: Make a 3-D version of your concept using sculpture clay, bisque-fired and decorated with acrylic colors.

4.12 Plants from "The Little Shop of Horrors"

Concept: A flower or plant can be an object of fantasy.

Reference: "Audrey II," an imaginative plant in the 1986 film "Little Shop of Horrors."

Key Synectic Trigger Mechanisms: Hybridize, Fantasize, Transfer

Studio Action: Create a humorous fantasy flower or plant. Apply selected synectic mechanisms to produce an outrageous image.

Follow-Up Studio Action (3-D): Realize your concept in a sculptural form. Produce a three-dimensional fantasy plant from found materials and mixed media. Exhibit your plant, along with others, in an "Artboretum".

Materials: (1) Colored pencils on black paper. (2) Papier-mâché, mixed media: paper-mâché, wood, wire, collage, etc.

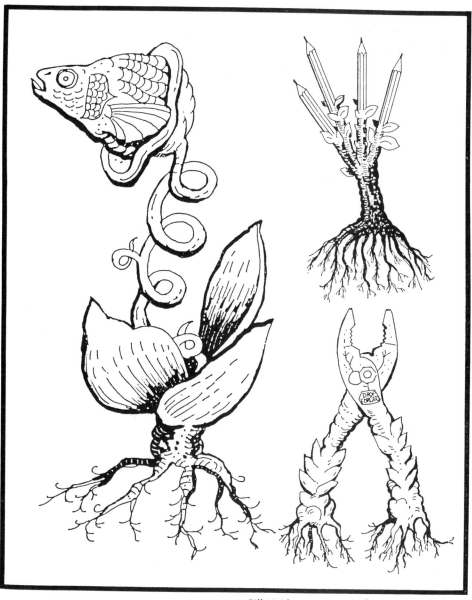

Bill Meidenger, **Fantasy Plants.** Pen and ink on paper. Courtesy the artist.

Al McWilliams, **Eggscape,** 1975. Lithographic image, sand, mirror, wood, egg, 6×12″ (15.3×30.5 cm). Courtesy the artist. The egg, transformed and placed in an irrational setting, becomes a visual oxymoron.

4.13 The Visual Oxymoron

Concept: A visual oxymoron is an absurd or seemingly self-contradictory image.

Literally defined, *oxymoron* means "foolishly wise," or "silly clever," as exemplified by verbal expressions such as "a loud silence," "clear as mud," "a lead balloon," etc. Similarly, visual oxymorons are pictorial contradictions.

Artist references: René Magritte, M.C. Escher, Salvador Dali, H.C. Westerman, Robert Arneson.

Key Synectic Trigger Mechanisms: Combine, Contradict, Transfer, Fantasize, Animate

Studio Action: Create a visual oxymoron. Take an ordinary object and do something to it to make it "self-contradictory" and preposterous. Make a transformation drawing from an actual subject, or work with images cut out of a magazine or newspaper.

Materials: Drawing paper, pen and ink, color media. Optional: collage and mixed media.

Rene Magritte, **L'Exception,** 1963. Oil on canvas, 33 × 41″ (83.8 × 104 cm). Courtesy Galerie Isy Brachot, Brussels.

4.14 More on Oxymoron

Concept: An artist can make an object be two things at once.

Artist reference: René Magritte

Key Synectic Trigger Mechanisms: Contradict, Transfer, Substitute, Hybridize, Fantasize

Studio Action: Select a common object and add something to it to make it self-contradictory, i.e., to make it be two things at once. Notice that Magritte's *The Cigar,* for example, is also a *fish.*

Use a collage idiom: Use an image found in a newspaper or magazine. Hybridize it: remove part of it and carefully graft a different shape in its place. Paste the hybrid image on a sheet of drawing paper and, with colored pencils, add any necessary elements to transform the original image into a new and comical design.

Follow-Up Studio Action (3-D): Create a sculpture based on the same idea. Select a three-dimensional object, remove or cover part of it, then glue a substitute object in its place to make a 3-D hybrid.

Materials: (1) Drawing paper, magazine illustrations, drawing pencils, glue. (2) A common object (roller skate, telephone, junked appliance), papier-mâché (or plasticine), found materials, liquid tempera or acrylic colors.

Rene Magritte, **Le Modele Rouge,** 1935. Oil on canvas, 28 × 19″ (72 × 48.5 cm). Courtesy Museum of Modern Art, Stockholm.

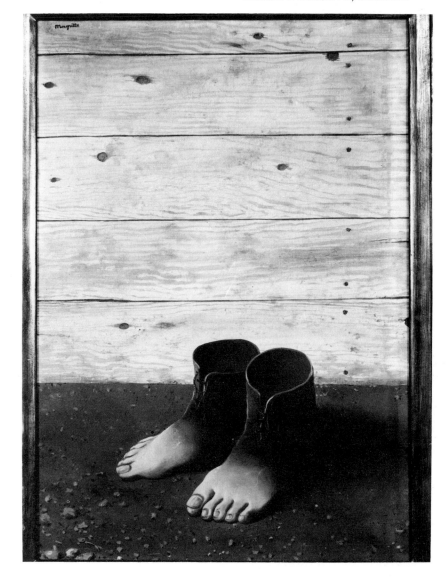

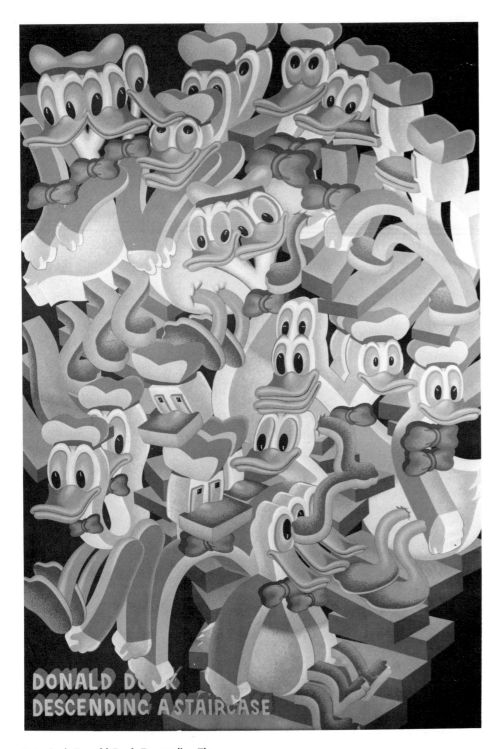

Peter Saul, **Donald Duck Descending The Staircase,** 1979. Acrylic on canvas, 62½×70¾″ (158.8×179.7 cm). Courtesy Allan Frumkin Gallery, New York.

4.15 Drawing from the Comics

Concept: A cartoon style can be used in a fine art context.
Artist reference: Roy Lichtenstein.

Key Synectic Trigger Mechanisms: Parody, Symbolize

Studio Action: Create a comic mythology—a humorous scenario set in a cartoon style. If you like, integrate an art style such as Cubism, Surrealism, Art Deco, etc. in your concept.
Exploit the predominant characteristics of comic art: the black outline, bright primary colors, half-tone dots and speech balloons.
Some possible themes:

- The party
- The movies
- User-friendly computer
- Beauty pageant
- The zoo
- Jocks
- Artists
- Media world
- Robotics
- Show biz
- Car freak
- Fast food junkies
- Beach bums
- *(add to the list)*

Materials: Media of your choice.

4.16 An Ordinary Object as an Art Form

Concept: Through Synectics, a common object can be transformed into an aesthetic object.

Key Synectic Trigger Mechanisms: Hybridize, Fantasize, Combine

Studio Action: Select a subject from each of the two categories listed below. Gather research material pertinent to each subject. Fuse the two factors to produce a humorous aesthetic object.

Object	Art Style
Automobile	Art Deco
Airplane	Pop Art
Table	Surrealism
Chair	Cubism
Pistol	Constructivism
Shoe	Futurism
Radio	Pointillism
Motorcycle	Naive art
Egg beater	Op art
Telephone	Fauvism
Hat	Expressionism
Tie	Classicism
T-shirt	Baroque
Telephone	Rococo

Materials: Clay, ceramic glazes or acrylics.

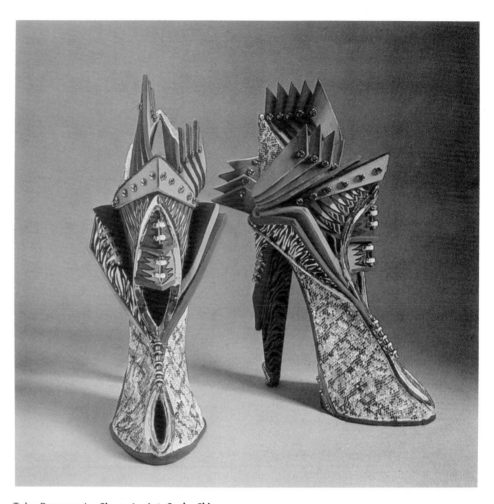

Toby Buonagurio, **Shoes As Art: Snake Skin Robot Shoes,** 1980. Ceramic, acrylic and lusters, 15½ × 5½ × 12″ (39.4 × 14 × 30.5 cm). Courtesy the artist.

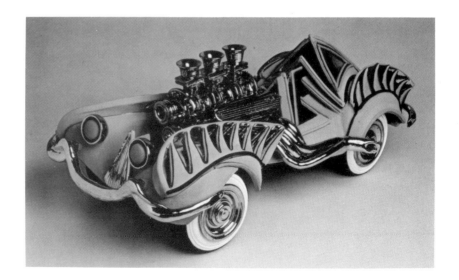

Toby Buonagurio, **Custom Street Rod,** 1980. Ceramic, acrylic and lusters, 13½ × 16½ × 30½″ (34.3 × 42 × 77.5 cm). Courtesy the artist.

Heinrich Kley, **Finish at the Snail's Race.**
Pen and ink. Courtesy Dover Publications.

4.17 Futuristic Mutation

Concept: A common subject can be imagined to mutate and develop a hybrid strain possessing extraordinary powers.

Key Synectic Trigger Mechanisms: Combine, Fantasize, Prevaricate, Contradict, Mythologize, Parody

Studio Action: What kind of image does this statement provoke:

"In the thirtieth century, the common garden snail will grow to be the world's fastest creature."

Make up a list of preposterous statements which involve surreal mutations. Select one from the list and illustrate the idea.

Materials: Art media of your choice.

4.18 Dream Fantasy Visualized

Concept: Dreams are sources of imagery.

Key Synectic Trigger Mechanisms: Combine, Fantasize

Studio Action: Recall or invent a dream scenario. Combine disparate, out-of-context images to produce one surreal image. Make a drawing, collage or a composition using mixed media.

Materials: Drawing paper, assorted media.

Salvador Dali, **The Persistence of Memory,** 1931. Oil on canvas, 9½×13″ (24.2×33 cm). Collection, The Museum of Modern Art, New York.

4.19 Chair-y Tale

Concept: A chair can be visualized as a surreal object.

Key Synectic Trigger Mechanisms:
Add, Subtract, Transform, Fantasize

Studio Action: Find a derelict chair (or fashion one of selected materials). Add and subtract some elements to change its function from a utilitarian to an aesthetic object. Decorate it with collage papers, colored yarn, feathers, cloth, acrylic colors, etc.

Materials: Assorted media and materials.

Ida Kohlmeyer, **Mythic Chair,** 1984. Mixed media on wood, 40×25×24″ (101.6×63.5×61 cm). Courtesy Arthur Roger Gallery.

Stan Klyver, **Utopian Energy Efficient House,** 1987. Pen and ink. 16×20″ (40.6×50.8 cm). Courtesy the artist.

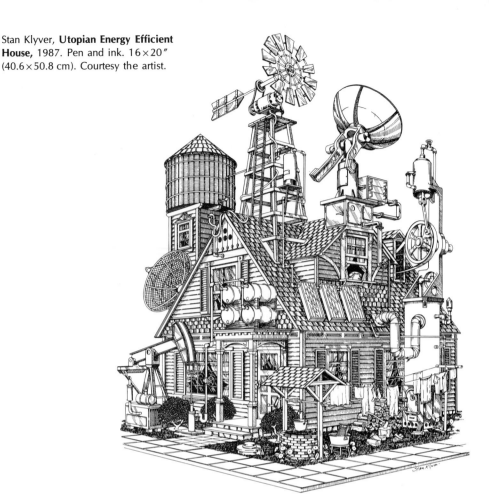

4.20 Architectural Fantasy (3-D)

Concept: A building can be a comical object.

Key Synectic Trigger Mechanisms:
Parody, Prevaricate, Distort, Contradict

Studio Action: Make a study of a particular building in your city (or a famous building elsewhere). Start with some preliminary drawings in preparation for making a sculpture. Caricature the edifice; change it into a humorous image. Visualize your concept in 3-D.

Materials: Wood, cardboard, fabric, glue, tempera or acrylic colors.

4.21 Utopian Scenario

Concept: Utopia is an imaginary condition which reflects impossible ideal conditions.

Key Synectic Trigger Mechanisms:
Prevaricate, Parody, Mythologize

Studio Action: Fantasize a humorous scenario which involves a utopian form of transportation, communication or technology. Make a cartoon drawing of your concept.

Materials: Drawing paper, pen and ink.

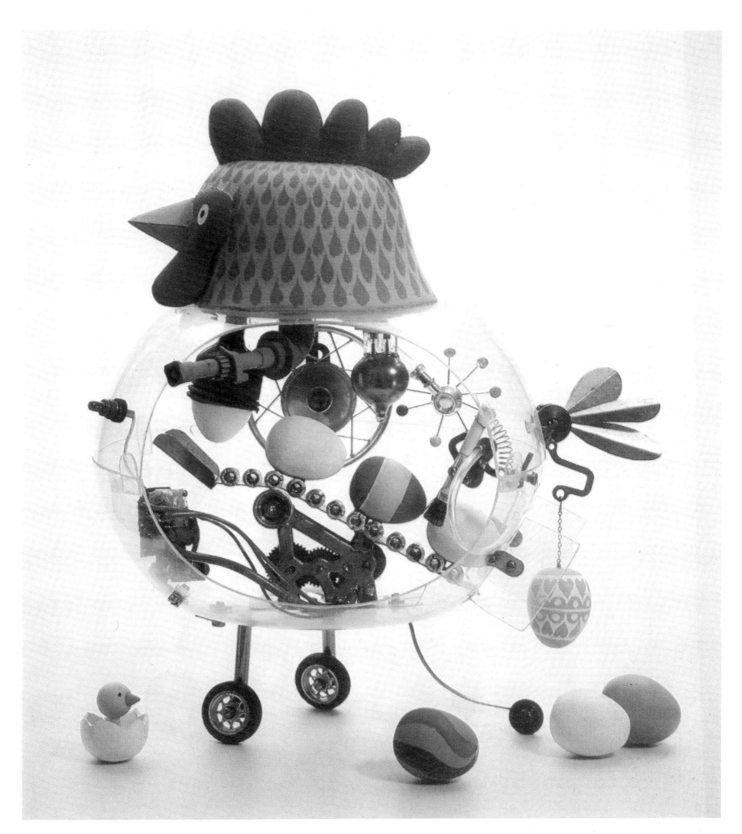

John Martin Gilbert, **Utopian Egg Manufacturing Device.** Mixed media. Courtesy the artist.

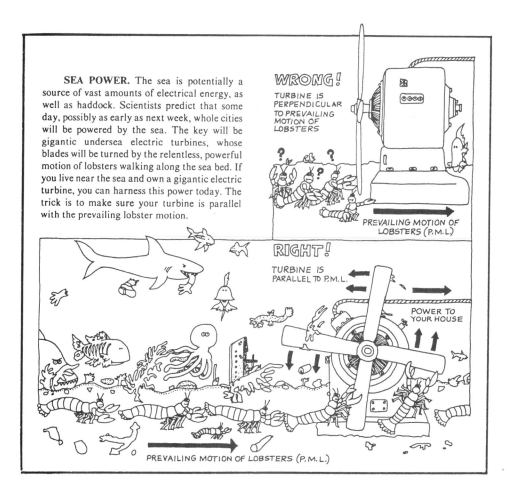

SEA POWER. The sea is potentially a source of vast amounts of electrical energy, as well as haddock. Scientists predict that some day, possibly as early as next week, whole cities will be powered by the sea. The key will be gigantic undersea electric turbines, whose blades will be turned by the relentless, powerful motion of lobsters walking along the sea bed. If you live near the sea and own a gigantic electric turbine, you can harness this power today. The trick is to make sure your turbine is parallel with the prevailing lobster motion.

WRONG! TURBINE IS PERPENDICULAR TO PREVAILING MOTION OF LOBSTERS

PREVAILING MOTION OF LOBSTERS (P.M.L.)

RIGHT! TURBINE IS PARALLEL TO P.M.L.

POWER TO YOUR HOUSE

PREVAILING MOTION OF LOBSTERS (P.M.L.)

Mock information: Jerry O'Brien, **Harnessing Sea Power.** From *The Taming of the Screw,* by Dave Barry, 1983. Pen and ink. Courtesy Rodale Press, Emmaus, Pennsylvania.

4.22 Mock Information

Concept: Prevarication (deviation from the truth) can trigger visual imagery.

Key Synectic Trigger Mechanisms: Prevaricate, Mythologize

Studio Action: Make up an outrageous story about the "Right and Wrong Ways" to do something. Visualize the idea in the form of a humorous drawing.

Materials: Drawing paper, pen and ink.

Follow-Up Studio Action: Draw a cartoon scenario which fantasizes "Where something comes from."
　Artist Reference: B. Kliban

Mock information: George Saeger, **Where Lightbulbs Come From.** Ink on paper. Courtesy the artist.

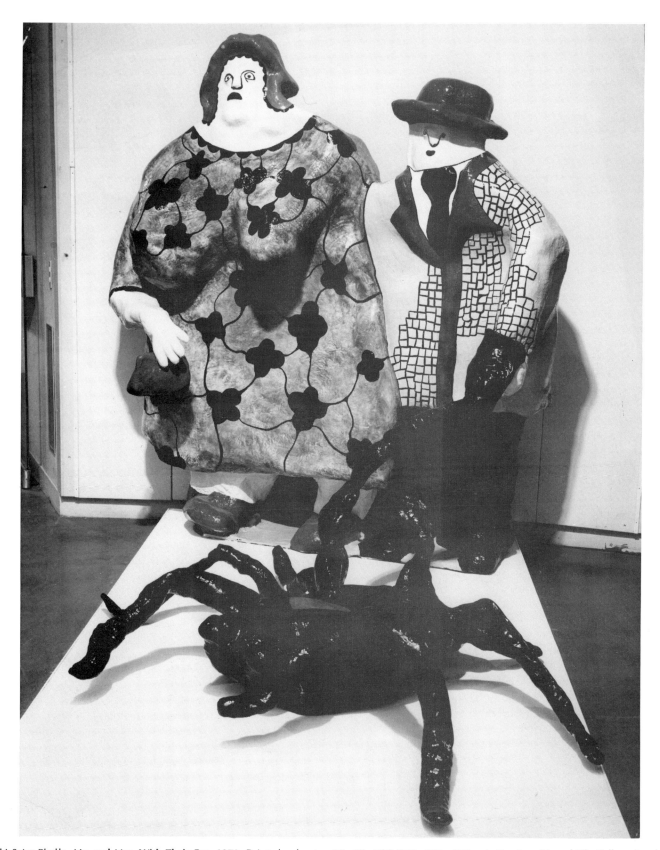

Niki Saint Phalle, **Mr. and Mrs. With Their Pet,** 1972. Painted polyester, 79×95×71″ (200×240×180 cm). Courtesy Gimpel Fils Gallery, London.

Ramona Audley, **American Gothic,** 1981.
Courtesy the artist. This soft sculpture is
made of cotton stockings, polyester fiberfill,
suture thread, accessories and clothing
altered to fit.

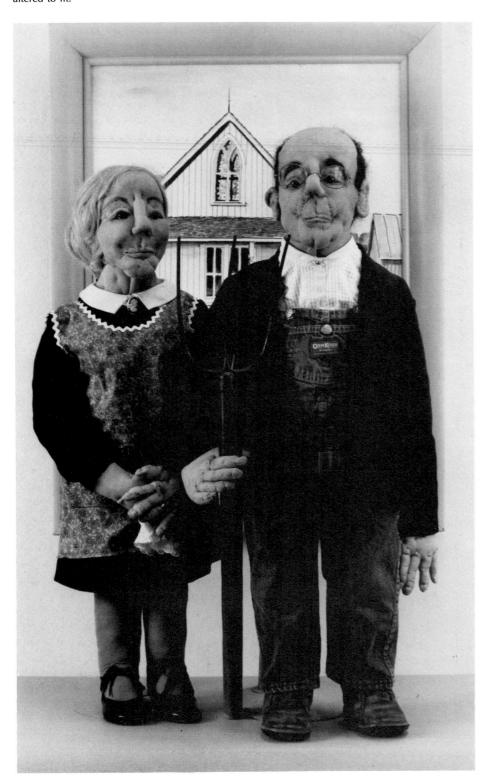

Red Grooms, **The Cedar Bar,** 1986. Water-
color, pencil and colored pencil on paper,
8′4½″×25′2½″ (255.3×768.4 cm).
Courtesy The Marlborough Gallery, New
York.

H.C. Westermann, **Phantom in a Wooden Garden,** 1970. 28 ×36×18¾″ (71×91.4×47.6 cm), douglas fir, pine, redwood, vermillion wood. Courtesy The Des Moines Art Center, Edmundson Art Foundation Inc.

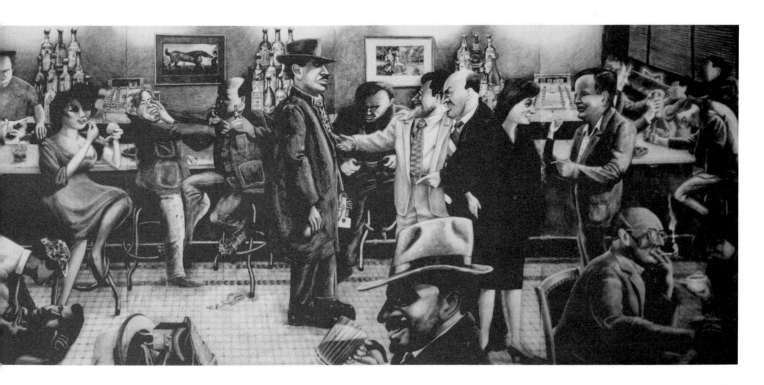

Change

M.C. Escher, **Metamorphosis II,** (continuation), 1939–40. Woodcut in three colors, 7⅝×157½″ (19×400 cm). Courtesy Cordon Art B.V., Holland.

Change: Progression and Variation

Within the art context, the concept of change implies some form of progression or sequential variation. Change can refer to two different factors: (1) The programmed optical movement, transition and sequence between the *visual elements* in a design (i.e., the shapes, forms and colors); and (2) The sequential transformation or metamorphosis of the design's *conceptual elements* (i.e., its content, idea or imagery).

Progression, in effect, denotes the use of a scheme of occurrence and interval. Swiss artist Max Bill emphasized the importance of this scheme when he said: "The laws of structure are the series, the rhythm, the progression, the polarity, the regularity, and the inner logic of sequence and arrangement."

There is no special way to plan progressive sequences or changes in art. Every artist, according to his or her particular task and concept, has a different way of designing—sometimes by logic, sometimes by intuition and serendipity, and sometimes by using all three creative modes. It must be remembered, too, that "beauty of proportion" has often been achieved by geometric and mathematical progression, a method which has been significantly extended by computer technology.

In fact, all things move and run, all things change rapidly. The profile before our eyes is never static but constantly appears and disappears.

— Ray Bethers

Previous page:
M.C. Escher, **Metamorphosis II,** (detail), 1939–40. Woodcut in three colors, 7⅝×157½″ (19×400 cm). Courtesy Cordon Art B.V., Holland.

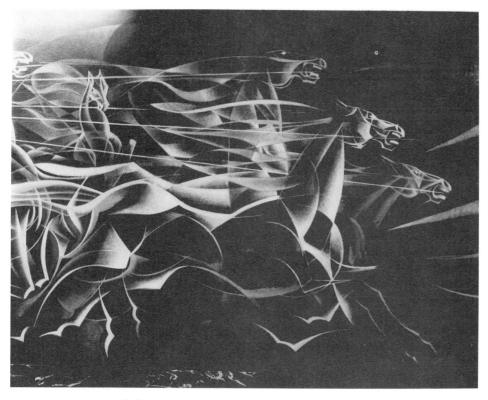

Jorge de la Vega, **Los Caballos.** Acrylic mural. Courtesy the artist.

Jan Zach, **Drapery of Memory,** 1987. Laminated wood, 72×63×33″ (182×160×83.8 cm). Courtesy the artist.

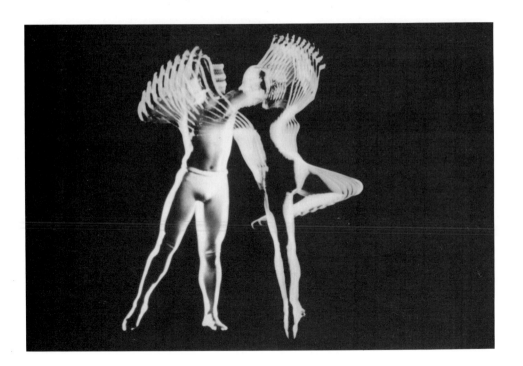

Norman Mclaren, **Pas de deux** (still from film). Courtesy National Film Board of Canada. The grace, beauty and movement of classical ballet is recorded through the use of strobe-like and multi-image patterns.

Repetition, Rhythm and Pattern

Repetition, rhythm and pattern are inseparable design components. Repetition, in particular, is the artist's principal means of programming intervals and occurrences (forms and spaces). In various ways, the artist can use repetition to achieve harmony, rhythmic movement, pattern and visual transition between the pictorial elements. Such visual movement is produced by designing the occurrences and characteristics of shape, color, texture, direction and position.

For the sake of brevity, the principle of rhythm is often subdivided into four classifications: *repetitive, alternative, progressive* and *flowing.*

An unvaried *repetition* of the same visual unit has a tendency to be boring, to create a static and tiring "beat." It can be used, however, as the basis for effective allover patterns. Andy Warhol, for example, made good use of unvaried repetition in his portraits of famous personalities.

Repetition and *alternation,* on the other hand, tend to relieve visual monotony and offer greater opportunity for developing interesting sequences of progression and permutation.

Progressive repetition is effected by the repetition and transition of visual elements; the total perceived effect is that of continuity, of interconnectedness.

A flowing rhythmic progression is dependent on a smooth visual pathway; depending on how the visual elements are arranged, a progression can be perceived as either continuous and flowing, or staccato.

Some ways of thinking about repetition and progression are:

- Repetition without variation (equal proportion, equal movement)
- Repetition and variation (development)
- Modular progression (repetition of a unit)
- Serialization (appearing in parts or intervals)
- Repetition and sequential subdivision of units
- Repetition and directional thrust
- Repetition with meter and tempo ("visual beat")
- Repetition and sequential addition
- Reverse progression: sequential subtraction
- Forward zoom: Progressing toward larger scale
- Backward zoom: Progressing toward smaller scale
- Repetition and permutation (progressive interpenetration)
- Repetition and superimposition (progressive overlap)
- Multiple simultaneous progression
- Progression and variation in a time-frame
- Random repetition and progression
- Combined random (disordered) and ordered repetition
- Mathematical progression
- Metamorphic evolution (growth and change)
- Narration: Serialization and symbolization

Ray Arnatt, **Open-Closed,** 1983. Gesso and plaster on wood, 28×20×1¼ ″ (71×50.8×3 cm). Courtesy the artist. A thirty-two slatted square field with a circular figure superimposed upon it has a single manipulation—one half closed, the other half opened. This produces a static/dynamic relationship between the two parts of the work. The artist views the work as a poetic metaphor which refers to the underlying paradoxes in life.

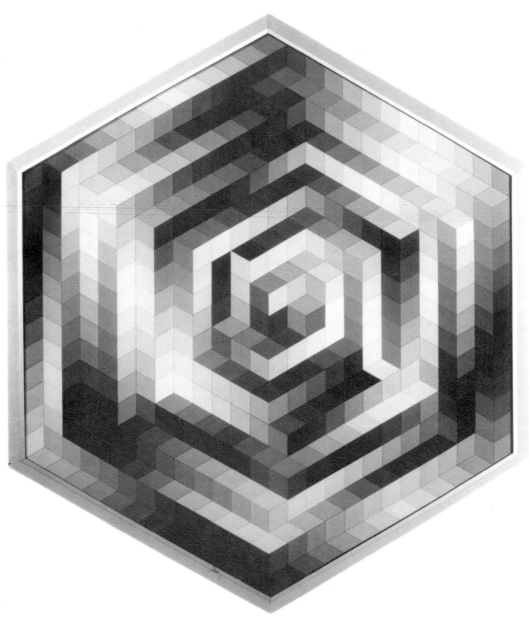

Victor Vasarely, **Hat IV,** 1972. Acrylic, 36½ × 31½″ (92.7 × 80 cm). Courtesy Denise Rene Gallery, Paris. The modular elements in this painting are highly unstable. Cubes seem to "flip" as the eye attempts to reconcile the visual overload.

Progression: In the Eye of the Beholder

Labels such as "conceptual art," "serial sculpture," "system art," and "ABC art" have been ascribed to the various contemporary art forms that have been produced from the concept of sequence and progression.

As we delve further into the concept of progression, however, we must keep in mind that the components of a drawing, painting, or sculpture are presented *simultaneously.* Calvin Harlan writes in *Vision and Invention* that the perception of rhythm in art, "instead of being a constituent of actual time and movement, as in music . . . lies in wait of an observer."

The Modular Unit in Art and Design

In their book, *The Golden Relationship*, Martha Boles and Rochelle Newman write, "We are just now beginning to understand that ours is a *modular* world built up of multiple replication of the simplest structures which we call atoms. There are only ninety-two different elements, each with their own atomic structure, which become the building blocks of our natural world. Atoms join together to form molecules which in turn cluster to form larger units of matter. The variety that nature provides is achieved by permutations of these building blocks."

In the visual arts, a modular unit (or module) is a particular unit which can be repeated or serialized to produce a pattern or design. Modules can be simple or complex, geometric or abstract, or figurative in nature.

Linda Whitford, **Metamorphic Progression,**
1986. Pen and ink on paper. 22×22″
(55.9×55.9 cm). Courtesy the artist.

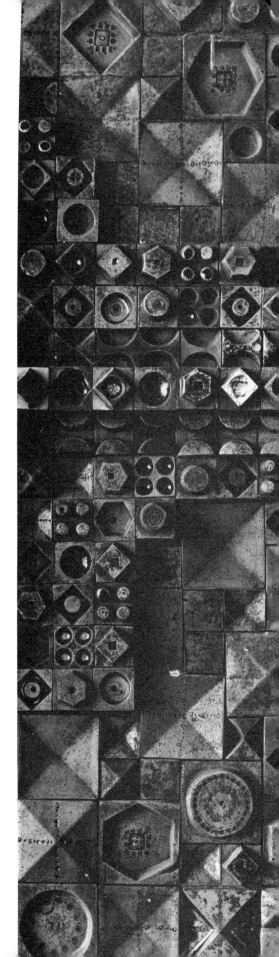

Rut Bryk, **Modular Construction** (detail).
Ceramic mural, 9×7′ (2.75×2.1 m).
Courtesy Oy Wartsila Ab Arabia Ceramics,
Helsinki.

The Grid

The grid is a convenient way of organizing things. It is a matrix, made up of horizontal and vertical lines within which modular units can be placed or spaces organized. Spaces within grids can be regular or irregular. Graph paper is an example of a regular (or equally spaced) grid matrix.

Irregular grid matrices are made up of lines which are not equally spaced and which form unequal subdivisions. Such grid patterns are seen in the work of Piet Mondrian and in Constructivist art.

There are many ways to use the grid. It can, for example, be a device that can play an active role only in the initial phase of the construction of a work of art, and later remain only as a latent structure, as seen in the painting by Fernand Leger. Or, conversely, the grid can be an overt factor in the completed work, as seen in the painting by Kawashima.

Kawashima, **New York Series.** Acrylic on canvas. Courtesy Waddell Gallery, New York.

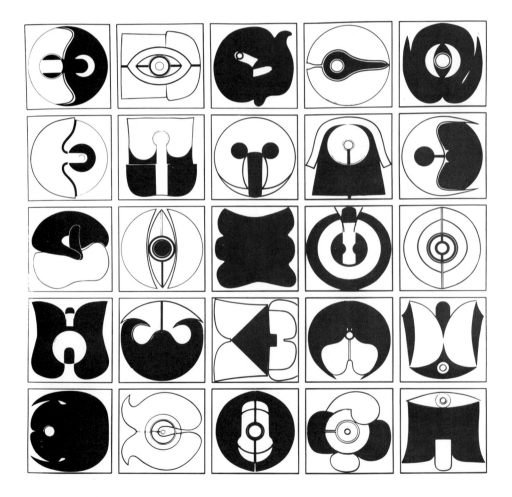

Joseph Cornell, **Untitled (Sunbox),** 1958.
Mixed media, 10½ × 14¾ × 5″
(26.7 × 37.6 × 12.7 cm). Courtesy John Berg-
gruen Gallery, San Francisco.

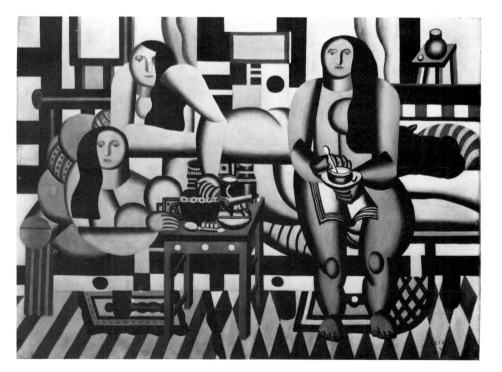

Fernand Leger, **Three Women,** 1921. Oil
on canvas, 6′ ¼″ × 8′ 3″ (183.5 × 251.5 cm).
Collection, The Museum of Modern Art,
New York. Mrs. Simon Guggenheim Fund.
An irregular-shaped underlying grid struc-
ture serves to unify the many disparate
elements in this composition.

Time As an Expressive Factor

An anonymous philosopher said, "Time is nature's way of keeping everything from happening at once." Although biological time imposes a progressive lineal sequence, as well as a limited term of existence on all living creatures, the concept of time as a factor in art is not similarly bridled. Armed with poetic license and synectic imagination, for example, the artist can imagine impossible time frame scenarios. Conceptually and pictorially, he can go back in time, advance to the future, or amalgamate present, past and future events in a single simultaneous view. In an art context, *simultaneous* and *psychological time* are subjective factors which operate outside the realm of biological limitation and are potent tools for creative expression. The time factor is the principal expressive device for the kinetic artist, choreographer, video artist, cinematographer and performance artist, whose works rely on concepts of chronological sequence or metamorphosis.

Nothing in the world that is alive remains unchanging. All Nature changes from day to day and minute to minute.
—Jawaharlal Nehru

Marlene Zander Gutierrez, **My Family (German Immigrant Series): Mother, Sleep In Heavenly Peace,** 1987. Mixed media: photos on film, serigraphy and collage, 26×20″ (66×50.8 cm). Courtesy the artist. Family photographs, arranged and reworked, provide the stimulus for a sensitive design as well as a cherished visual diary.

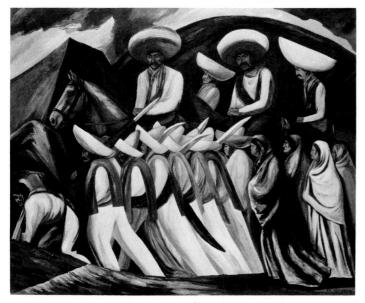

Jose Clemente Orozco, **Zapatistas,** 1931.
Oil on canvas, 45×55" (114.3×139.7 cm).
Collection, The Museum of Modern Art,
New York. Repetition and variation are the
principal factors employed by the artist to
portray the effect of movement in this
painting.

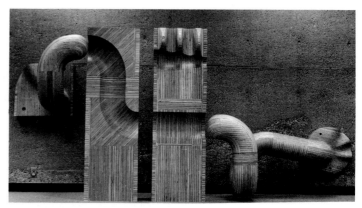

Alan Friedman, **Positive-Negative #2,** 1973.
Laminated wood, 6½'×4'×20'
(2×1.2×6 m). Courtesy the artist.

Movement: Implied and Actual

Although a drawing or painting is not capable of physical movement, the effect of "motion" can nonetheless be invoked and communicated. Any art form which causes a viewer to perceive movement is categorized as a *visual kinetic*. The composition creates an *implied* movement which is stimulated solely by the arrangement of the artwork's parts and by the inherent properties of human visual perception.

Sol LeWit, **Modular Cube,** 1966. Painted aluminum, 60×60×60"
(152.4×152.4×152.4 cm). Courtesy Art Gallery of Ontario.

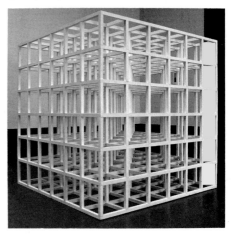

As mentioned before, the eye tends to scan a visual field and link things together. In doing this, it apprehends pictorial transition and rhythmic flow. In the case of three-dimensional art, such as sculpture or architecture, visual kinetics are produced by spectator displacement—which means that the work, although static, appears to "change" as the viewer walks around or through it. In this instance, a *sympathetic movement* is generated, i.e., a different composition is presented as the viewer changes his position and angle of view. In all of the examples mentioned above, the art object is static. The viewer's response is the catalyst that initiates the psychologically perceived "movement."

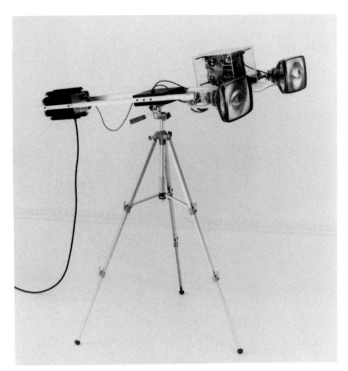

Alan Rath, **Voyeur,** 1987. Video sculpture. Courtesy the artist. Displayed on the screen are kinetic images of the human body-blinking eyes, mouth opening and closing, etc. The electronic components are deliberately exposed to call the viewer's attention to the nature of the medium which produces the imagery, as well as to the idea that the medium itself is a sculptural presence. In a similar work, the viewer is invited to type on the keyboard in order to make the mouth on the display screen ''talk.''

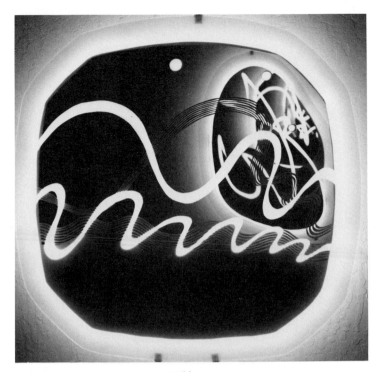

Beverly Reiser, **Portal (Reflecting Ribbons In Love),** 1987. Kinetics, neon and sand-blasted glass. Courtesy the artist. Hidden tubes of neon light behind organic shapes made of mirror and sandblasted glass are programmed to create a kinetic pattern of ribbons and subtle color shapes.

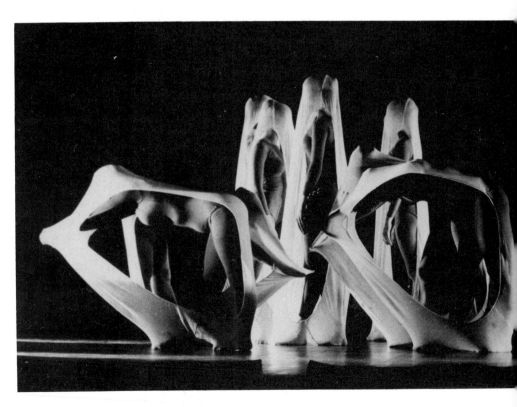

Alwin Nikolais, **Sanctum.** Dance theatre piece. Courtesy the artist.

Kinetic art, on the other hand, is an art form which involves *actual* movement. Kinetic artists express their ideas through time-lapse and kinetic forces. Their work explores light, motion, perception and audience interaction. It often integrates art with the technology of computers, electronics, lasers, light, and so on.

In the *Realist Manifesto,* published in the early 1920's, Naum Gabo and Antoine Pevsner started an interest in kinetics by proclaiming, "We renounce the thousand year old delusion in art that held the static rhythms as the only elements of the plastic and pictorial arts. We affirm in these arts a new element, the kinetic rhythms, as the basic forms of our perception of real time."

In summary, some possibilities in kinetic art can be realized through media and devices such as:

- Graphic design which exploits optical illusions;
- Three-dimensional works constructed so that their appearance changes as the spectator changes his viewing position;
- Art forms which present programmed or random movement by special lighting effects;
- Art forms which change by the effects of natural phenomena (air-powered mobiles, whirly-gigs, art that flies, floats, is altered by the effects of rain, snow, ice, magnetic fields, chemical reaction, etc.);
- Three-dimensional structures with mechanical moving parts;
- Art forms which involve motion picture, video, computer, laser or other electronic devices.

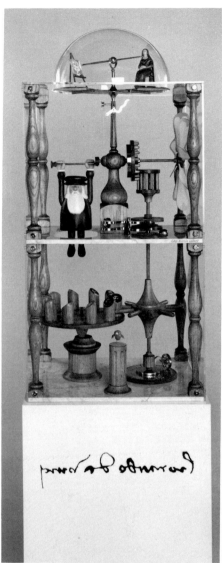

John Martin Gilbert, **Leonardo's Thank-You Machine,** 1987. Oak, Brass, paint, mechanics. Courtesy the Vancouver Art Gallery, British Columbia. Such whimsical machines are a sensory delight; they serve to humanize the often austere atmosphere in art museums.

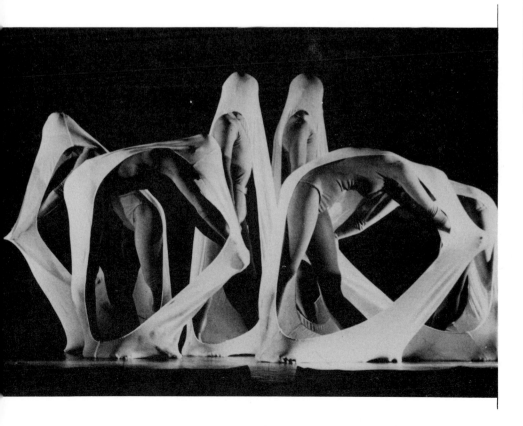

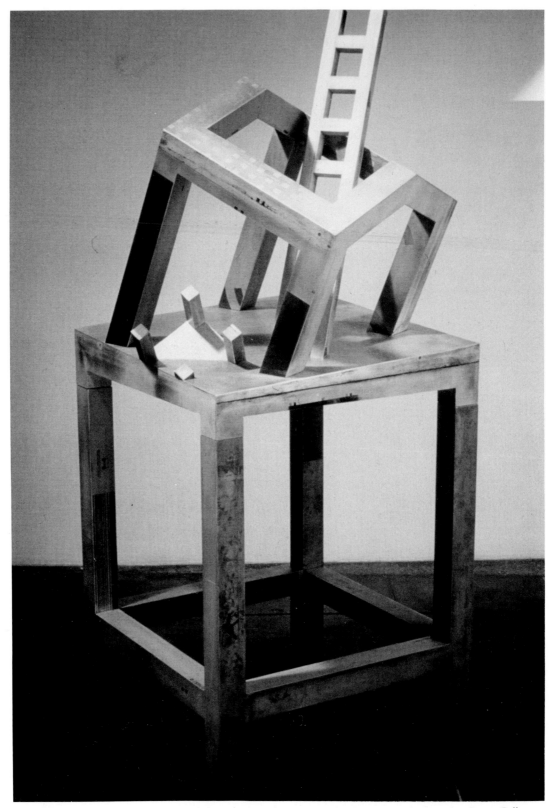

Steven R. Heino, **Flow,** 1987. Litho plates on wood, 61″ × 2′ × 2′ (155 × 61 × 61 cm). Courtesy Jan Baum Gallery, Los Angeles. A unique progression of shapes is presented as the design "flows" from linear to planar shapes and to skeletal volumes.

5 / Change
STUDIO ACTION

5.1 Nine-Panel Progression

Concept: Complexity can be achieved by adding lines and shapes in a progressive sequence.

Key Synectic Trigger Mechanisms: Repeat, Divide, Superimpose, Combine

Studio Action: On graph paper, draw nine squares of equal size. Start a sequence based on the following progression:

1. A
2. A + B
3. A + B + C
4. A + B + C + D
5. A + B + C + D + E
6. A + B + C + D + E + F
7. A + B + C + D + E + F + G
8. A + B + C + D + E + F + G + H
9. A + B + C + D + E + F + G + H + I

Have a different kind of line represent each letter. Make the progression interesting by varying the length, thickness and direction of the modular components, as well as the spaces they create.

Transfer the design to drawing paper and render the lines in color.

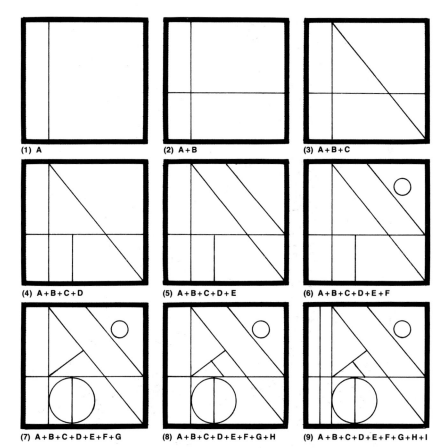

(1) A (2) A + B (3) A + B + C (4) A + B + C + D (5) A + B + C + D + E (6) A + B + C + D + E + F (7) A + B + C + D + E + F + G (8) A + B + C + D + E + F + G + H (9) A + B + C + D + E + F + G + H + I

Nicholas Roukes, **Progressive Sequence.** Pen and ink. An additional element is added to each panel as the series progresses from #1 to #9.

Assign a different color to each line (e.g., A = blue, B = red, C = yellow, D = orange, E = violet, F = green, G = black, H = white, I = gray, etc.) Work out a color sequence suited to your design.

Materials: Graph paper, drawing paper, ruler, compass, colored felt-tipped pens or pencils.

5.2 Modules

Concept: A module is a design unit that can be repeated to form an interlocking pattern or architectural design.

Key Synectic Trigger Mechanisms: Repeat, Change, Combine

Studio Action: On graph paper, draw four equal-sized squares. Carefully mark the centers (establishing reference points) on each side of the four squares. Draw four different designs on each square, making sure that the design starts and ends at any of the designated reference points. By so doing, every module will be an interchangeable unit that can be turned in any way, or used in any combination with the other modules to produce an allover pattern.

Enlarge and transfer the graph paper drawings to colored construction paper. Cut, arrange and paste the components to produce bigger modules. Arrange the units on a larger sheet of paper to form an integrated allover pattern.

Follow-Up Studio Action (3-D): Transfer the patterns to Foamcore or plywood to make 3-D (bas-relief) modules. Paint the units with acrylic colors and arrange them to form an architectural panel.

Materials: (1) Graph paper, pencil, ruler, compass, colored construction paper, gluestick. (2) Foamcore (or plywood or Masonite) panel, white glue, electric jigsaw, acrylic colors.

Nicke Rosen, **Interchanging Modules,** 1970. Injection-formed plastic. Courtesy the artist.

Four-Panel Sequence. Student work. pen and ink on paper, University of Calgary Design workshop.

5.3 5-Panel Sequence

Concept: The multi-panel sequence (the format of the comic strip) can be used to plan progressions in design and fine art.

Key Synectic Trigger Mechanisms: Repeat, Add, Metamorphose

Studio Action: Draw five rectangles, 4½ × 4½″ (11 × 11 cm) square, aligned horizontally as in the comic strip format. Allow ¼″ (5 mm) spacing between the panels.) Create a progression of abstract geometric shapes that begins in the first square and presents a developmental sequence in the subsequent four panels. Some possible ways of developing the sequence are:

- Have the design become more complicated.
- Have the elements appear to rise from the bottom, top or side of the panel.
- Have the elements get darker.
- Have the elements progress from black and white to color.
- Have the elements appear to zoom out of the panel.
- Have the elements appear to explode or contract.
- Use any combination of the above sequences.

Materials: Drawing paper, waterproof black felt-tipped pen, ruler, compass. Optional: Plastic templates (circles, ellipses, geometric shapes), #3 sable brush (for filling in solid black areas), india ink, colored inks.

What has become of paramount importance in design is the idea and theory of visual phenomena and relationships, and added to this is their effect upon one's behavior and spirit.

—Gregory Battcock

Victor Vasarely, **Zobor-II,** 1983. Drawing, 31½ × 28½ ″ (80 × 72 cm). Courtesy Denise René Gallery, Paris.

5.4 Superimposed Line Patterns

Concept: Two different line progression patterns can be overlapped to produce an integrated effect.

Key Synectic Trigger Mechanisms: Repeat, Add, Superimpose

Studio Action: Integrate two different line progression designs. Start by making one pattern. Then overlay a sheet of tracing paper on the pattern and draw the second one, using the underlying pattern as reference for making a contrasting yet integrated design. Tape the two images together and trace the combined patterns onto drawing paper. Ink the design with a black waterproof felt-tipped pen.

Materials: Tracing and drawing paper, ruler, ink, compass (optional), black felt-tipped pen.

Lemaitre, **The Apple.** Lithograph. Courtesy Wizard and Genius, Zurich.

5.5 Variations on a Theme

Concept: The way a subject is styled and rendered can radically affect its appearance.

Key Synectic Trigger Mechanisms: Simplify, Transfer, Substitute

Studio Action: Select an organic or inorganic object as the subject for interpretive variation. Make an accurate pencil drawing of the object to serve as a reference. Next, draw four different variations of the subject, each time using a different style and rendering technique. Make all of the drawings on a common sheet of paper, placing the representational rendering in the center.

Make a library search of different art styles (e.g., Pointillism, Impressionism, Art Deco, Collage, Cubism, Pop Art) as well as techniques used in commercial art.

Materials: Drawing paper, optional media: watercolors, colored pencils and markers, wax crayon, collage, gouache, tempera, acrylics, etc.

5.6 Three-Panel Metamorphosis

Concept: Metamorphosis can be depicted in serialized form.

Key Synectic Trigger Mechanisms: Subtract, Substitute, Metamorphose

Studio Action: Use a photograph or reproduction of a figure, face, flower or animal as a metamorphosis subject. Start by dividing a sheet of drawing paper into three equal-sized panels. In the first box, draw the subject as accurately as you can, first lightly in pencil and then in pen and ink. Next, make a light pencil tracing of the image and transfer it to the second and third panels.

Instead of inking the next two images as in panel one, substitute a different visual element such as a network of abstract shapes, numerals or letters. Render part of the image in panel two with some of the substitute marks, along with lines as in the reference drawing. In the last panel, show the object completely metamorphosed; ink in the entire image with the substitute marks.

Materials: Drawing paper, pencil, pen and ink.

Howard Lamson, **Three-Panel Metamorphosis.** Photocopy collage and pen and ink. Courtesy the artist.

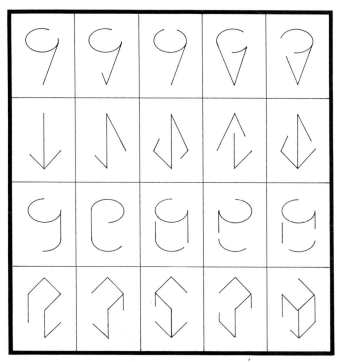

Dennis Brighton, **Variations of Incomplete Figures,** 1982. Pen and ink. Courtesy the artist.

Dennis Brighton, **Variations of Incomplete Figures (Based on a Representational Image),** 1982. Pencil. Courtesy the artist.

Roy Lichtenstein, **Bull Series.** Lithographs, each image 27 × 35" (68.6 × 88.9 cm). Courtesy Gemini G.E.L., Los Angeles.

5.7 Variations of an Incomplete Structure

Concept: A shape or an image can be depicted in various states of completeness.

Key Synectic Trigger Mechanisms: Repeat, Subtract, Combine

Studio Action: Draw a volumetric shape to serve as the subject for this experiment (i.e., a cube, cone, cylinder, tetrahedron, etc.). Make at least five identical pencil tracings of the shape within five gridded panels. Make the final drawing in pen and ink, but complete only a part of the subject. Make each panel different.

Materials: Drawing paper, pencil, ruler, felt-tipped pen. Optional: plastic templates.

Follow-Up Studio Action: Make a series of six different line tracings as a photographic image. Have each image depict only a part of the subject and arrange the images inside a gridded panel. Plan your design to show either a sequential or a random variation of incomplete structures.

5.8 Abstraction: Progressing from Conventional to Abstract

Concept: A representational image can be simplified and transformed into abstract pattern.

Key Synectic Trigger Mechanisms: Simplify, Metamorphose

Studio Action: Make a three-panel composition based on the analysis and reconstruction of a subject. Work either directly from an actual subject or from a photograph. Draw the image in the first panel as an accurate representation; this will serve as a visual reference for the next two drawings. Next, from this reference drawing, produce an abstract design. In this second drawing, reduce the shape and detail, and at the same time exploit the emerging aesthetic qualities. Finally, in the third drawing, produce an even more abstract composition. Omit yet more detail and produce a composition that bears only a faint resemblance to the original subject. The third drawing should be perceived as an abstract design with vague symbolic overtones.

Materials: Drawing paper, pen and ink, colored pencils.

5.9 Zoom

Concept: A progressive sequence can depict magnification or reduction.

Key Synectic Trigger Mechanisms: Repeat, Change Scale, Combine

Studio Action: Select any ordinary object to serve as the subject for this "zoom" composition. Start by dividing your drawing paper into six panels. Beginning in the panel at the top left, make a drawing that shows the entire view of the subject, drawn in a realistic style. In the next five sequences, make a series of closeup drawings, each of which progressively "zooms" into the subject. Use a magnifying glass or microscope as an aid for drawing the detail in the last drawing.

Materials: Drawing paper, waterproof felt-tipped pen, #3 pointed sable brush, india ink.

Scale change composition. Superimposed reproductions of an image. Student work, University of Calgary.

Follow-Up Studio Action: Create a "scale-change" composition by superimposing various reductions of an image. Overlap six or more images of either a photograph or an original drawing; make the reductions by using either an overhead projector or a zoom photocopier.

Roy Lichtenstein, **The Red Horsemen,** 1947. Oil and Magna on canvas, 84×112″ (213.5×285.5 cm). Courtesy The Museum of Modern Art, Vienna. As in Marcel Duchamp's *Nude Descending a Staircase,* this painting conveys the effect of movement by the repetition and superimposition of diagonal lines and shapes.

5.10 "Movement" in the 2-D Plane

Concept: A graphic image, although inherently static, can be made to convey the effect of movement.

Artist References: Marcel Duchamp, Thomas Eakins, Gino Severini, Giacomo Balla.

Key Synectic Trigger Mechanisms: Simplify, Repeat, Add, Superimpose, Combine, Animate

Studio Action: Depict an action event which involves a figure such as a diver, cyclist, runner, hockey player, golfer, skier, dancer, etc.

Modify the subject and produce a composition which suggests motion by applying the synectic mechanisms listed above.

Materials: Drawing paper, art media of your choice.

Frank Luchessi, **Melt-Down,** 1983. Pen and ink. Courtesy the artist.

Progressive Distortion, student work, University of Calgary. The progressive distortion in this six-panel composition was created by moving the image as it was being photocopied.

5.11 Progressive Distortion

Concept: An image can be distorted in a progressive sequence.

Key Synectic Trigger Mechanisms:
Repeat, Distort, Change Scale, Metamorphose

Studio Action: Depict the "melt-down" of a common object in a six-panel sequence. In the first panel, show the object in its normal state. Then draw five subsequent images showing the object gradually melting into a soft lump.

Materials: Drawing paper, colored pencils.

Follow-Up Studio Action: Use a photocopier to create a distortion series. Place a drawing or photograph on the photocopier and move the image as the machine is going through its copy cycle. (Faster movements produce greater distortion.) Develop the images further by working into them with colored pencils or other selected media.

Lori-Ann Latremouille, **Birth of a Song.**
Charcoal and oil pastel on paper. Courtesy
the artist. An egg decorated with the *ankh*
The Egyptian symbol of life, knowledge and
immortality) hatches a musical note, which
in turn produces a bird, which begets song
and in turn triggers an ongoing eternal
process.

5.12 Symbolic Progression

Concept: An idea can be symbolized and depicted by a graphic progression of images.

Key Synectic Trigger Mechanisms:
Add, Combine, Mythologize, Symbolize

Studio Action: On a sheet of drawing paper, conceptualize an idea based on a genesis theme such as:

- Birth of a song
- Birth of an invention
- Birth of a poem
- Birth of an art form
- Birth of a problem
- *(add to the list)*

Arrange selected symbols and images to convey the idea and produce an integrated and aesthetically pleasing design.

Materials: Drawing paper, pencil, liquid tempera or optional color media.

1	1	1	1	1
2	2	2	2	2
3	3	3	3	3
2	2	2	2	2
1	1	1	1	1

3	3	3	3	3
3	2	2	2	3
3	2	1	2	3
3	2	2	2	3
3	3	3	3	3

3	2	1	2	3
2	2	1	2	2
1	1	1	1	1
2	2	1	2	2
3	2	1	2	3

1	2	3	2	1
2	3	2	3	2
3	2	1	2	3
2	3	2	3	2
1	2	3	2	1

Repetition and Variation. This diagram shows four possible options for serializing modular components.

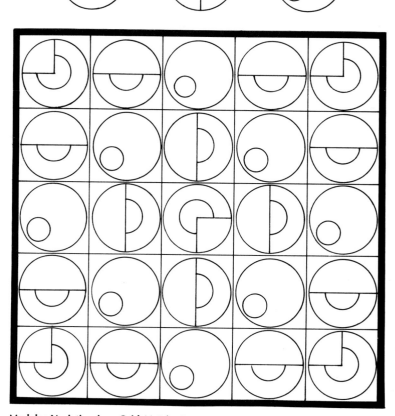

5.13 Progression and Variation Within a Grid Matrix

Concept: The grid can serve as a matrix for organizing and serializing modular units.

Key Synectic Trigger Mechanisms:
Repeat, Combine, Add (Extend)

Studio Action: Divide a large sheet of colored paper into twenty-five equal-sized units, i.e., five across and five down. Next, design three to six different modules to be programmed in the grid matrix. (Cut shapes from colored paper that contrast with the background color.) Decide on a system to serialize the modules, a method to show them in a "state of change." Select one of the options shown here, or make up your own. Depending on the system used, either an alternating, progressing, concentric, mosaic or zigzag pattern can be produced.

Materials: Colored art paper, ruler, compass, scissors, glue.

Modular Variation in a Grid Matrix. Student work, University of Calgary. Three modules, shown above, are repeated and sequenced to produce an allover design.

Victor Baumgartner, **Scale Change Composition,** 1983. Pen and ink. Courtesy the artist.

Scale-Change Diagrams. Some of the possible ways of varying a regular grid matrix are shown in these designs.

Follow-Up Studio Action: SCALE-CHANGE GRID

Concept: A grid matrix can be composed of unequal sized compartments

Studio Action: Make a scale-change grid based on one of the diagrams shown here. Use it with a module and a selected system to create an allover pattern.

The idea becomes the machine that makes the art.

—Sol Lewit

5.14 Spiral Progression Within a Grid Matrix

Concept: A spiral progression can be depicted in a grid matrix.

Key Synectic Trigger Mechanisms:
Repeat, Add (Extend), Metamorphose

Studio Action: Grid a large sheet of drawing paper into a matrix of 100 squares (ten across and ten down), each square measuring 2½ × 2½″ (6 × 6 cm). Let one of the middle squares serve as the "reference pivot" from where the spiral sequence will begin.

Using colored art paper, compose a simple cut-paper design measuring 2½″ (6 cm) and paste it in the middle square. Next, while thinking of an outward spiral movement, paste a slightly altered version of the same design in the adjoining square. Continue to add designs in a spiral progression, each time "metamorphosing" the previous design. Progress from thick to thin, solid to skeletal, geometric to freeform, dark to light, non-textural to textural, achromatic to colored, and so on, as you fill the spiral grid matrix.

Materials: Colored art paper, ruler, scissors, X-acto knife, glue.

Kurt Kranz, **Spiral-Grid Matrix Narrative (Hawaii),** 1966. Acrylic on canvas. 40×48″ (101×122 cm). Courtesy the artist.

5.15 Antipodal Progression

Concept: A transition from a stable to an unstable arrangement can be depicted in a progressive sequence.

Antipodal: Opposed, diametrically opposite

Key Synectic Trigger Mechanisms: Repeat, Transfer, Combine

Studio Action: Within a grid format, create an abstract allover design which depicts an antipodal progression from order to randomness. Repeat a module such as a square, circle, triangle, etc. and compose an ordered structure which, through a sequence of change, gives way to a random or unstabilized grouping.

Materials: Drawing paper, black waterproof felt-tipped pen, optional mixed media.

George Snyder, **Twenty Eight Days in April.** Acrylic on canvas, 64×64″ (162.6×162.6 cm). Courtesy the artist. The artist destroys the symmetry of a regular grid matrix by depicting a progression from an ordered to a randomly organized visual field.

5.16 Progression Towards Simplification

Concept: A series of progressive simplifications can be combined in a single presentation.

Artist Reference: Maurits Escher

Key Synectic Trigger Mechanisms: Repeat, Simplify, Subtract, Metamorphose, Combine, Change Scale

Studio Action: Inside the space of a single panel, create a sequence of drawings which depicts the gradual breakdown of an image from a representational picture to a geometric abstraction and, ultimately, to a pattern of straight lines. Arrange the sequence to form an integrated overall pattern.

Materials: Drawing paper, pencil, waterproof felt-tipped pen, #3 sable brush, india ink. Optional: tracing paper, photocopied images.

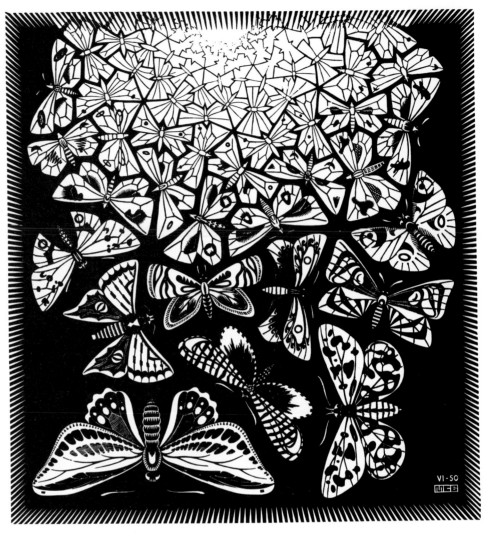

M.C. Escher, **Butterflies,** 1950. Wood engraving, 110×102″ (281×260 cm). Courtesy Cordon Art, B.V., Holland.

5.17 Eccentric Reconstructions

Concept: Surrealistic imagery is characterized by non-contextural arrangements.

Key Synectic Trigger Mechanisms: Fantasize, Subtract, Add, Hybridize

Studio Action: (Collage) Make some "reconstructions" that defy logical perception. Start by cutting out pictures of ordinary objects from magazines and catalogs. Manipulate them by subtracting and adding things so that they become non-contextural images. An image of an egg, for example, could have a train coming out of it; a zucchini could have a telephone attached, etc. As you fantasize the possible ways of changing a picture, keep in mind the words of Salvador Dali: "The stronger the displacement between images, the stronger the voltage." Make your hybrids outrageous apparitions; the more bizarre, the better.

Follow-Up Studio Action: Make a three-dimensional sculpture based on this idea.

Materials: (1) Drawing paper, images from magazines and catalogs, scissors, glue. (2) Found objects, mixed media.

Peter Blindon, **Eccentric Progression**, 1987. Collage. Courtesy the artist.

5.18 Paradoxical Progression

Concept: Impossible linking triggers surreal imagery.

Synectic Trigger Mechanisms:
Fantasize, Combine, Metamorphose

Studio Action: Make a drawing which depicts an irrational progression and fusion between two unlikely subjects. It can be, for example, a picture of a still life which grows into a street scene, as in Maurits Escher's famous print, an image of a room interior which progresses to an extraterrestrial moonscape, a human figure which becomes architecture, etc. Draw the picture in such a way as to provide a smooth optical transition between the disparate images.

Materials: Drawing paper, pencil.

Follow-Up Studio Action: Make a surreal 3-D construction based on this idea. Create something out of wood, clay, papier-mâché or mixed media which can be fused with a "found object" such as a:

- Garden rake
- Plunger
- Umbrella
- Broom
- Fly swatter
- Mousetrap
- Wine bottle
- Pipe
- Hammer
- Tree branch
- Chair
- Shoe
- Clothes hanger
- Baseball bat
- Yardstick
- Chair
- Egg carton
- Book
- Bird cage
- Rope
- Junked object
- *(add to the list)*

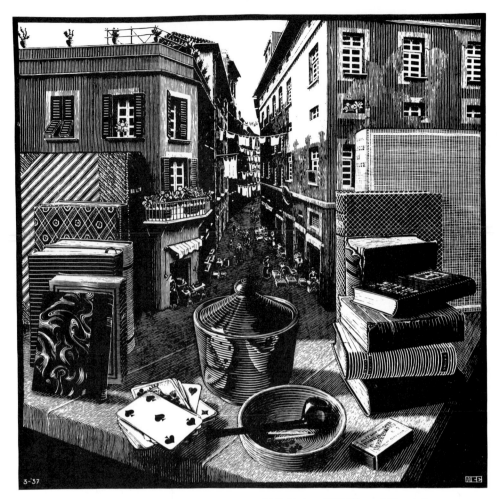

M.C. Escher, **Still Life and Street** (A Metamorphic progression), 1937. Woodcut, 192×193″ (487×490 cm). Courtesy Cordon Art B.V., Holland.

The fragrance of dimensions; The juice of stone.

—Marcel Breuer

Concept: Time, psychologically perceived, has immense and fathomless dimensions.

Key Synectic Trigger Mechanisms: Fantasize, Transfer, Superimpose, Combine, Mythologize

Studio Action: Create a composition which contravenes chronological time. Assemble images which portray a theme based on either a *simultaneous dimension* (e.g., a real or imagined pictorial biography which, in one picture, combines images signifying different events in a subject's life) or a *surreal dimension* (entering a "parallel time dimension" such as a dream-time dimension).

Materials: Drawing paper, colored pencils or media of your choice.

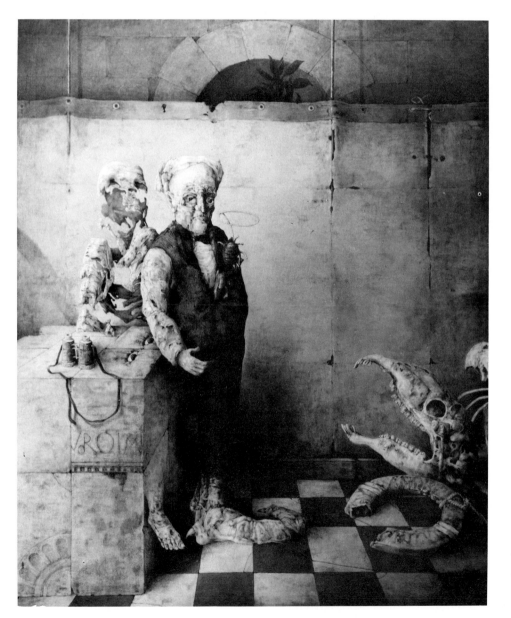

Jose Hernandez, **Pensador Amenazado,** 1975. Oil on canvas. Courtesy Juana Mordo Gallery, Madrid. This image presents a surreal metamorphosis—an irrational, dreamlike reality.

5.20 Progressing From Two-Dimensional to Three-Dimensional

Concept: A design can begin as a two-dimensional image and progressively "grow" out of the picture plane.

Key Synectic Trigger Mechanisms: Repeat, Add, Metamorphose, Combine

Studio Action: Combine drawing, painting and sculpture: Create a composition made up of visual elements that "grow" from painted images into 3-D forms. Work on a canvas or Masonite panel. Draw and paint the design first. Then glue cardboard or wood cutouts (or other materials) to the surface. Echo the shapes of the painted designs with the 3-D forms to produce an integrated and rhythmic progression. Use white glue to attach the 3-D objects and materials.

Materials: Canvas or Masonite panel, acrylic colors, wood, glue, mixed media and materials; electric jigsaw or hand tools.

Mary Bauermeister, **Put-Out,** 1970. Mixed media. Courtesy the artist. In this painting, things literally come "off the wall"; two-dimensional images become three-dimensional forms which drop out of the painting and onto the floor.

Sympathetic kinetic structure (two views). Student work, University of Calgary. Of balsa wood and cellophane. Although the sculpture does not actually "move," it is visually kinetic because it presents radically different compositions as it is viewed from different positions.

Sympathetic kinetic structure. Student work, University of Calgary. Of balsa wood and mixed media. The linear arrangement of constituent parts provides a sequence of different visual alignments as the viewer examines the sculpture from different points of view.

5.21 Sympathetic Movement

Concept: Although physically immobile, a sculpture is said to have *sympathetic movement* insofar as it presents different views of its structure as the spectator views it from different angles.

Key Synectic Trigger Mechanisms: Combine, Animate

Studio Action: Exploit the properties of sympathetic movement in 3-D form. Create a sculptural construction whose visual characteristics change drastically as you move around it. For example, a skeleton cube or an elongated form present radically different shapes in their foreshortened and end views; an achromatic shape can conceal a colorful design on its reverse side, a slick surface can give way to a prickly one, etc. Use materials of your choice to create the sculpture.

Materials: Assorted 3-D materials.

I can make my art fly, suspend itself in the air, or radiate odors.
—Mel Johnson
Chicago sculptor

Phillip Johnson, **Untitled,** 1987. Mechanized mixed media and color. This kinetic construction of brightly colored shapes is both sculpture and painting and presents a rhythmic motion which effects a parody of "the machine" not unlike Charlie Chaplin's in "Modern Times."

5.22 Kinetics: Art That Moves

Concept: Kinetic art involves interrelationships of movements in points of time and space.

Key Synectic Trigger Mechanisms: Combine, Animate

Studio Action: Create a three-dimensional art form that:

- Flies
- Floats
- Grows
- Moves
- Radiates sound
- Radiates odor
- Changes its appearance
- Mimics nature
- Reacts with water
- Reacts to light
- Reacts to sound
- Reacts to movement
- Reacts to gravity
- Reacts to touch
- (add to the list)

Make a library search of books on kinetic art; talk to technicians; go to flea markets, garage sales or junkyards to acquire interesting found objects.

Materials: Assorted mixed media.

Some Concepts For Kinetic Events:

- *Transformation:* Evolution, transition, change, mutation.
- *Mimesis:* Of nature, ecosystems, biological systems, sociological systems: analogy, metaphor.
- *Game:* Cooperation, viewer-response structures, play.
- *Homeostasis:* Self-organizing, self-seeking, self-balancing systems.
- *Experiental:* Involving an "event," human participation.
- *Teleological:* Self-destructing, consumable.
- *Autocreative:* Self-structuring

BIBLIOGRAPHY

Arieti, Silvano, *Creativity: The Magic Synthesis.* New York: Viking Press, 1979.

Arnheim, Rudolf, *Visual Thinking.* Berkeley: University of California Press, 1970.

Arnheim, Rudolf, *New Essays on the Psychology of Art.* Berkeley: University of California Press, 1986.

Barthes, Roland, *The Responsibility of Forms.* New York: Hill and Wang, 1985.

Behrens, Roy, *Design in the Visual Arts.* Englewood Cliffs, New Jersey: Prentice-Hall Inc., 1984.

Baumgartner, Victor, *Graphic Games: From Pattern to Composition.* Englewood Cliffs, New Jersey: Prentice-Hall, Inc., 1983.

Cardinal, Roger, *Figures of Reality.* New York: Barnes and Noble, 1981.

Carraher, Ronald G., and Jacqueline B. Thurston, *Optical Illusions and the Visual Arts.* New York: Van Nostrand Reinhold, 1966.

Cheatham, Frank R., Jane Hart Cheatham, Sheryl A. Haler, *Design Concepts and Applications.* Englewood Cliffs, New Jersey: Prentice-Hall, Inc., 1983.

Chetwynd, Tom, *Dictionary of Symbols.* London: Granada Publishing, 1982.

DeBono, Edward, *Lateral Thinking.* London: Ward Lock Education Ltd, 1970.

Deely, John, *Semiotics.* Lanham, Maryland: University Press Of America, 1982.

Ehrenzweig, Anton, *The Hidden Order of Art.* London: Weidenfeld and Nicolson, 1967.

Eliot, Alexander, *Myths.* New York: McGraw-Hill, Inc., 1976.

Harlan, Calvin, *Vision and Invention.* Englewood Cliffs, New Jersey: Prentice-Hall, Inc., 1970.

Fuller, Buckminster F., *Synergetics.* New York: MacMillan, 1975.

Gordon, William J.J. *Synectics.* New York: Harper and Row, 1961.

Grillo, Paul Jacques, *Form, Function and Design.* New York: Dover, 1960.

Hervey, Sandor, *Semiotic Perspectives.* Boston: George Allen And Unwin, 1982.

Jung, Carl, *Man And His Symbols.* New York: Doubleday, 1964.

Kepes, Gyorgy, *Structure in Art and in Science.* New York: George Braziller, 1967.

Kince, Eli, *Visual Puns in Design.* New York: Watson-Guptill Publications, 1982.

Knobler, Nathan, *The Visual Dialog.* New York: Holt, Rinehart, and Winston, 1980.

Koestler, Arthur, *The Act of Creation,* New York: Macmillan, 1964.

Langer, Suzanne, *Feeling and Form.* New York: Charles Scribner's Sons, 1971.

Lauer, David, *Design Basics.* New York: Holt, Rinehart, and Winston, 1985.

Leisure, Jerry, and Jonathan Block. *Understanding Three Dimensions*. Englewood Cliffs, New Jersey: Prentice-Hall Inc., 1987.

Locher, J.L., *The World of M.C. Escher*. New York: Abrams, 1971.

Ocvirk, Otto G., Robert O. Bone, Robert E. Stinson, *Art Fundamentals*. Dubuque, Iowa: Wm. C. Brown, 1981.

Ornstein, Robert E. *The Nature of Human Consciousness*. San Francisco: Freeman, 1973.

Osborn, Charles, *Applied Imagination*. New York: Charles Scribner's Sons, 1963.

Mitchell, W.J.T., *Iconology*. The University of Chicago Press, 1986.

Panofsky, Erwin, *Meaning in the Visual Arts*. Garden City, New York: Doubleday Anchor, 1983.

Parnes, Sidney J., Harold F. Harding, *Source Book for Creative Thinking*. New York: Charles Scribner's Sons.

Roukes, Nicholas, *Art Synectics*. Worcester, Massachusetts: Davis Publications, Inc., 1982.

Samples, Bob, *The Metaphoric Mind*. Reading, Massachusetts: Addison-Wesley.

Stevens, Peter S. *Patterns in Nature*. Boston: Little, Brown and Co., 1974.

Schwenk, Theodor, *Sensitive Chaos: The Creation of Flowing Forms in Water and Air*. London: Rudolf Steiner, 1965.

Thomas, Lewis, *The Medusa and the Snail*. New York: Viking Press, 1979.

Thompson, D'Arcy, *On Growth and Form*. London: Cambridge University Press, 1961.

Von Orch, Roger, *A Whack on the Side of the Head*. New York: Warner Books, 1983.

Wallis, Mieczylaw, *Arts and Signs*. Bloomington, Indiana: Indiana University Publications, 1975.

White, Lancelot Law, *Aspects of Form*. London: Percy Lund, Humphries and Co., 1968.

INDEX

Adair, Ann, *Two Gators Playing Pool*, 164
add, 15
Ajami, Jocelyn, *Orphic Experiments, Calyx II*, 81
Albers, Joseph, 71
Amoldi, Charles, *Small Sculpture*, 142
analog, 24,
 constructed, 39
 design, 24, 110
 empathy, 25, 111
 fantasy, 26, 111
 function, 23, 110
 phenomena, 23, 111
 psychological, 25
 sensory, 25, 111
 stimulus and constructed, 83
 symbolic, 111
 visual, 24, 110
analogical thinking, 23
analogistics, visual, 27
analogize, 19
analogy, 23, 110
ancient signs, 104
Anderson, Donald M., 70
Andres, Marion, *Synectic Composition*, 61
animate, 16
Anusziewicz, Richard, *Division of Intensity*, 85, 132
Archimboldo, Giuseppe, *Summer*, 155
Arnheim, Rudolph, 30, 31, 40, 54
Arnoldi, Charles, *Small Sculpture*, 134
art-think, 21
Audley, Ramona, *American Gothic*, 180

Bailey, Clayton, *Robot Lady with Arf the Robot Pet*, 18
Baj, Enrico, *Catherine Henrietta de Balzac*, 62
balance, 73
 symmetrical, 73
 asymmetrical, 73
Barell, John, 14
Barthes, Roland, 107
Baskin, Leonard, *Oppressed Man*, 145
Bauermeister, Mary, *Put-Out*, 134
 Pain-Ting, 138
 Momento Mary on St. Sebastian from Boticelli, 107

Beardy, Jackson, *Rebirth*, 112
Beasley, James, *Dancing at the Copa*, 113
Bell, Leonard, *Isometric Fantasy*, 96
Benes, Barton Lidice, *Money*, 67
Berguson, Alice, *Design Derived From Crossectioned Pomegranate*, 84
Bill, Max, 76
Blackwood, David, *The Great Peace of Brian and Martin Winsor*, 117
Bonnardi, Joe, *Design Derived From Inflorescence Pattern*, 86
Botey, Gimenez, *Man of Wood*, 22
Brauchli, Pierre, *Babylon Today*, 26
Broderson, James, *Axial System Design*, 84
Bronowski, Jacob, 11, 12
Brown, Roger, *Warp-Woof—The Fabric of City Life*, 158
Bruegel, Pieter, *Avarice*, 102
Buonagurio, Toby, *Shoes As Art: Snake Skin Robot Shoes*, 173
 Custom Street Rod, 173
Burchfield, Charles, *The East Wind*, 128
Bury, Paul, *The Staircase*, 98

Calder, Alexander, *Constellation*, 59, 154
Campin, Robert, *The Annunciation*, 35
Caplan, Ralph, 15
Cardinal, Roger, 27, 43, 110, 111
Carman, Nancy, *Monument To My Failures*, 66
Chagall, Marc, 25
Chapman, Rob, *Counterchange Pattern*, 88
Chetwynd, Tom, 105
 Dictionary of Symbols, 129
Ching, Francis D. K., 75
Collins, Dennis W. A., *Queen Elizabeth*, 53
color
 chording, 132
 contrasts, 131
 discordant, 134
 wheel, 130
Colton, Charles Caleb, 148
combine, 15
comic idiom, 153
conceptual grouping, 43
contradict, 18
contrast, 131

Cooper, Michael Jean, *Trainer Tricycle*, 66
creative thinking, tools for, 15
Cubist painters, 16, 150

D'Souza, Kevin, *Phenomenon of Force, Forms and Color*, 32
Dali, Salvador, *The Persistence of Memory*, 175
 Apparition of a Face and Fruit-Dish on a Beach, 153
 Enchanted Beach With Three Fluid Graces, 162
Daumier, Honoré, 156
DaVinci, Leonardo, 127
de Bono, Edward, 27
Deardon, Michael, *Pen Pals*, 163
del Pezzo, Lucio, *Untitled*, 15
 Box, 131
DeLonga, Leonard, *Tree*, 110
design, 71
discordant color, 134
disguise, 18
distort, 17
Doolittle, Helen, *Memory Matrix*, 60
Dower, Mary, *The Eyes Have It*, 52
Duin, Ed, *Ynim-602*, 143
Durer, Albrecht, *Melancholia*, 105
Dvorak, R.R., *Lifetree*, 152

Earl, Jack, *Where I Used To Live in Genoa, Ohio*, 120
Effect of Forces on Form, The, 44
Eluard, Paul, 106
empathize, 16
equilibrium, dynamic, 33
equivocate, 19
Ernst, Max, 11
 Old Man and Flower, 43
Escher, M.C., *Reptiles*, 10

fantasize, 21
Fleming, Frank, *Birdhand*, 27
forces, 30
form, 76
fragment, 17

Friederberg, Pedro, *One-Point Perspective Fantasy*, 138
Fuller, Buckminster, 11, 75, 116
Fuseli, Henry, 16

Gallagher, David, *Shoe Tree*, 163
Gamble, Ed, *Editorial Cartoon*, 157
Gerstner, Karl, 133
Getzels, J.W., 18
Gilbert, John Milton, *Personality Portrait: Stanley Marcus*, 168
Utopian Egg Manufacturing Device, 177
globular cluster M92, the, 30
Goethe, 132
Gordin, Sidney, *Untitled*, 72, 139
Gordon, William J.J., 11
Grant, Denis, *Transformations*, 165
graphic signs, 103
Graves, Morris, *Bird Singing in the Moonlight*, 25
Grey, Alex, *Kissing*, 109
Grillo, Paul J., 72, 78, 82
Grooms, Red, *Dali Salad*, 148
Walking the Dogs, 154
The Cedar Bar, 180
Grossman, Nancy, *Gunhead #2*, 115

Haeckel, Ernst, *Crab Drawing*, 24
Radiolaria, 85
Haese, Gunther, *Olymp*, 98
Halbritter, Kurt, *Crosslink Critters*, 167
Halverson, Jane, *Towards Structure*, 82
Hamilton, Richard, *She*, 58
Harlan, Calvin, 133
Hart, Johnny, B.C., 12
Hesse, Herman, 102
hobo Signs, 103
Hofmann, Hans, 31
Hogarth, William, 150
Fisherman, 151
Hokusai, Katsushika, *The Great Wave*, 111
Hudson, Robert, *Gaze*, 63
Letter Head, 139
Posing the Question, 148
Hunt, Graham, *Words and Shapes*, 114
Hushlak, Gerald, *Heraclitus' Dendro in Six Progressions*, 142
hybridize, 19

iconography, 104
icons, 104
images, camouflaged, 152
inflorenscence patterns, 86
Isle of Man, The: The Rocks of Scilly at a Distance, 162
isolate, 17
Itten, Johannes, 132, 133

Jackman, Sandra, *A Fact of Life*, 136
James, Henry, 78

Jenkins, Paul, *Phenomena Spectrum Dial*, 132
Johns, Jasper, *Target with Four Faces*, 102
Picasso Cup, 150
Johnson, Philip, *Untitled*, 127
Johnston, Peter, *Synectic Energy Encounters*, 46
Jones, Mary, *Beauty*, 74
Jung, Carl, 11

Kaufman, Curt, *Untitled*, 95
Kepes, Gyorgy, 76
Kerzie, Ted, *City Life*, 132
Kince, Eli, 155
King, William, *Phobia*, 121
Klee, Paul
Snail, 23, 25, 77
Around the Fish, 104
Kley, Heinrich, *At the Hofbrau*, 157
The Bottle Family, 164
Klimt, Gustav, *Water Serpents*, 161
Klyver, Stan, *Home in the Woods*, 19
Utopian Energy Efficient House, 176
Knowlton, Ken, *Charlie Chaplin*, 30
Lazarus' Poem and Statue of Liberty Image, 53
Koestler, Arthur, 110
Kohlmeyer, Idea, *Mythic Chair*, 176
Kostyniuk, Rond, *Relief Structure in Three Parts*, 89, 133
Koursaros, Harry, *First Olympiad*, 141

Laky, Gyongy, *House*, 47
lampooning, 156
Langer, Suzanne, 106, 149
lattice design, 92
LeCorbusier, 70
Levi-Strauss, Claude, 20
Lewis, G. H., 40
Lippold, Richard, *Variations Within a Sphere*, 78
Lohse, Richard Paul, *Thirty Vertical Systems*, 144
Lucie-Smith, Edward, 148

MacKinnon, Donald W., 22
Magritte, René, *Le Modele Rouge*, 171
L'Exception, 171
The Blank Signature, 149
Time Transfixed, 21
Mallarmé, Stephane, 148
Markman, Ronald, *Fish Dinner*, 137
Marti-Ibanez, Felex, 105
Martinelli, John, *Shape Wars*, 46
Matisse, Henri, *The Bees*, 49
Maurois, André, 154
May, Rollo, 11
McCoy, Edward, *Lucky Day: Tuesday*, 118
McWilliams, Al, *Eggscape*, 170
meandering line composition, 90
Meidenger, Bill, *Fantasy Plants*, 169
Menkin, Arther, *Pointillistic Pattern*, 51

Merkowsky, Julie, 52,
Mandala Portrait, 91
Merrick, Hank, *Constellations*, 59
metamorphose, 19, 20
metaphor, 106
Mitchell, W.J.T., 128
Mondrian, Piet, *Composition with Grey, Red, Yellow, and Blue*, 33
Broadway Boogie Woogie, 38
Moore, Henry, *Reclining Figure*, 36, 76
Morrison, Jens, *Casa de Tonozintla*, 122
mutation, 20
mythologize, 20

Newman, Richard, *Assassination Monument*, 103
Bird Monument, 124,
Trojan Horse, 125
nonsymbolic, 110
Notkin, Richard, *Cube Skull Teapot*, 108
Endangered Species #1, 115

O'Brien, Jerry, *Harnessing Sea Power*, 178
Onslow-Ford, Fordon, *Who Lives*, 48
optical
illusion, 150
movement, 34
order, 70
Orwell, George, 18
Ovid, 20

Paine, Tom, 18
Panofsky, Irwin, 104
Pantellas, Andrew, *Motif Divided and Rearranged*, 80
paradox, visual, 148
paradoxical images, perspective, 150
parody, 18
Patton, Louise, *Analysis and Anomaly*, 166
Paz, Octavio, 123
Pellan, Alfred, *Floraison/Blossoming*, 25
perception
of forms and forces, 31
visual, 31
grouping, 40, 42
linking, 40
Perry, Yolanda, *Images and Energy Field*, 56
Peter, L.J., 153
Pfenning, Reinhold, 76
Picasso, Pablo, *Baboon and Young*, 155
Three Musicians, 73
pictographs, 104
Pinardi, Enrico, *Tower Sentinel*, 80
pointillism, 51
Pousette-Darte, Richard, *Imploding White*, 3:
Ramapo Web, 133
Untitled, 47
Pratt, Christopher, 71
prevaricate, 17, 19
principles of visual organization, 72
Proch, Don, *Delta Night Mask*, 11, 135

puns, visual, 155
Pye, David, 12, 72

Rasmusen, Henry, 34
Ratia, Arni, 15
Razik, R.L., 12
reconstructing, 23
referring, 22
reflecting, 22
repeat, 15
Resultay, Jun, *Metamorphic Crystals*, 135
Ricci, Franco Maria, *Fantasy Architecture*, 94
Riley, Bridget, 33
Robson, Mike, *Dancing Bull and Bird*, 58
Rojas, Cecilia, *Cluster Composition*, 87
Rothenburg, Albert, 12
Roukes, Nicholas, *Kaleidoscope*, 34
 Endotopic and Exotopic Constructions, 97
Rousseau, Jean Jacques, 21
Ruskin, John, 71

Saeger, George, *Where Lightbulbs Come
 From*, 178
Saint Phalle, Niki, *Mr. and Mrs. With Their Pet*,
 179
 La Lune, 165
Samples, Bob, 106
Santayana, George, 153
Sarri, Sergio, *Camera D'Analist Syn-ext*, 64
Saul, Peter, *Donald Duck Descending The
 Staircase*, 172
scale, change, 17
Scharf, Kenny, *When Earths Collide*, 156
schematic
 analog, 108
 doodles, 113
Schultz, Diane, *If You Live Fast*, 123
Schultz, Dorothy, *Meander Pattern*, 89
Schultz, Rand, *Diner*, 20
Selchow, Roger, *Sea Chanty*, 119
semiotics, 107
Shakespeare, William, 19
Shropshire, Walter, Jr., 24
Signs, 103, 104
Silverman, Gene, *Camouflaged Object*, 160
Simpson, Tommy, *Climbing the Success
 Ladder*, 106
Smith, Hassel, *Untitled*, 34
 Untitled, 140
Snail, Roman (Helix pomatial), 23
Snelson, Kenneth, *Easy Landing*, 71
Snyder, George, *Facet*, 88
 Twenty-eight Days in April, 135
space
 illusory, 74
 actual, 75
Spencer, H., 77
Steinberg, Saul, *Fantasy in one-point·
 perspective*, 93
Steir, Pat, 126
Steir, Pat, *Line Lima*, 126
Stella, Frank, *Lac Laronge III*, 140

structure, 76
Studio Action, 45-66: shapes and forces,
 synectic energy encounter, synectic
 encounter #2, the scribble field, dot-
 energy pattern, extruded lines and dots,
 afterimage pattern, pointillistic pattern,
 patterns by grouping letters or numerals,
 similarity grouping: dot matrix patterns,
 the interrupted energy field, proxemic
 variations, visual closure, constellation,
 image matrix, design by combining an
 organic and inorganic subject, close
 encounters, idiosyncratic grouping,
 antitheses as a fantasy stimulus, design
 from word play, grouping by surface
 similarity
Studio Action, 79-99: synectic lines, walking
 the line, divide and rearrange, "Barnacle"
 grouping, combining geometric and
 organic shapes, toward structure: the
 cohesion of visual units, stimulus from
 industrial structures, design from nature:
 cross sections, axial systems, explosion
 patterns, branching systems, cluster
 systems, crystalline pattern, meanders,
 counterchange pattern, concentrics:
 shapes from shapes, more concentrics:
 Mandala motif, lattice pattern, fantasy in
 one-point perspective, fantasy in two-
 point perspective, isometric perspective,
 endotopic and exotopic, design by
 chance
Studio Action, 113-128: visual onomatope,
 synoptic scribbles, ideography, word-
 image poetry, art and issue, coactive
 images, mythmaking, astrological portrait,
 subjective signification, dual portrait,
 identity in packages, duality in 3-D,
 signifying emotion, iconic dwelling, dream
 fantasy: idiosyncratic representation,
 private symbols, surreal signs, wacky
 monuments, déjà vu: reconstructing an
 old myth, analogical thinking made
 visible, function analog, sensory analog,
Studio Action, 159-178: effecting visual
 discontinuity: the camouflaged contour,
 figure-ground camouflage, the
 camouflaged 3-D object, patterning,
 double-image, visual pun, mimics,
 making it strange, more making it
 strange, preposterous crosslinks, comic
 portrait, plants from "The Little Shop of
 Horrors", visual oxymoron, more on
 oxymoron, drawing from the comics, an
 ordinary object as an art form, futuristic
 mutation, dream fantasy visualized,
 architectural fantasy, utopian scenario,
 mock information
substitute, 17
subtract, 15
Sully, J., 15
superimpose, 16
symbolic, 110
symbolize, 20

symbols, 105
synaesthetic, 25
synectic
 theory, 11
 pinball machine, 13
 think cycle, 22
 trigger mechanisms, 12, 14
 thinking, 11
 ways of working, 12
 attitude, 12
system, 70

Tatro, Ron, *Scribble Man*, 114
Taylor, Geoffrey, 156
Thomas, Lewis, 70
Thompson, D'arcy, 39
Thoreau, Henry David, 15
Thurber, James, 154
Torrance, E. Paul, 11
transfer, 16
trilobyte, 39

Van Gogh, Vincent, *Self Portrait with Grey Felt
 Hat*, 37
VanDalen, Anton, *Aliens Rescue Animals
 From Central Park Zoo*, 153
variations, proxemic, 57
Vasarely, Victor, *Tlinko*, 41
 Betelgeuse II, 41
 Epsilon, 50
 Supernovae, 55
 Hat IV, 141
Verdi, Richard, *Klee and Nature*, 23
Vicissitudes of Family Life, The, 114
visual
 analog, 110
 analogistics, 77
 elements, 74
von Oech, Roger, 14
Vulliamy, Benjamin, *Regulator Clock*, 70

Waldin, Jein, *Packaged Identities*, 120
 Alter Ego, 17
 My Fantasy, 122
Westermann, H.C., *Phantom in a Wooden
 Garden*, 181
Wittgenstein, Ludwig, 149
Wunderlich, Paul, *Sphinx and Death*, 136

Yamanaka, Kunio, *Return to a Square*, 91
Young, Peter, *Dot Design*, 48

synectic (si-nek-tik). a. (LL. *synecticus,*
Gk. *synectikos,* holding together.) 1. Bringing
different things into real connection.

DESIGN
SYNECTICS

Stimulating Creativity in Design

Design Synectics is a practical guide to visual thinking. It unites Synectics, a theory of creativity based on the idea of combining opposites, with the design process. This unique approach to design can be used to generate new percep- tions, develop new metaphors and link disparate elements in both two- and three-dimensional art.

An invaluable resource on creative problem solving, *Design Synectics* stimulates both rational (left brain) and non-rational (right brain) thinking through a series of over 100 challenging art and design exercises. Each chapter intro- uces a basic design idea, and then provides activities that reinforce, modify and expand it. Ample illustrations from past and present clarify the concepts presented.

Design appeals to the artist's sense of reason and order. Synectics mobilizes fantasy and "off-the-wall" thinking. In combination, they allow artists to see connections between things that did not seem connected before. Whether used as a reference, an art "workbook" or an inspirational tool, *Design Synec- tics* will help artists of all ages and abilities find such connections and use them expressively.

About the author: NICHOLAS ROUKES has written numerous articles and books on art. His paintings and sculptures have been shown at the San Fran- cisco Museum of Art, the Stanford Art Gallery, The Stanford Research Institute, the Phoenix Art Gallery, and the Bolles Gallery in San Francisco, among other galleries both in the United States and Canada.

Roukes, professor of art and art education at the University of Calgary (Canada), has for over 20 years been investigating new approaches and tech- niques for the fine arts. He is author of *Sculpture in Plastics, Masters of Wood Sculpture, Acrylics Bold and New,* and *Art Synectics.*

Davis Publications, Inc.
Worcester, Massachusetts
ISBN 0-87192-198-7